THE
HIP
HOP
WARS

THE
HIP
HOP
WARS

What We Talk About When
We Talk About Hip Hop
—and Why It Matters

TRICIA ROSE

BASIC
CIVITAS
BOOKS

A Member of the Perseus Books Group
New York

Books published by BasicCivitas are available at special discounts for bulk purchases in
the United States by corporations, institutions, and other organizations. For more infor-
mation, please contact the Special Markets Department at the Perseus Books Group,
2300 Chestnut Street, Suite 200, Philadelphia, PA 19103, or call (800) 810-4145, ext.
5000, or e-mail special.markets@perseusbooks.com.

Library of Congress Cataloging-in-Publication Data
Rose, Tricia.
 The hip hop wars : what we talk about when we talk about hip hop / Tricia Rose.
 p. cm.
 Includes bibliographical references and index.
 ISBN 978-0-465-00897-1 (alk. paper)
 1. Hip-hop—Social aspects—United States. 2. Rap (Music)—Social aspects—United
States. 3. Social change—United States. 4. Subculture—United States. 5. African
Americans—Social conditions. 6. United States—Social conditions. I. Title.

HN59.2.R68 2008
305.896'07301732—dc22

 2008031637

10 9 8 7 6

Contents

PART TWO: PROGRESSIVE FUTURES

For Andre, Clark, and Coleman

Preface

HIP HOP IS NOT DEAD, but it is gravely ill. The beauty and life force of hip hop have been squeezed out, wrung nearly dry by the compounding factors of commercialism, distorted racial and sexual fantasy, oppression, and alienation. It has been a sad thing to witness. I am not prone to nostalgia but will admit, with self-conscious wistfulness, that I remember when hip hop was a locally inspired explosion of exuberance and political energy tethered to the idea of rehabilitating community. It wasn't ideal by any means: Carrying many of the seeds of destruction that were part of society itself, it had its gangsters, hustlers, misogynists, and opportunists; it suffered from the hallmarks of social neglect and disregard; it expressed anger and outrage in sometimes problematic ways. But there was a love of community, a drive toward respect and mutuality that served as a steady heartbeat for hip hop and the young people who brought it into existence. These inspirational energies kept hip hop alive as a force for creativity and love, affirmation and resistance.

I wrote my first book on hip hop in the early 1990s, just before the dramatic changes that redefined hip hop—the ones to which this book is devoted—really set in. *Black Noise: Rap Music and Black Culture in Contemporary America* is a scholarly book that explored the cultural and political origins of rap music and hip hop culture. It argued for the value and importance of hip hop and emphasized the possibilities I felt the music and culture represented. It was a labor of intellect and heart. I was raised in the Bronx during the 1970s, so it was a personal subject for me. But I was also intellectually inspired by hip hop; I was fascinated by its challenges to musical rules, its ability to use the powerful tradition of black oration and storytelling to render stylistically compelling music dealing with the pleasures and

pains lived by those with the least. The problems in hip hop were apparent to me, too, but I also felt that their overall impact on hip hop was dwarfed by hip hop's potential. At the time, hip hop served as a rich alternative space for multicultural, male and female, culturally relevant, anti-racist community building. Its ability to revise and transform so much about American culture with so few resources was breathtaking.

But the world of hip hop on which *Black Noise* was based—the vision of hip hop on which a good deal of the field has been grounded—is not what dominates the U.S. airwaves and recording industry today. A few artists elsewhere around the globe, along with some who have slipped into American radio rotation and others in the so-called underground, reflect the extraordinary life force that remains. However, the gap between "then and now" for the most visible, most widely consumed hip hop is profound. Many progressive cultural critics simply work around this disjuncture by seeking out— and finding in the underground or on the commercial margins— less-promoted artists or songs that open up new spaces or challenge the existing mainstream obsession with black men and women as gangstas, pimps, and hoes. These alternative works are vitally important, and they need attention. At the same time, though, the terms of the commercial mainstream—and the artists who capitulate to them—need to be directly challenged. Simply pointing to alternatives has not been enough. The industry-generated focus in hip hop has largely been uninterrupted by positive attention directed toward marginalized hip hop artists. And, as corporate influence has expanded, the quality of the public conversation has contracted, disabling progressive responses to both the conservative attacks and the commercial manipulations that have brought hip hop to the ICU ward.

The terms of this public conversation have worried me for quite some time. I've lectured on hip hop widely for fifteen years and, in the last few of these, have spent a good deal of time emphasizing what has gone wrong with commercial hip hop and drawing attention to alternatives with the hope that smaller conversations would

substantially contribute to a grassroots redirection of commercial hip hop. All the while, I grew incredibly frustrated with the terms of the public conversation, which seemed to be trapped in endless repetitions of silly, exaggerated claims by critics and supporters alike—repetitions that enervated the conversation and dulled critical development. In many of the smaller conversations I have had about these changes in hip hop, my challenges to the destructive forces of commercialized manufacturing of ghetto street life were embraced by some students, fans, and colleagues. But many others bristled at my emphasis; they wanted to point to the underground as proof that things were not so bad. It was as if the mere existence of underground artists meant that hip hop was healthy, and that because of such artists, these commentators didn't have to confront either what the most powerful and commercially viable brand of hip hop had become or its vast influence on an entire generation's creativity. By remaining silent or feigning disinterest in corporate mainstream hip hop, they could, it seemed, avoid being labeled "haters" in a world where haters are banished from hip hop and players are embraced. It became clear to me that the public hostility toward hip hop—matched only by the self-destructive terms of embrace—were disabling progressive critique of this latest incarnation of commercial hip hop.

I recall one particularly memorable conversation in which I described my disappointment with the repetition of the same arguments and counterarguments about hip hop, likening them to comedian David Letterman's Top Ten feature—but my version was a top-ten list of the most popular and wrongheaded arguments about hip hop. It was then that *The Hip Hop Wars*, a sustained response to these debates, came into focus. Because of my interest in tackling the racial, gender, and sexual imagery and ideas being promoted at the heart of mainstream hip hop, this book does not focus on multicultural or international aspects of hip hop. It's true that hip hop fans and artists come from many different national, ethnic, and religious backgrounds, and are diverse in terms of gender and sexual orientation as well. But the highly coveted commercial market for hip hop

in the United States, to which this book is devoted, reconstructs hip hop as all-black and, because of this, black youth are marked by it and simultaneously invest in it heavily. Despite the diversity of fans and artists on the commercial margins, then, the public struggle over hip hop is waged over the images, stories, and market power associated with black male and female bodies. Likewise, the language, style, and attitudes associated with hip hop are coded and understood and performed as "black." So, if hip hop is going to get well, if we're going to learn from what has happened to it, we need to arm young black men and women, and everyone else, with powerful critical tools so that they can expose and challenge the state of commercial hip hop, divest it from this pernicious brand of blackness, and make far more room for a wide range of alternatives.

Introduction

I'd like to say to all the industry people out there that control what we call hip hop, I'd like for people to put more of an effort to make hip hop the culture of music that it was, instead of the culture of violence that it is right now. There's a lot of people that put in a lot of time, you know the break-dancers, the graffiti artists, there's people rapping all over the world. . . . All my life I've been into hip hop, and it should mean more than just somebody standing on the corner selling dope—I mean that may or may not have its place too because it's there, but I'm just saying—I ain't never shot nobody, I ain't never stabbed nobody, I'm forty-five years old and I ain't got no criminal record, you know what I mean? The only thing I ever did was be about my music. So I mean, so, while we're teaching people what it is about life in the ghetto, then we should be teaching people about what it is about life in the ghetto, me trying to grow up and to come up out of the ghetto. And we need everybody's help out there to make that happen.

> —Melle Mel, lead rapper of and main songwriter for the seminal rap group Grandmaster Flash and the Furious Five, in an acceptance speech during the group's induction into the Rock and Roll Hall of Fame, March 2007

HIP HOP IS IN A TERRIBLE CRISIS. Although its overall fortunes have risen sharply, the most commercially promoted and financially successful hip hop—what has dominated mass-media outlets such as television, film, radio, and recording industries for a dozen years or so—has increasingly become a playground for caricatures of black gangstas, pimps, and hoes. Hyper-sexism has increased

1

dramatically, and homophobia along with distorted, antisocial, self-destructive, and violent portraits of black masculinity have become rap's calling cards. Relying on an ever-narrowing range of images and themes, this commercial juggernaut has played a central role in the near-depletion of what was once a vibrant, diverse, and complex popular genre, wringing it dry by pandering to America's racist and sexist lowest common denominator.

This scenario differs vastly from the wide range of core images, attitudes, and icons that defined hip hop during its earlier years of public visibility. In the 1980s, when rap's commercial value began to develop steam, gangsta rappers were only part of a much larger iconic tapestry. There were many varieties of equally positioned styles of rap—gangsta as well as party, political, afrocentric, and avant-garde, each with multiple substyles as well. However, not only were many styles of rap driven out of the corporate-promoted mainstream, but since the middle to late 1990s, the social, artistic, and political significance of figures like the gangsta and street hustler substantially devolved into apolitical, simple-minded, almost comic stereotypes. Indeed, by the late 1990s, most of the affirming, creative stories and characters that had stood at the defining core of hip hop had been gutted. To use a hip hop metaphor, they were driven underground, buried, and left to be dug up only by the most deeply invested fans and artists.

Gangstas, hustlers, street crimes, and vernacular sexual insults (e.g., calling black women "hoes") were part of hip hop's storytelling long before the record industry really got the hang of promoting rap music. Gangstas and hustlers were not invented out of whole cloth by corporate executives: Prior to the ascendance of corporate mainstream hip hop, these figures were more complex and ambivalent. A few were interesting social critics. Some early West Coast gangsta rappers— N.W.A., and W.C. and the Maad Circle, for example—featured stories that emphasized being trapped by gang life and spoke about why street crime had become a "line of work" in the context of chronic black joblessness. Thwarted desires for safe communities and meaningful work were often embedded in street hustling tales. Even-

tually, though, the occasional featuring of complicated gangstas, hustlers, and hoes gave way to a tidal wave of far more simplistic, disproportionately celebratory, and destructive renderings of these characters. Hip hop has become buried by these figures and "the life" associated with them.

This trend is so significant that if the late Tupac Shakur were a newly signed artist today, I believe he'd likely be considered a socially conscious rapper and thus relegated to the margins of the commercial hip hop field. Tupac (who despite his death in 1996 remains one of hip hop's most visible and highly regarded gangsta rappers) might even be thought of as too political and too "soft." Even as he expressed his well-known commitment to "thug life," his rhymes are perhaps too thoughtful for mainstream "radio friendly" hip hop as it has evolved since his death.

This consolidation and "dumbing down" of hip hop's imagery and storytelling took hold rather quickly in the middle to late 1990s and reached a peak in the early 2000s. The hyper-gangsta-ization of the music and imagery directly parallels hip hop's sales ascendance into the mainstream record and radio industry. In the early to middle 1990s, following the meteoric rise of West Coast hip hop music producer Dr. Dre and of N.W.A., widely considered a seminal gangsta rap group, West Coast gangsta rap solidified and expanded the already well-represented street criminal icons—thug, hustler, gangster, and pimp—in a musically compelling way. This grab bag of street criminal figures soon became the most powerful and, to some, the most "authentic" spokesmen for hip hop and, then, for black youth generally.

For the wider audience in America, which relies on mainstream outlets for learning about and participating in commercially distributed pop culture, hip hop has become a breeding ground for the most explicitly exploitative and increasingly one-dimensional narratives of black ghetto life. The gangsta life and all its attendant violence, criminality, sexual "deviance," and misogyny have, over the last decade especially, stood at the heart of what appeared to be ever-increasing hip hop record sales. Between 1990 and 1998, the Recording Industry

Association of America (RIAA) reported that rap captured, on average, 9–10 percent of music sales in the United States. This figure increased to 12.9 percent in 2000, peaked at 13.8 percent in 2002, and hovered between 12 and 13 percent through 2005. To put the importance of this nearly 40 percent increase in rap/hip hop sales into context, note that during the 2000–2005 period, other genres, including rock, country, and pop, saw decreases in their market percentage. The rise in rap/hip hop was driven primarily by the sale of images and stories of black ghetto life to white youth: According to Mediamark Research Inc., increasing numbers of whites began buying hip hop at this point. Indeed, between 1995 and 2001, whites comprised 70–75 percent of the hip hop customer base—a figure considered to have remained broadly constant to this day.[1]

I am not suggesting that all commercial hip hop fits this description, nor do I think that there is no meaningful content in commercial hip hop. I am also not suggesting that commercially successful gangsta-style artists such as Jay-Z, Ludacris, 50 Cent, T.I., and Snoop Dogg lack talent. It is, in fact, rappers' lyrical and performative talents and the compelling music that frames their rhymes—supported by heavy corporate promotion—that make this seduction so powerful and disturbing. They and many others whose careers are based on these hip hop images are quite talented in different ways: musically, lyrically, stylistically, and as entrepreneurs. The problems facing commercial hip hop today are not caused by individual rappers alone; if we focus on merely one rapper, one song, or one video for its sexist or gangsta-inspired images we miss the forest for the trees. Rather, this is about the larger and more significant trend that has come to define commercial hip hop as a whole: The trinity of commercial hip hop—the black gangsta, pimp, and ho—has been promoted and accepted to the point where it now dominates the genre's storytelling worldview.

The expanded commercial space of these three street icons has had a profound impact on both the direction of the music and the conversation about hip hop—a conversation that has never been *just*

about hip hop. On the one hand, the increased profitability of the gangsta-pimp-ho trinity has inflamed already riled critics who perceive hip hop as the cause of many social ills; but, on the other, it has encouraged embattled defenders to tout hip hop's organic connection to black youth and to venerate its market successes as examples of pulling oneself up by the bootstraps. The hyperbolic and polarized public conversation about hip hop that has emerged over the past decade discourages progressive and nuanced consumption, participation, and critique, thereby contributing to the very crisis that is facing hip hop. Even more important, this conversation has become a powerful vehicle for the channeling of broader public discussion about race, class, and the value of black culture's role in society. Debates about hip hop have become a means for defining poor, young black people and thus for interpreting the context and reasons for their clearly disadvantaged lives. This is what we talk about when we talk about hip hop.

The State of the Conversation on Hip Hop

The excessive blame leveled at hip hop is astonishing in its refusal to consider the culpability of the larger social and political context. To many hot-headed critics of hip hop, structural forms of deep racism, corporate influences, and the long-term effects of economic, social, and political disempowerment are not meaningfully related to rappers' alienated, angry stories about life in the ghetto; rather, they are seen as "proof" that black behavior creates ghetto conditions. So decades of urban racial discrimination (the reason black ghettos exist in the first place), in every significant arena—housing, education, jobs, social services—in every city with a significant black population, simply disappear from view. In fact, many conservative critics of hip hop refuse to acknowledge that the ghetto is a systematic matrix of racial, spatial, and class discrimination that has defined black city life since the first half of the twentieth century, when the Great Black Migration dramatically reshaped America's cities. For some, hip hop

itself is a black-created problem that promotes unsafe sex and represents sexual amorality, infects "our" culture and society, advocates crime and criminality, and reflects black cultural dysfunction and a "culture of poverty." As hip hop's conservative critics would have it, hip hop is primarily responsible for every decline and crisis worldwide except the war in Iraq and global warming.

The defenses are equally jaw-dropping. For some, all expression in commercialized hip hop, despite its heavy manipulation by the record industry, is the unadulterated truth and literal personal experience of fill-in-the-blank rapper; it reflects reality in the ghetto; its lyrics *are the result of poverty itself*.[2] And my favorite, the most aggravating defense of commercial hip hop's fixation on demeaning black women for sport—"well, there *are* bitches and hoes." What do fans, artists, and writers mean when they defend an escalating, highly visible, and extensive form of misogyny against black women by claiming that there *are* bitches and hoes? And how have they gotten away with this level of hateful labeling of black women for so long?

The big media outlets that shape this conversation, such as Time/Warner, News Corporation, Bertelsmann, General Electric, and Viacom, do not frame hip hop's stories in ways that allow for a serious treatment of sexism, racism, corporate power, and the real historical forces that have created ghettos. When well-informed, progressive people do get invited to appear on news and public affairs programs, they wind up being pushed into either "pro" or "con" positions—and as a result, the complexity of what they have to say to one side or the other is reduced. Although the immaturity of "beef" (conflict between rappers for media attention and street credibility) is generally considered a hip hop phenomenon, it actually mirrors much of the larger mainstream media's approach to issues of conflict and disagreement. Developing a thoughtful, serious, and educated position in this climate is no easy task, since most participants defend or attack the music—and, by extension, young black people—with a fervor usually reserved for religion and patriotism.

Why We Should Care About Hip Hop

The inability to sustain either a hard-hitting, progressive critique of hip hop's deep flaws or an appreciation for its extraordinary gifts is a real problem, with potentially serious effects that ripple far beyond the record industry and mass-media corporate balance sheets. We have the opportunity to use the current state of commercial hip hop as a catalyst to think with more care about the terms of cross-racial exchanges and the role of black culture in a mass-mediated world. Indeed, we should be asking larger questions about how hip hop's commercial trinity of the gangsta, pimp, and ho relates to American culture more generally. But, instead, we have allowed hip hop to be perceived by its steadfast defenders as a whipping boy (unfairly beaten for all things wrong with American society and blamed as a gateway to continued excessive criticisms of black people's behavior) and charged by its critics as society's career criminal (responsible for myriad social ills and finally being caught and brought to trial). Not much beyond exhaustion, limited, and one-sided vicious critique, and nearly blind defense is possible in this context. Very little honest and self-reflective vision can emerge from between this rock and hard place.

Why should we care about hip hop and how should we talk about it? Serial killer, whipping boy, whatever, right? It's just entertainment—it generates good ratings and makes money for rappers and the sputtering record industry, but it doesn't matter beyond that. Or does it? In fact, it matters a great deal, even for those who don't listen to or enjoy the music itself. Debates about hip hop stand in for discussion of significant social issues related to race, class, sexism, and black culture. Hip hop's commercial trinity has become the fuel that propels public criticism of young black people. According to some critics, if we just got rid of hip hop and the bad behavior it supports (so the argument goes), "they'd" all do better in school, and structurally created racism and disadvantage would disappear like vapor. This hyper-behavioralism—an approach that overemphasizes individual action and underestimates the impact of institutionalized

forms of racial and class discrimination—feeds the very systematic discrimination it pretends isn't a factor at all.

The public debates about hip hop have also become a convenient means by which to avoid the larger, more entrenched realities of sexism, homophobia, and gender inequality in U.S. society. By talking about these issues almost exclusively in the context of hip hop, people who wouldn't otherwise dare to talk about sexism, women's rights, homophobia, or the visual and cultural exploitation of women for corporate profit insinuate that hip hop itself is sexist and homophobic and openly criticize it for being so. It's as if black teenagers have smuggled sexism and homophobia into American culture, bringing them in like unauthorized imports.

This conversation about the state of hip hop matters for another reason as well: We have arrived at a landmark moment in modern culture when a solid segment (if not a majority) of an entire generation of African-American youth understands itself as defined primarily by a musical, cultural form. Despite the depth of young black people's love of the blues, jazz, and R&B throughout various periods in the twentieth century, no generation has ever dubbed itself the "R&B generation" or the "jazz generation," thereby tethering its members to all things (good and bad) that might be associated with the music. Yet young people have limited their creative possibilities, as well as their personal identities, to the perimeters established by the genre of hip hop. No black musical form before hip hop—no matter how much it "crossed over" into mainstream American culture—ever attracted the level of corporate attention and mainstream media visibility, control, and intervention that characterizes hip hop today. It is now extremely common for hip hop fans of all racial and ethnic backgrounds, especially black fans, to consider themselves more than fans. They're people who "live and breathe hip hop every day."

This level of single-minded investment, forged in the context of sustained blanket attacks on hip hop music and culture, makes objective critique nearly impossible. Of course, this investment is itself partly a response to the deep level of societal disregard that so many

young, poor minority kids experience. As Jay-Z says in the remixed version of Talib Kweli's "Get By," "Why listen to a system that never listens to me?" For anyone who feels this way about anything (religion, patriotism, revolution, etc.), critical self-reflection is hard to come by. The more under attack one feels, the greater the refusal to render self-critique is likely to be. But such fervor is also the result of market manipulation that fuels exaggerated brand loyalty and confuses it with black radicalism by forging bonds to corporate hip hop icons who appear to be "keeping it real" and representing the 'hood. In turn, the near-blind loyalty of hip hop fans is exploited by those who have pimped hip hop out to the highest bidder. Members of the hip hop generation are now facing the greatest media machinery and most veiled forms of racial, economic, sexual, and gender rhetoric in modern history; they need the sharpest critical tools to survive and thrive.

Another reason this conversation is important is that the perceptions we have about hip hop—what it is, why it is the way it is—have been used as evidence against poor urban black communities themselves. Using hip hop as "proof" of black people's culpability for their circumstances undermines decades of solid and significant research on the larger structural forces that have plagued black urban communities. The legacy of the systemic destruction of working-class and poor African-American communities has reached a tragic new low in the past thirty years.

Since the early 1980s, this history has been rewritten, eclipsed by the idea that black people and their "culture" (a term that is frequently used when "behavior" should be) are the cause of their condition and status. Over the last three decades, the public conversation has decidedly moved toward an easy acceptance of black ghetto existence and the belief that black people themselves are responsible for creating ghettos and for choosing to live in them, thus absolving the most powerful segments of society from any responsibility in the creation and maintenance of them. Those who deny the legacy of systematic racism or refuse to connect the worst of what hip hop expresses to this history and its devastating effects on black

community are leveling unacceptable and racist attacks on black people.

The generalized hostility against hip hop impinges on the interpretation of other visible forms of black youth culture. For instance, black NBA players are tainted as a group for being part of the hip hop generation stylistically, no matter their personal actions. The few who have committed violent or criminal acts "prove" the whole lot of them worthy of attack. In a league that has mostly black players and mostly white fans, this becomes a racially charged (and racially generated) revenue problem. Such group tainting does not occur among white athletes or fans. The National Hockey League, a league that is predominantly white (in terms of both fans and players) and experiences far more incidents of game-related violence (they take time-outs to brawl!) is rarely described as problematically violent. Indeed, no matter how many individual white men get in trouble with the law, white men as a group are not labeled a cultural problem. At a more local level, hip hop gear, while considered tame—even cute—on middle-class white wearers, is seen as threatening on black and brown youth, who can't afford not to affiliate with hip hop style if they are going to have any generational credibility.

In short, the conversation about hip hop matters a great deal. Our cultural perceptions and associations have been harmful to black working-class and poor youth—the most vulnerable among us. The polarized conversation also provokes the increasing generation gap in the black community—an age gap that, in past eras, was trumped by cross-generational racial solidarity. But I wonder, too, if the effects of corporate consolidation—and of the new generational and genre-segregated market-niche strategies that dismantled the multigenerational and cross-genre formats that defined black radio in the past—have exaggerated, if not manufactured, the development of a contentious generational divide in the black community.

Who is hurt by our misunderstandings of hip hop? Surely, all of American society is negatively affected by both the antagonism leveled against it and the direction that commercial hip hop has taken. If we continue to talk about black people and race generally in near-

parodic terms, our nation will not overcome its racial Achilles' heel; the American democratic promise, as yet unfulfilled, will end up an irreparable, broken covenant. The current state of conversation about hip hop sets destructive and illiterate terms for cross-racial community building. The people *most* injured by the fraught, hostile, and destructive state of this conversation are those who most need a healthy, honest, vibrant (not sterile and repressed) cultural space: young, poor, and working-class African-American boys and girls, men and women—the generation that comprises the future of the black community. They have the biggest stake in the conversation, and they get the shortest end of the stick in it.

In this climate, young people have few visible and compassionate yet unflinchingly honest places to turn to for a meaningful appreciation and critique of the youth culture in which they are so invested. The attacks on black youth through hip hop maintain economic and racial injustice. Many working-class and poor black young people have come up in black urban communities that have been dismantled by decades-long legacies of policy-driven devastation of such communities. This devastation takes many forms, including urban and federal retreat from affordable housing, undermining of anti-discrimination laws that were designed to end structural racism, police targeting, racially motivated escalations of imprisonment, and reductions in support for what are still mostly segregated and deeply unequal public schools. Very little of this history is common knowledge, and critics avoid serious discussion of these factors, focusing instead on rappers and the ghettos they supposedly represent.

The defenses of hip hop are also destructive. The same media that pump commercial hip hop 24/7 fail to take the time to expose the crucial contexts of post–civil rights era ghetto segregation for hip hop's development. Rappers and industry moguls who profit enormously from hip hop's gangsta-pimp-ho trinity defend their empires purportedly in the interests of black youth. The constant excuses made about sexism, violence, and homophobia in hip hop are not just defenses *of* black people via hip hop; they are hurtful *to* black people. Corporate media outlets empower these businessmen-rappers, underpromote

the more sophisticated rhymes, and play down the vigorous and well-informed analysis and criticism. Many fans consume lopsided tales of black ghetto life with little knowledge about the historical creation of the ghetto; some think the ghetto equals black culture. These decisions not only dumb down the music but minimize fan knowledge and constrain the conversation as a whole.

The public conversation is both an engine for and a product of the current state of commercial hip hop. Driven by one-dimensional sound bites from the polarized camps—a format designed to perpetuate a meaningless and imbalanced form of "presenting both sides"—this conversation is not only contributing to the demise of hip hop but has also impoverished our ability to talk successfully about race and about the role of popular culture, mass media, and corporate conglomerates in defining—and confining—our creative expressions.

Versions of what has happened to hip hop that include both the ways that hip hop reflects black and brown lived experience and creativity *and* represents market and racial manipulation have been, thus far, destined for media obscurity. It is as if the real sport of our conversation about hip hop is mutual denial and hostile engagement. Intelligent, nuanced dialogue has been drowned out by the simple-minded sound bites that sustain this antagonistic divide.

Advocates and supportive critics have made a valiant effort to participate in this conversation in complex, subtle, and meaningful ways. Many writers, journalists, poets, scholars, and activists have made important contributions to the popular, literary, and scholarly treatments of hip hop. Michael Eric Dyson, Davey D, bell hooks, Mark Anthony Neal, Patricia Hill-Collins, Cornel West, Adam Mansbach, Jeff Chang, Dream Hampton, Scott Poulson-Bryant, Oliver Wang, Nelson George, Gwendolyn Pough, Imani Perry, Jeffery Ogbar, Paul Porter, Greg Tate, Marcyliena Morgan, Lisa Fager Bediako, Angela Ards, Kevin Powell, George Lipsitz, Robin Kelley, Bakari Kitwana, Joan Morgan, and Kelefah Sanneh have all offered insightful reflections on and analyses of hip hop in their respective fields. Several others have contributed blogs and other web commen-

taries that try to sort through the current state of hip hop in a productive way. But these writers and scholars are not being relied upon to frame the mainstream conversation.

The terms of this conversation need our direct attention because they keep black youth and progressive thinkers and activists locked into one-sided positions and futile battle. If we fail to address its contradictions, denials, and omissions, we will become subjected to and defined by the limits of the conversation rather than proactive participants in shaping it. I want to delineate the key features—the broadest strokes—of this conversation, since the microstruggles in which hip hop gets embroiled usually cover up the larger terms that perpetuate tiresome and disabling conflict.

This conversation is an integral part of the current state of commercial hip hop. But to properly situate the conversation, we need to account for the larger forces driving the changes in hip hop. Why has the black gangsta-pimp-ho trinity been the vehicle for hip hop's greatest sales and highest market status? Why did a substyle based on hustling, crime, sexual domination, and drug dealing become rap's cultural and economic calling card and thus the key icon for the hip hop generation? Familiar answers like industry manipulation and racism contain important truths but gloss over five key factors that have worked synergistically to create these toxic conditions:

- New technologies and new music markets
- Massive corporate consolidation
- Expansion of illicit street economies
- America's post–civil rights appetite for racially stereotyped entertainment
- Violence and sexually explicit misogyny as "valued" cultural products

Together, these five factors explain the complicated forces that have grossly distorted the legacy of hip hop while also contributing to the conversation about it. Whereas the final three are discussed in the context of the various debates about hip hop that I examine in the

chapters that follow, the first two—the role of new technologies and new music markets and the unprecedented impact of massive corporate consolidation—have a systemic effect on the entire field of discussion, and so their inclusion in this introduction is warranted. For now, let us simply note that the debates that have played out in the hip hop wars mask the full depth of the corporate and economic circumstances that redirected commercial hip hop, with an especially dramatic turn taken in the middle to late 1990s.

New Technologies, New Music Markets

Hip hop came of age at the beginning of a new technological revolution. After the late 1970s, when hip hop emerged onto the public scene, all forms of media technology exponentially expanded. Network television met stiff competition as cable televisions' hundreds of niche market–driven cable stations increased market share, especially as music became a predominantly visual medium (MTV and BET served as major anchors for this shift). Our listening format changed from records to CDs and computer technology. Advanced recording and digital technology became widely accessible to independent artists, producers, and consumers, changing the way music was made, purchased, consumed, shared, distributed, and stolen. Today, cell phones are MP3 players, with downloads and ringtones representing yet another expansion of the music market. These changes have made room for additional independent record labels and more local music production and distribution (at less cost and greater profits), thereby sustaining genres that might have been impossible to maintain solely with local support before this revolution took place.

Hip hop, like nearly all black musical forms that preceded it, began as a commercially marginal music that was subjected to segregated treatment and underfunding. It was characterized by smaller production and promotion budgets along with the assumption that the rap audience would be a youthful segment of African-Americans—an al-

ready proportionately small consumer market—and an even smaller percentage of whites and other ethnic groups. During the 1980s, when rap artists were developing commercial appeal, traditional but highly irregular sales measures were still being used—measures that especially underrepresented fan interest in unconventional music. As *New York Times* writer Neil Strauss described it: "Until 1991 the pop music charts were notoriously unreliable. Paying off record store employees with free albums, concert tickets, and even vacations and washing machines was the standard music-business method of manipulating record sales figures. Even the Billboard magazine charts, considered the most prestigious in the business, were compiled from the store managers' oral reports, which were inaccurate to begin with and easily swayed."[3]

In 1991, Soundscan, a sales measurement system that tracks album purchases at their point of sale, was introduced. Although new methods of sales figure manipulation were eventually developed by record industry sales executives, new and explosive information emerged with the advent of Soundscan: Two renegade genres, hard rock and rap, came in at the top of the charts, showing the greatest actual sales and outstripping mainstream pop acts. Two weeks after the advent of Soundscan, Paula Abdul's "Spellbound" was "replaced at the top by the Los Angeles rap group N.W.A.'s 'Efil4zaggin',' which had appeared on the chart at No. 2 the previous week."[4]

Soundscan initiated a dramatic reconsideration of what the record industry believed mainstream youth wanted to purchase; the results indicated that large numbers of young white consumers (whose consumption drove pop chart positions) wanted to hear gangsta-oriented rap music and would support it heartily. This encouraged an increase in record label investment in hip hop production, distribution, and promotion on radio, especially for gangsta rap. Radio was considered the big breakthrough for hard-edged rap. Veteran radio and music programmer Glen Ford—co-owner and (from 1987 to 1994) host of *Rap It Up*, the first nationally syndicated radio hip hop music program—draws crucial connections between

the new data about consumption and the new corporate strategy for promoting gangsta rap:

> By 1990, the major labels were preparing to swallow the independent labels that had birthed commercial hip hop, which had evolved into a wondrous mix of party, political and "street"-aggressive subsets. One of the corporate labels (I can't remember which) conducted a study that shocked the industry: The most "active" consumers of Hip Hop, they discovered, were "tweens," the demographic slice between the ages of 11 and 13. The numbers were unprecedented. Even in the early years of Black radio, R&B music's most "active" consumers were at least two or three years older than "tweens." It didn't take a roomful of PhDs in human development science to grasp the ramifications of the data. Early and pre-adolescents of both genders are sexual-socially undeveloped—uncertain and afraid of the other gender. Tweens revel in honing their newfound skills in profanity; they love to curse. Males, especially, act out their anxieties about females through aggression and derision. This is the cohort for which the major labels would package their hip hop products. Commercial Gangsta Rap was born—a sub-genre that would lock a whole generation in perpetual arrested social development.[5]

In 1993, Bill Stephney, a well-respected musician, producer, and promoter known for his ground-breaking work with political rap group Public Enemy, saw older teens being targeted as well. "It's a function of the culture," Stephney noted in connection with industry decisions that had driven hard rap's triumph over the FM airwaves. "You now have the prime 18-to 24-year-old demographic people who grew up only on rap music, whether they be black, Latino or white. Radio has decided they want to target this generation, and that rap music is the music they're gonna program. . . . The radio stations have had to play it; advertisers have had to deal with it; and corporate America has understood it."[6] In the context of new technologies and the expansion of media markets, this new interest in gangsta rap as a

mainstream profit stream moved swiftly into a multitude of markets and related products.

Massive Corporate Consolidation

During this same period, the consolidation of mass-media industries, aided by ongoing government deregulation, began to pick up steam. Regulations designed to prevent monopolization were overturned and large-scale consolidation in and across various media industries took place in a very short period of time. Consolidation within a given industry (when one or two record companies merge) gave way to single corporations with dominant holdings in all mass media, from newspapers, television, and musical venues to publishing houses, movies, magazines, and radio stations. As late as the early 1980s, these industries operated relatively independent of one another and encompassed many internally competitive companies. Media scholar Ben Bagdikian put it like this:

> In 1983, the men and women who headed the fifty mass media corpo-
> rations that dominated American audiences could have fit comfort-
> ably in a modest ballroom. The people heading the twenty dominant
> newspaper chains probably would form one conversational cluster to
> complain about newsprint prices . . . the broadcast network people in
> another . . . etc. By 2003, five men controlled all these media once
> run by the fifty corporations of twenty years earlier. These five, owners
> of additional digital corporations, could fit in a generous phone
> booth.[7]

Five conglomerates—Time/Warner, Disney, Viacom, Newscorpo-
ration, and Bertelsmann (of Germany)—now control the vast major-
ity of the media industry in the United States. (General Electric is a close sixth.) Viacom, for example, owns MTV, VHI, and BET, along with CBS radio, which operates 140 radio stations in large radio mar-
kets. The four biggest music conglomerates (each made up of many

record companies) are Warner Music, EMI, Sony/BMG, and Universal Music Group. Together they control about 70 percent of the music market worldwide and about 80 percent of the music market in America. A multitude of artists have contracts with the companies that fall within these vast media categories. While rappers seem to be on a wide variety of labels and in different and competing camps and groups of subaffiliated artists, in fact many artists labor underneath one large corporate umbrella. For example, Warner Music (which falls under Time Warner) has more than forty music labels including Warner Brothers (where rappers such as Crime Mob, E-40, Talib Kweli, and Lil' Flip are signed); Atlantic (where rappers such as Flo Rida, Webbie, Twista, Trick Daddy, Plies, Diddy, and T.I. are signed), Elektra, London-Sire, Bad Boy, and Rhino Records, to name just a few. Even a high-profile "beef" such as the one between rappers The Game and 50 Cent looks somewhat tamer when one considers that The Game, whose music is distributed by Geffen, and 50 Cent, whose music is distributed by Interscope, are both included under the Universal Music Group parent company.[8]

Mass-media consolidation was rendered even more profound for the record industry after the Telecommunications Act of 1996. Although it enabled dramatic consolidation of ownership within the radio industry, the music industry's key promotional and sales-generating venue, the Telecommunications Act was described by many of its supporters as a telephone industry bill designed to allow Baby Bell phone companies to get into long-distance service, spur competition, and deregulate cable rates. Included in this sweeping act, though, was a nearly buried provision that lifted all ownership caps for radio-station broadcasters across the nation and permitted companies to operate as many as eight stations in the largest markets. Previously, broadcasters could own only forty stations nationwide, and only two in a given market. But now, with such limited restrictions, wealthy and powerfully connected investors were able to snap up a dizzying number of radio stations in an incredibly short period of time. By the end of 1996, ownership of 2,157 radio stations had changed hands. And as of 2001, 10,000 radio transactions worth approximately $100 billion had taken place.[9]

Until this point, a relatively large network of small- to medium-sized local radio-station owners were accountable to the public and its local musical, cultural, religious, newscasting, community, and political needs. Now, our public airwaves are profoundly dominated by a small number of very large national and international corporations. According to a study published by the Future of Music Coalition, "Ten parent companies dominate the radio spectrum, radio listenership and radio revenues. . . . Together these ten parent companies control two-thirds of both listeners and revenue nationwide." Clear Channel is the mightiest of them all, owning a dramatic 1,240 radio stations nationwide, thirty times more than previous congressional regulation allowed. With more than 100 million listeners, Clear Channel reaches over one-third of the U.S. population.[10]

This consolidation has affected radio programming in many ways, including a higher consolidation of playlists within and across formats, higher levels of repetition of record industry–chosen songs, homogenized and in some cases automated programming, and the near erasure of local, non-record-industry-sponsored artists. Large corporations profit from maintaining high levels of efficiency and consistency, which help them maintain the widest possible market share. Both efficiency and consistency of product encourage cuts in local staffing as well as in idiosyncratic programming such as local acts and news that cannot be packaged and rebroadcast elsewhere. Commercially established major-label acts, because of their visibility and notoriety, are easily packaged for a national audience and easily transportable across regions. Thus they dominate their genre-specific playlists across the country.

Officially speaking, record stores are the primary sales venue for recorded music; in reality, radio stations and music video programs provide the bulk of music promotion and sales. Radio and music video airplay are at the heart of artist visibility and record industry profits. Record companies try to convince owners and radio and music video program directors to play their artists' music in elaborate and ever-evolving ways. Consolidation of radio-station ownership focused and consolidated the record industry's "promotional" contracts

with independent promoters, who do the radio-and television-station schmoozing and bribing on behalf of the record companies to encourage them to add their clients' songs to the stations' playlists. Instead of having to develop promotional relationships with hundreds of independent program directors, now record companies can negotiate with fewer corporate program directors who determine the playlists for dozens of stations around the country.

Industry-wide consolidation had a distinctive impact on black radio, and this in turn dramatically influenced the direction of commercial hip hop. Counting just those formats that emphasize hip hop/contemporary R&B (sometimes dubbed "hot urban" stations, with a target demographic of 12- to 24-year-olds), we find that Clear Channel, Radio One, and Emmis Radio have an astounding number of major urban markets covered. "Urban" is a euphemism for black music genres and markets. The stations listed below represent the depth of corporate consolidation of stations dedicated to playing hip hop on urban radio stations. Keep in mind that these lists comprise only the names of "hot urban"/hip hop–focused stations; other black urban music formats such as Rhythmic Adult Contemporary (with a target demographic of 18- to 34-year-olds) and Urban Adult Contemporary (with a target demographic of 29- to 45-year-olds) feature some hip hop but much more soul and R&B. Many of these other formatted stations are controlled by the same key players, however.

Clear Channel owns stations with the "hot urban"/hip hop and R&B format in nearly all major cities, many with large black populations, including Boston (94.5 WJMN), Chicago (107.5 WGCI), Columbus (98.3 WBFA), Detroit (98 WJLB), Memphis (97 WHRK), New Orleans (93.3 WQUE), New York (105.1 WWPR), Norfolk/Virginia Beach (102.9 WOWI), Oakland/San Francisco (106 KMEL), Philadelphia (99 WUSL), and Richmond (106.5 WBTJ). Emmis Radio owns 106 KPWR in Los Angeles and 97 WQHT in New York.

Radio One, the other major player in the hip hop radio market, is black owned and controls at least fifty-three urban music stations in sixteen markets, fourteen of which are hip hop focused. Radio One founder Catherine Hughes, who began as the owner of a small black

radio station, carried out the legacy of black radio as a local commu-
nity service operation—one among many of her roles and capacities.
Despite this legacy, Radio One—given its need to remain profitable
in the context of massive consolidation—has supported the record
industry's drive to promote the consolidation of programming that in-
cludes destructive caricatures of black people. Radio One owns ma-
jor hip hop stations in Atlanta (107.9 WHAT), Baltimore (92.3
WERQ), Cincinnati (101.1 WIZF), Cleveland (107.9 WENZ),
Columbus (107.5 WCKX), Dallas (97.9 KBFB), Detroit (102.7
WHTD), Houston (97.9 KBXX), Indianapolis (96.3 WHHH),
Philadelphia (100.3 (WPHI), Raleigh-Durham, NC (97.5 (WQOK),
Richmond (92.1 WCDX), St Louis (104.1 WHHL), and Washing-
ton, D.C. (93.9 WKYS).

Consolidation had an especially negative impact on black radio
news programming that went beyond the drastic reduction of news
on all radio stations. Historically, black radio news programs played a
powerful role in gathering and disseminating information about
black social-justice issues that were largely omitted from other radio
program formats. Such programs comprised a vital communication
network for the civil rights movement, for example. Bruce Dixon,
managing editor of the *Black Agenda Report*, describes the historical
role of black radio as "a transmitter and conveyor, as the very circula-
tory system of public consciousness in African-American communi-
ties." The deep reductions in local news programming and
journalism felt nationwide in commercial radio have cut into a cru-
cial form of black social activism not easily replaced by other news
media. Indeed, it could be argued that the absence of local news re-
ports on such activism, coupled with the expansion of destructive
and simple-minded fare, has negatively affected African-American
public consciousness—specifically, by reducing black community
knowledge about crucial issues.[11]

The consolidation of radio-station ownership not only raised the
stakes for getting radio stations to play record companies' designated
songs; it also resulted in greater airplay on a wider network of sta-
tions. The history of payola—paying to get your song played on the

radio—is long and storied. The refusal of most people in the industry to publicly admit to it has rendered payola a shadowy but still powerful force, plied in sophisticated ways to evade payola-inspired laws. It is a crime for a radio-station employee to accept any sort of payment to play a song unless the radio station informs listeners about the exchange. Thus, record companies' direct method of paying for airplay has been replaced by the indirect method of payoff. Independent promotion firms (called "indies") are hired by record companies to "do promotion" at radio stations. As reporter Eric Boehlert explains: "In exchange for paying the station an annual promotion budget ($100,000 for a medium size market) the indie becomes the station's exclusive indie and gets paid by the record companies every time that station adds a new song. (Critics say it's nothing more than a sanitized quid pro quo arrangement—station adds a song, indie gets paid.)"[12]

In the case of urban music, considered by some the wild west of an industry widely perceived as corrupt and volatile, the money is less likely to go toward the radio's budget than to end up in the program director's hands—either as cash or in some other form of gifting. This arrangement takes place in both radio and music video programming, despite public denials from corporate executives. Reports that the practice is prevalent have been made by many industry insiders, nearly all of whom want to remain anonymous. In 2001, Eric Boehlert asked an urban industry insider whether payoff-taking is widespread. The latter replied: "What do you mean 'widespread'? It's all the [urban] stations everywhere."[13]

Paul Porter—a former radio and BET video programmer who, with Lisa Fager Bediako, cofounded Industry Ears, a nonprofit, nonpartisan, and independent organization that focuses on the impact of media on communities of color and children—has spoken openly about how payola works both at radio stations and at music video stations like BET:

During my first week as program director at BET, I set up the playlist, deciding which videos would be played and how often. I cut

the playlist from four hundred titles to a mere eighty because they had been playing any videos a record company sent over. Some industry executives were elated because their videos got more airplay; the others were furious. And if you were a record label executive, you needed to make sure I was happy. Almost everybody in this industry takes money. If they have the power to put a song on the radio or a video on television, they've been offered money to do it—and they've taken it. Maybe it's only been once or twice. But they've done it.[14]

Porter admits to taking cash payments for adding songs and videos (which was standard operating procedure). He also reveals how the high cost of music videos raised sales expectations and thus expanded payoffs:

Videos became so expensive. I just started noticing all the pressure when it came to adding videos, everybody wanted to be on BET since MTV wasn't playing anything black in those days. It started small, with sending you and your girl to Miami for the weekend first class, nice hotels, tickets to Knicks playoff games, offers to big ticket concerts in Europe. Then it just became money, flat-out straight money. I went to work in New York for two years and when I came back to BET in '99 as program director, the second week I was there I was staying in Hotel George and I got a call from the promoter who said, "Hey man, I'm sending you this package," it was for Arista records, right, and I'm like "cool," I've never met the guy blah blah blah—I got a FedEx on Saturday, I got fifteen grand! In an envelope![15]

In this era of massive corporate mergers, corrupt record industry promotional methods in collusion with radio stations are empowered and consolidated while independent black local musical culture and radio are subsumed or dismantled. Commercial hip hop is driven by this Byzantine system; gangstas, pimps, and hoes are products that promotional firms, working through record companies for corporate conglomerates, placed in high rotation.

While the swift consolidation and hyper-marketing of the hip hop trinity haven't entirely killed off more diverse portrayals, they have substantially reduced their space and their value. As a result, such portrayals are now harder to see, less commercially viable, and less associated with prestige and coolness. Veteran "conscious rapper" Paris was quoted as saying: "*What* underground? Do you know how much good material is marginalized because it doesn't fit white corporate America's ideals of acceptability? Independents can't get radio or video play anymore, at least not through commercial outlets, and most listeners don't acknowledge material that they don't see or hear regularly on the radio or on T.V."[16]

Throughout *The Hip Hop Wars*, when I use the phrase "commercial hip hop," I am not referring to any artist signed to a record company. In this market environment, nearly all artists who want to survive have to sign up to one label or another. "Commercial hip hop," then, refers to the heavy promotion of gangstas, pimps, and hoes churned out for mainstream consumption of hip hop. Powerful corporate interests that dominate radio, television, record production, magazines, and all other related hip hop promotional venues are choosing to support and promote negative images above all others—all the while pretending that they are just conduits of existing conditions, and making excuses about these images being "reality."

Challenges that emphasize the role of corporate power are on the rise. In the face of sustained protests and opposition by individuals and interest groups such as Al Sharpton, the Enough Is Enough campaign, Spelman alum and Feminist Majority member Moya Bailey, and Industry Ears, mass-media executives have remained remarkably silent. In May 2007 Marcus Franklin reported in *USA Today* that Universal chairman Doug Morris and president Zach Horowitz declined repeated requests to discuss the issue, as did Warner chairman and chief executive Edgar Bronfman, Sony chairman Andrew Lack, chief executive Rolph Schmidt-Holtz, and EMI Group CEO Eric Nicoli.[17]

Cowardly silence aside, these executives could not have transformed commercial hip hop into a playground for destructive street

icons alone. Clearly, the corporate takeover of commercial hip hop has also been facilitated, directly or indirectly, by artists (especially those who have become moguls and entrepreneurs) who gleefully rap about guns and bitches, liberal and conservative critics and academics, and journalists who uncritically profile these artists and hip hop fans of all races, classes, and genders. This shift was not inevitable; it was *allowed* to happen. We must be more honest in thinking about how black ghetto gangsta-based sales are the *result* of marketing manipulation and the *reflection* not only of specific realities in our poorest black urban communities but also of the *exploitation* of already-imbedded racist fears about black people.

"Mainstream" white America, black youth, black moguls (existing and aspiring), and big mass-media corporations together created hip hop's tragic trinity, the black gangsta, pimp, and ho—the cash cow that drove the big mainstream crossover for hip hop. Unless we deal with this part of the equation and see the dynamic as both new and very old—unless we acknowledge that racialized and sexualized fantasies and the money they generate for corporate mass media helped elevate this trinity in hip hop—we'll be back here again in no time, to a different black beat.

In the following chapters, readers will find the Hip Hop Top Ten: the top-ten arguments about hip hop, five from each side of the polarized debate. One way or another, the public debates about hip hop always come back to these ten issues. In each chapter, I will explore one of these favorite claims against and defenses of hip hop, challenging excesses, myths, denials, and manipulations as well as identifying the elements of truth that each argument contains.

Hip Hop's Critics

1. Hip Hop Causes Violence
2. Hip Hop Reflects Black Dysfunctional Ghetto Culture
3. Hip Hop Hurts Black People
4. Hip Hop Is Destroying America's Values
5. Hip Hop Demeans Women

Hip Hop's Defenders

6. Just Keeping It Real
7. Hip Hop Is Not Responsible for Sexism
8. "There Are Bitches and Hoes"
9. We're Not Role Models
10. Nobody Talks About the Positive in Hip Hop

There are two kinds of traps set by these popular, polarized, and partially true positions. I've already talked about their lack of complexity. But there is another trap: the hidden mutual denials on opposing sides of the debate. Indeed, the fact that critics and defenders share many underlying assumptions about hip hop only mires us more deeply within this conversation. In Chapter 11, I explore these mutual denials and discuss how they work to mask underlying attitudes shared by both sides. They direct our attention away from the ugly truths about ghetto fantasies and corporate influences, but also away from the kinds of progressive solutions that could nourish hip hop, open up opportunities for poor youth, and contribute to affirming multiracial vision.

Extraordinary creativity and possibility continue to come up through the narrow spaces that still remain. Not only do some artists find lyrically creative and community-affirming ways to make well-worn stories about street life seem renewed, but many brilliant artists and local community activists continue to write and perform rich, dynamic stories and trenchant political commentary, the likes of which listeners almost never hear on commercial radio. I will identify these marginalized but crucial artists and activists in Chapter 12. Among them are filmmaker Byron Hurt, director of the extraordinary film *Hip Hop: Beyond Beats and Rhymes*, who challenges fans as well as hip hop artists and their corporate representatives in powerful and progressive ways; Raquel Cepeda, whose fascinating film *Bling: A Planet Rock* connects U.S. consumption of diamonds to exploitation and violence and poverty in Sierra Leone; and rappers Lupe Fiasco and Jean Grae, whose music is funky, lyrically sophisticated, vibrant,

and progressive. These filmmakers and artists are rarely promoted. They are given little airtime in mainstream media, and thus many readers might think they simply don't exist, might believe that the mainstream corporate rappers, producers, and promoters who support and excuse hip hop's most destructive elements are all there is to hip hop.

Hurt, Cepeda, Fiasco, Grae, and many others are part of the solution because they are developing hip hop generation–based progressive terms for the conversation about hip hop and encouraging community-affirming terms of creativity. Equally important, they are finding ways to critique hip hop without bashing the entire genre, to support hip hop without nourishing sexist, homophobic, or racist ideas or promoting economic exploitation of the communities from which hip hop comes.

Finally, if my point about our being trapped in the false oppositions sustained by our polarized conversation on hip hop has any value, it will generate some version of the following questions: What do we do next? How do we—those who have progressive visions and appreciate hip hop's gifts—participate, judge, critique, reject, and support hip hop? How can we help hip hop's youngest fans become conscious of what they are being fed and of its impact on them and their communities? How can we change the conversation and the terms of play in hip hop itself? Which position should we take up vis-à-vis hip hop, and on what should it be based?

To answer these questions, I conclude with six ideas for guiding progressive hip hop creativity and participation. So many of us are caught between rejecting hip hop and embracing it, while turning a blind eye to what has become the genre's greatest profit engines. The terms of embrace and rejection we often settle on are not clear, nor do they help us shape a progressive vision that can transform what we have now into what we might want to see in the future.

These ideas represent community-inspired standards marked by a balanced, loving, socially and politically progressive vision of creativity and black public thought, action, and reaction. Developing this vision isn't a repression of anger or sexuality or of artists telling their

truths. On the contrary, it is a vehicle for encouraging creativity that does not revolve around hurling insults and perpetuating social injustices. Countless times, in these hip hop wars, hip hop media mogul Russell Simmons has defended the right of artists to "speak from their hearts," to tell their own truths. But do they tell all their truths in hip hop? And to what ends, to serve whom? Surely, no one wants artists to speak from a false place, but the heart is not a predetermined place: It is a cultivated one.

Communities have always set limits on the depths of self-destructive iconography, language, and action that will be allowed. This isn't a matter of invoking police or government action. It is about taking cultural control of ourselves in a society that has long been involved in the destruction of black self-love, dignity, and community survival. Operating in the larger progressive interests of the black community—and society at large—is the aim. But to fulfill this aim, we have to consolidate and illuminate the actions of those who are working toward community-sustaining goals and promote the key principles about how self-expression can be cutting-edge, angry, loving, honest, sexy, meaningful, and *empowering*, no matter the subject. Black music has always been a central part of this affirming, truth-telling process, but in this so-called post–civil rights era, it is up against new pressures and requires new strategies.

We cannot truly deal with what is wrong in hip hop without facing the broader cultures of violence, sexism, and racism that deeply inform hip hop, motivating the sales associated with these images. Yet, those of us who fight for gender, sexual, racial, and class justice also can't *defend* the orgy of thug life we're being fed simply because "sexism and violence are everywhere" or because corporations are largely responsible for peddling it. We can explain and contextualize why hip hop seems to carry more of this burden, but we can't defend it. Even if sexism and violence are everywhere (and, sadly, they are), what I care most about is not proving that hip hop did or did not invent sexism, or the gangsta figure, bitch, ho, thug, or pimp, but showing how the excessive and seductive portrayal of these images among

black popular hip hop artists is negatively affecting the music and the very people whose generational sound is represented by hip hop.

The destructive forms of black, racist-inspired hyper-masculinity for which commercial hip hop has become known make profound sense given the alchemy of race, class, and gender in U.S. society. But we shouldn't sit idly by or celebrate the fixation with the black pimp, his ornate pimp cup, and the culture of sexual, economic, and gender exploitation for which this persona stands. Understanding and explaining are not the same as justifying and celebrating, and this is the crucial distinction we must make if we stand a fighting chance in this perpetual storm. The former—understanding and explaining—are an integral part of solving the problems with hip hop; the latter—justifying and celebrating—are lazy, reactionary, dangerous, and lacking in progressive political courage. Yes, hip hop's excesses will continue to be used as a scapegoat; but we must develop our own progressive critique, not just stand around defending utter insanity because our enemies attack it. The mere fact that our enemies attack something we do does not make our actions worthy of defense.

We must fight for a progressive, social justice–inspired, culturally nuanced take on hip hop—a vision that rejects the morally hyper-conservative agenda and the "whatever sells works for me" brand of hustlers' neo-minstrelsy that have become so lucrative and accessible for the youth in poor black communities today. *The Hip Hop Wars* is a sometimes polemical, always passionate assessment of where we are, what's wrong with the conversation we are having about hip hop, why it matters, and how to fix it. Too many people on both sides of this debate seem to have lost their collective minds, taking a grain of truth and using it to starve a nation of millions.

I hope this book will help galvanize progressive conversation and action among the thousands of current and aspiring artists, fans, parents, teachers, and cultural workers—black, white, Latino, Asian, young and old, of all backgrounds, from all places and spaces. I am even hoping that various industry workers and record and television

executives will read this book, see themselves as part of the solution, and work harder to develop community-enabling ways to stay in business. This book is for everyone who feels uneasy about commercial hip hop—some who know that something is really wrong but can't name it; others who are working to make hip hop the kind of cultural nourishment it can be but are getting very little help to fix it; and still others who remain sidelined, worried that jumping into the fray means being forced to take impossible sides in an absurdly polarized battle.

Top Ten Debates in Hip Hop

1

Hip Hop Causes Violence

I'm giving you my opinion that says he is not an artist, he's a thug. . . . [Y]ou can't draw a line in the sand and say Ludacris, because he is a subversive guy that, number one advocates violence, number two, narcotics selling and all the other things, he's not as bad as Pol Pot [Cambodian communist] so we'll put a Pepsi can in his hand.

——Bill O'Reilly, on the subject of Ludacris as a
Pepsi celebrity representative, *The O'Reilly Factor*,
August 28, 2002

Ronald Ray Howard was executed Thursday [October 6, 2005] for fatally shooting a state trooper, a slaying his trial attorneys argued was prompted by Howard's listening to anti-police rap music. . . . Howard's trial attorney, Allen Tanner, told a reporter: "He grew up in the ghetto and disliked police, and these were his heroes . . . these rappers . . . telling him if you're pulled over, just blast away. It affected him." Howard didn't say for certain that rap music was responsible for his crime. [But he did say:] "All my experiences with police have never been good, whether I've been doing something bad or not."

——David Carson (www.txexecutions.org/reports/
350.asp, October 7, 2005)

I would say to Radio 1, do you realise that some of the stuff you play on Saturday nights encourages people to carry guns and knives?

——David Cameron, British politician, www.BBC.com,
June 7, 2006

A KEY ASPECT OF MUCH OF THE CRITICISM that has been lev-
eled at hip hop is the claim that it glorifies, encourages, and
thus causes violence. This argument goes as far back as the middle to
late 1980s—the so-called golden age of hip hop—when politically
radical hip hop artists, such as Public Enemy, who referred to direct
and sometimes armed resistance against racism "by any means neces-
sary," were considered advocates of violence. It is important to zero
in on the specific issue of violence because this was the most highly
visible criticism of hip hop for over a decade. The concern over hip
hop and violence peaked in the early to mid-1990s when groups like
N.W.A. from Los Angeles found significant commercial success
through a gang-oriented repertoire of stories related especially to anti-
police sentiment. N.W.A.'s 1989 song "*uck the Police"—with lyrics
boasting that when they are done, "it's gonna be a bloodbath of cops
dyin' in LA"—was at the epicenter of growing fears that rappers' tales
of aggression and frustration (which many critics mistakenly per-
ceived as simply pro-criminal statements of intent) were stirring up
violent behavior among young listeners. The 1992 debut commer-
cial single for Snoop Doggy Dogg, "Deep Cover" (from the film of
the same name), garnered attention because of Snoop's laconic rap
style, Dr. Dre's extra-funky beats, and the chorus phrase "187 on a
undercover cop" ("187" is the police code for homicide). As what we
now call gangsta rap began to move to the commercial center stage,
the worry that increasing portrayals of violence in rap lyrics might en-
courage fans to imitate them evolved into a belief that the rappers
were *themselves* criminals—representing their own violent acts in the
form of rhyme. Snoop's own criminal problems authenticated his
lyrics and added to the alarm about gangsta rap. As this shift in com-
mercial hip hop has solidified, many vocal public critics have begun
to characterize violence-portraying lyrics as autobiographical thug-
gery to a soundtrack. In turn, this link of violent lyrics in hip hop and
behavior has been used in the legal arena by both defense and prose-
cuting attorneys. As the above epigraphs reveal, hip hop lyrics have
indeed been considered strong influences. Increasingly, this connec-
tion has been extended into the realm of establishing character in

murder trials. Prosecutors around the country have buttressed their cases with defendants' penned lyrics as evidence of their criminal-mindedness.

The criticism that hip hop advocates and thus causes violence relies on the unsubstantiated but widely held belief that listening to violent stories or consuming violent images *directly* encourages violent behavior. This concern was raised vis-à-vis violent video games during the 1980s, but also more recently, in relation to heavy metal music. Although the direct link between consumption and action may appear to be commonsensical, studies have been unable to provide evidence that confirms it. Recent challenges to the video game industry's sale of exceptionally gory and violent video games were stymied by the absence of such data and confirmation. Direct behavioral effect is, of course, a difficult thing to prove in scientific terms, since many recent and past factors—both individual and social—can contribute to a person's actions at any given time. The absence of direct proof doesn't mean that such imagery and lyrics are without negative impact. I am not arguing *for* the regular consumption of highly violent images and stories, nor am I saying that what we consume has no impact on us. Clearly, everything around us, past and present, has an impact on us, to one degree or another. Studies do show that violent music lyrics have been documented as increasing aggressive thoughts and feelings. High-saturation levels of violent imagery and action (in our simulated wars and fights in sports, film, music, and television but also, more significantly, in our real wars in the Middle East) clearly do not support patient, peaceful, cooperative actions and responses in our everyday lives.[1]

However, the argument for one-to-one causal linking among storytelling, consumption, and individual action should be questioned, given the limited evidence to support this claim. And, even more important, the blatantly selective application of worries about violence in some aspects of popular culture and everyday life should be challenged for its targeting of individuals and groups who are already overly and problematically associated with violence. So, what may appear to be genuine concern over violence in entertainment

winds up stigmatizing some expressions (rap music) and the groups with which they are associated (black youth). A vivid example of this highly selective application took place during the 1992 presidential campaign when George W. Bush said "it was 'sick' to produce a record that he said glorified the killing of police officers, but saw no contradiction between this statement and his acceptance of support and endorsement from Arnold Schwarzenegger. As one [*New York Times*] reporter put it: 'I stand against those who use films or records or television or video games to glorify killing law enforcement officers,' said Mr. Bush, who counts among his top supporters the actor Arnold Schwarzenegger, whose character in the movies 'Terminator' and 'Terminator II: Judgment Day' kills or maims dozens of policemen."[2]

We live in a popular cultural world in which violent stories, images, lyrics, and performances occupy a wide cross-section of genres and mediums. Television shows such as 24 and *Law and Order*; Hollywood fare such as gangster, action, suspense, murder-driven, war, and horror films; video games; metal musics; and novels—together, these comprise a diverse and highly accessible palate of violent images attached to compelling characters and bolstered by high-budget realistic sets and backdrops. Although anti-violence groups mention many of these genres and mediums, the bulk of the popular criticism about violence in popular culture is leveled at hip hop, and the fear-driven nature of the commentary is distinct from responses to the many other sources of violent imagery. There are three important differences between the criticisms of hip hop and rappers and those leveled at other music, films, shows, and videos—most of which, unlike rap music, are produced (not just consumed) primarily by whites.

First, hip hop gets extra attention for its violent content, and the *perception* of violence is heightened when it appears in rap music form rather than in some other popular genre of music featuring violent imagery. Rappers such as Lil' Jon, Ludacris, 50 Cent, and T.I. who claim that there is violence throughout popular culture and that they get overly singled out are right: Some violent imagery and lyrics in popular culture are responded to or perceived differently from oth-

ers. Social psychologist Carrie B. Fried studied this issue and concluded that the perception of violence in rap music lyrics is affected by larger societal perceptions and stereotypes of African-Americans. In her study, she asked participants to respond to lyrics from a folk song about killing a police officer. To some of the participants the song was presented as rap; and to others, as country. Her study supports the hypothesis that lyrics presented as rap music are judged more harshly than the same lyrics presented as country music. She concluded that these identical lyrics seem more violent when featured in rap, perhaps because of the association of rap with the stereotypes of African-Americans.[3]

Nevertheless, saying that there is violence elsewhere and that one is being unfairly singled out in connection with it isn't the best argument to make. Rappers' claims that violence is everywhere isn't a compelling case for hip hop's heightened investment in violent storytelling, especially for those of us who are worried about the extra levels of destructive forces working against poor black people. It is important, however, to pay close attention to the issue of unfair targeting, blame, and the compounded effect this perception of blacks as more violent has on black youth.

Second, many critics of hip hop tend to interpret lyrics literally and as a direct reflection of the artist who performs them. They equate rappers with thugs, see rappers as a threat to the larger society, and then use this "causal analysis" (that hip hop causes violence) to justify a variety of agendas: more police in black communities, more prisons to accommodate larger numbers of black and brown young people, and more censorship of expression. For these critics, hip hop is criminal propaganda. This literal approach, which extends beyond the individual to characterize an entire racial and class group, is rarely applied to violence-oriented mediums produced by whites.

Despite the caricature-like quality of many of hip hop's cultivated images and the similarity of many of its stories, critics often characterize rappers as speaking entirely autobiographically, implying that their stories of car-jacking, killing witnesses to crimes, hitting women, selling drugs, and beating up and killing opponents are

statements of fact, truthful self-portraits. Thus, for instance, the rhyme in Lil' Wayne's "Damage Is Done" that describes him as running away with a "hammer in my jeans, dead body behind me, cops'll never find me" would be interpreted by many critics as a description of actual events. This assumption—that rappers are creating rhymed autobiographies—is the result of both rappers' own investment in perpetuating the idea that everything they say is true to their life experience (given that the genre has grown out of the African-American tradition of boasting in the first person) and the genre's investment in the pretense of no pretense. That is, the genre's promoters capitalize on the illusion that the artists are not performing but "keeping it real"—telling the truth, wearing outfits on stage that they'd wear in the street (no costumes), remaining exactly as they'd be if they were not famous, except richer. Part of this "keeping it real" ethos is a laudable effort to continue to identify with many of their fans, who don't see their style or life experiences represented anywhere else, from their own points of view; part of it is the result of conformity to the genre's conventions. It makes rappers more accessible, more reflective of some of the lived experiences and conditions that shape the lives of some of their fans. And it gives fans a sense that they themselves have the potential to reach celebrity status, to gain social value and prestige while remaining "true" to street life and culture, turning what traps them into an imagined gateway to success.

But this hyper-investment in the fiction of full-time autobiography in hip hop, especially for those artists who have adopted gangsta personas, has been exaggerated and distorted by a powerful history of racial images of black men as "naturally" violent and criminal. These false and racially motivated stereotypes were promoted throughout the last two centuries to justify both slavery and the violence, containment, and revised disenfranchisement that followed emancipation; and they persisted throughout the twentieth century to justify the development of urban segregation. In the early part of the twentieth century, well-respected scientists pursuing the "genetic" basis of racial and ethnic hierarchy embraced the view that blacks were biologically inferior, labeling them not only less intelligent but also

more prone to crime and violence. These racial associations have been reinforced, directly and indirectly, through a variety of social outlets and institutions and, even today, continue to be circulated in contemporary scientific circles. In 2007, for example, Nobel laureate biologist Jim Watson said that he was "inherently gloomy about the prospects of Africa" because "all our social policies are based on the fact that their intelligence is the same as ours, whereas all the testing says not really." He went on to say that while he hoped everyone was equal, "people who have to deal with black employees find this is not true." And in the now-infamous, widely challenged 1994 book *The Bell Curve*, Richard J. Herrnstein and Charles Murray argued that it is highly likely that genes partly explain racial differences in IQ testing and intelligence and also claimed that intelligence is an important predictor of income, job performance, unwed pregnancy, and crime. Thus the pseudoscientific circle was closed: Blacks are genetically less intelligent, and intelligence level predicts income, performance, criminality, and sexually unsanctioned behavior; therefore, blacks are genetically disposed toward poverty, crime, and unwed motherhood.[4]

This history of association of blacks with ignorance, sexual deviance, violence, and criminality has not only contributed to the believability of hip hop artists' fictitious autobiographical tales among fans from various racial groups but has also helped explain the excessive anxiety about the popularity and allure of these artists. The American public has long feared black criminality and violence as particularly anxiety-producing threats to whites—and the convincing "performance" of black criminality taps into these fears. So, both the voyeuristic pleasure of believing that hip hop artists are criminal minded and the exaggerated fear of them are deeply connected. Hip hop has successfully traded on this history of scientific racism and its imbedded impact on perceptions of poor black people, and has also been significantly criticized because of it.

A third central difference between the criticism of hip hop and rappers and the criticism leveled at other forms of popular culture has to do with the way the artists themselves are perceived in relation

to their audiences and to society. Hip hop's violence is criticized at a heightened level and on different grounds from the vast array of violent images in American culture, and these disparities in perception are very important. While heavy metal and other nonblack musical forms that contain substantial levels of violent imagery are likewise challenged by anti-violence critics, the operative assumption is that this music and its violence-peddling creators will negatively influence otherwise innocent listeners. Therefore (according to these critics), metal, video games, and violent movies influence otherwise nonviolent teenagers, encouraging them to act violently. From this perspective, "our youth" must be protected from these outside negative, aggressive influences.

In the case of rap, the assumption is that the artists and their autobiographically styled lyrics represent an existing and already threatening violent black youth culture that must be prevented from affecting society at large. The quote from Bill O'Reilly at the outset of this chapter reflects this approach. For O'Reilly, Ludacris is advocating violence and selling narcotics. Allowing him to be a representative for Pepsi would, as O'Reilly's logic goes, be similar to giving power to Pol Pot, the Cambodian leader of the brutal Khmer Rouge government, allowing a "subversive" guy access to legitimate power. This difference in interpretation—such that black rappers are viewed as leaders of an invading and destructively violent force that undermines society—has a dramatic effect on both the nature of the criticism and the larger perceptions of black youth that propel the ways in which they are treated. It sets the terms of how we respond, whom we police, and whom we protect.

Tales of violence in hip hop share important similarities with the overall investment in violence as entertainment (and political problem solving) in American culture, but they have more localized origins as well—namely, the damaging and terrible changes in black urban America over the past forty or so years. Although hip hop's penchant for stories with violent elements isn't purely a matter of documentary or autobiography, these stories are deeply connected to real social conditions and their impact on the lives of those who live

them, close up. My point here may be confusing: On the one hand, I am saying that rappers are not the autobiographers they are often believed to be and that seeing them that way has contributed to the attacks they specifically face. But, on the other hand, I am also saying that much of what listeners hear in hip hop stories of violence is reflective of larger real-life social conditions. How can both be true?

This is a crucial yet often improperly made distinction: Hip hop is not pure fiction or fantasy (such as might emerge from the mind of horror writer Stephen King), but neither is it unmediated reality and social advocacy for violence. Nor is rap a product of individual imagination (disconnected from lived experiences and social conditions) or sociological documentation or autobiography (an exact depiction of reality and personal action). Yet conversations about violence in hip hop strategically deploy both of these arguments. Defenders call it fiction, just like other artists' work, whereas critics want to emphasize rappers' own claims to be keeping it real as proof that these stories "advocate violence" or, as British politician David Cameron suggested, "[encourage] people to carry guns and knives."

Neither of these positions moves us toward a more empowering understanding of violent storytelling and imagery in hip hop or toward the fashioning of a productive, pro-youth position that recognizes the impact of these powerfully oppressive images without either accepting or excusing their negative effects. This is the line we must straddle: acknowledging the realities of discrimination and social policies that have created the conditions for the most dangerous and fractured black urban communities and, at the same time, not accepting or excusing the behaviors that are deeply connected to these local, social conditions.

The origins for the depth of investment in hip hop's myriad but context-specific stories involving guns, drugs, street culture, and crime are directly related to a combination of drastic changes in social life, community, and policies of neglect that destroyed neighborhood stability in much of black urban America. These local, social condition–based origins matter because the causal assumption that violent material when consumed increases violent actions

underestimates the environmental forces at work. Although hip hop's violence has been marketed and exaggerated, its origins in violent urban communities and the reasons these communities became so violent must be understood. This context helps explain why hip hop's poorest inner-city fans and artists remain so invested in such stories. Rather than creating violence out of whole cloth, these stories are better understood as a distorted and profitable reflection of the everyday lives of too many poor black youth over the past forty or so years.

While context is crucial for explaining what we hear in a good deal of hip hop, context as justification for rap's constant repetition of violent storytelling is highly problematic. Rapper Tupac, for example, claimed that he was hoping to reveal the conditions in a powerful way to incite change: "I'm gonna show the most graphic details about what I see in my community and hopefully they'll stop it. Quick."[5] Unfortunately, profits increased with increasingly violent, criminal-oriented rap while conditions remained and worsened. Despite the reality that these real conditions are not being changed because of rappers' stories and, instead, have become fodder for corporate profits, rappers continue to justify the use of black urban community distress and criminal icons along these lines, thus maintaining their value as a revenue stream. 50 Cent defended his lyrics, claiming that "[i]t's a reflection of the environment that I come from," and Jay-Z has confessed that "it's important for rappers to exaggerate 'life in the ghetto' because this is the only way the underclass can make its voice heard."[6]

This context—the destruction of black community in urban America since the mid-1970s—has five central elements, each of which exacerbates the others, causing the serious dismantling of stable communities and resulting in several forms of social breakdown, one of which is increased violence.

High Levels of Chronic Joblessness

The issue of black and brown teen joblessness took on crisis proportions during the first two decades of hip hop's emergence. Unem-

ployment and very low-paying, unstable employment have been concentrated in poor minority urban communities since the early part of the twentieth century, but this lengthy history of how race limits working-class opportunity took an especially pernicious turn in the 1980s and continued through the 1990s and beyond. What many scholars and economists call "permanent unemployment" or "chronic joblessness" began to plague poor black and brown communities, and the younger adults in these communities began to understand that traditional avenues for working-class job stability were becoming closed to them.

The effects of deindustrialization—the swift and extensive loss of unionized, well-paying manufacturing jobs out of urban areas to rural and nonunionized regions and out of the country entirely—hit all workers hard and dramatically undercut working-class economic mobility. This loss was accompanied by a growth in low-wage "service" jobs, which tended to be part-time and to offer limited or no benefits and few opportunities for upward mobility. Owing to both historical and contemporary forms of racial discrimination in the job market, these overall changes have been especially devastating for black communities. Indeed, blacks continued to be last hired and thus first fired when factories closed, and they were disproportionately kept in lower-level positions where upward advancement and skill-building (and thus job rehiring opportunities) are limited. During Ronald Reagan's second term, for example, more than one-third of black families earned incomes below the poverty line. By contrast, poverty rates hovered between 8 and 9 percent among white families. During the same period, black teenagers' already high levels of unemployment increased from 38.9 to 43.6 percent nationally, and in some regions, such as the Midwestern cities in the Great Lakes region, the figures were as high as 50 to 70 percent. By contrast, white teenage unemployment was around 13 percent.[7]

Chronic and very high levels of unemployment and the poverty it creates, especially when magnified by long-standing injustice and discrimination, produce not only economic crisis but deep instabilities within families and across communities. These, in turn, result in

higher levels of homelessness, street crime, and illegal income-generating activities (such as the drug trade), and alienation, rage, and violence.

Dramatic Loss of Affordable Housing/
Urban Renewal

The legacies of thirty years of "urban renewal" began to bear rotten fruit in the middle to late 1970s. Dubbed "negro removal" by James Baldwin, the urban renewal programs designed to "clear slums" because they were considered "eyesores" proved to be terribly ill-conceived forms of neighborhood destruction that had a disproportionately negative impact on poor black urban communities. While the migration of millions of black people to cities in the twentieth century was met with forced urban housing segregation (producing what we now call black ghettos), those neighborhoods were also sources of community strength and general stability. Yes, poverty, discrimination, and other urban problems persisted, but areas like Watts in Los Angeles, Harlem in New York City, East St. Louis, and the Hill District in Pittsburgh became stable, multiclass communities where black people, as scholar Earl Lewis maintained, "turned segregation into congregation."

Urban renewal, especially during and after the 1960s, destroyed these low-income but highly network-rich and socially stable communities to make room for private development, sports arenas, hotels, trade centers, and high-income luxury buildings. Far from being a plan to create affordable housing, it created the massive housing crisis we still face today. By the summer of 1967, 400,000 residential units in urban renewal areas had been demolished; only 10,760 low-rent public housing units were built on these sites. In 1968, the Kerner Commission report pointed out that

> [i]n Detroit a maximum of 758 low-income units have been assisted through (federal) programs since 1956. . . . Yet, since 1960, approximately 8,000 low-income units have been demolished for urban re-

newal. . . . Similarly in Newark, since 1959, a maximum of 3,760 low-income housing units have been assisted through the programs considered. . . . [D]uring the same period, more than 12,000 families, mostly low income, have been displaced by such public uses of urban renewal, public housing and highways.[8]

This pattern of demolishing and not replacing thousands of units of existing affordable housing in poor black communities had a devastating impact in black communities all around the country, creating the constellation of symptoms in many major cities that we see today.

This was not just a housing problem, although the homeless crisis it produced was immense. The physical destruction of so many buildings was accompanied by the demolition of most of the adjacent venues and stores that served as community adhesive. Corner stores, music clubs, social clubs, beauty parlors, and barber shops were also displaced or destroyed, fraying community networks and patterns of connection. Social psychologist Mindy Fullilove refers to the destruction caused by urban renewal as "root shock," the "traumatic stress reaction to the destruction of all or part of one's emotional ecosystem." She astutely contextualizes this widespread destruction of housing and the social networks around it as one that destroyed communities, resulting in social disarray and increased levels of violence:

Root shock, at the level of the individual, is a profound emotional upheaval. . . . [It] undermines trust, increases anxiety, . . . destabilizes relationships, destroys social, emotional and financial resources, and increases the risk for every kind of stress-related disease, from depression to heart attack. Root shock, at the level of the local community, . . . ruptures bonds, dispersing people to all the directions of the compass. . . . The great epidemics of drug addiction, the collapse of the black family and the rise in incarceration of black men—all of these catastrophes followed the civil rights movement, they did not precede it. Though there are a number of causes of this dysfunction that cannot be disputed—the loss of manufacturing jobs, in particular—

the current situation of Black America cannot be understood without a full and complete accounting of the social, economic, cultural, political and emotional losses that followed the bulldozing of 1,600 neighborhoods.[9]

Drug-Trade Expansion

The emergence of very cheap, addictive, and profitable drugs, such as PCP, but especially crack cocaine, in the mid-1980s made bad matters worse. The bleak economic reality of high levels of chronic joblessness and the loss of community networks produced by the destruction of black communities and massive housing demolition created not only a financial incentive for dealing hard drugs but an emotional one as well. The desire for drugs is directly linked to the longing to numb pain and suffering. Cheap, easily accessible, and highly addictive drugs like crack are especially alluring to the poor and others who face not only their own personal demons but also demons unleashed by society that are largely beyond their control. The affordability and profitability of crack created quick wealth for otherwise chronically unemployed people turned street dealers and fostered violent drug-gang turf wars and a whole generation of people in the clutches of a highly addictive drug.

This was at once a new phenomenon and part of a long history of black communities' serving as commercial shopping zones for all drug users from all class positions and racial backgrounds; crack's notoriously addictive qualities and low price—coupled with inattention to attacking drug distribution at higher levels—created a flourishing local and violent drug trade that spurred, expanded, and intensified gang activities in poor black and brown communities. The impact of drug addiction on the social public sphere was dramatic. The street sex trades became more linked to drugs; women especially, but also men who needed only a small amount of cash to get high, began selling themselves to support their crack habit. Drug addiction, which also fueled the spread of HIV/AIDS, was both a symptom and a cause of the extraordinary breakdown of poor black urban communities

nationwide. Many rappers such as Jay-Z, 50 Cent, and T.I. are known for transforming themselves from drug dealers to rap moguls. Lyrics that reflect their history as drug dealers abound. Consider, for example, the chorus for 50 Cent's "Bloodhound": "I love to pump crack, I love to stay strapped."

But the crisis was so widespread that a whole generation of black comedians such as Chris Rock, David Chapelle, and others who grew up in and around this very dark period in black urban America came out with popular, biting, powerful routines and dark jokes about crack addiction and its impact on black communities. In a sense, the ground-level impact of crack, unemployment, and community destruction became a generational experience for many black youth. In a *Rolling Stone* interview, Chris Rock talked about the deep effects that crack had on the economic, social, and gender relations in black communities. The interviewer asked him: "How about crack? So many of your jokes and characters revolve around crack." Rock replies: "Basically, whatever was going on when you started getting laid will stick with you for the rest of your life. So crack was just a big part of my life, between my friends selling it or girls I use to like getting hooked on it. White people had the Internet; the ghetto had crack. . . . I have never been to war, but I survived that shit. I lost friends and family members. The whole neighborhood was kinda on crack. Especially living in Bed-Stuy [in Brooklyn], man." And in one of many David Chapelle skits featuring the memorable crack-head Tyrone Biggums, Biggums says: "Why do you think I carjacked you, Rhonda?" Rhonda replies, "'Cause the cops found you in it three hours later asleep, high on crack!" Biggums responds: "That's impossible, Rhonda. How can you sleep when you're high on crack? Chinese riddle for you."[10]

AK-47: Automatic Weapons and the Drug Economy

If this highly profitable illegal drug trade had been protected just by fists and knives, it would have been violent but not nearly as deadly.

Instead, this always violent young men's drug trade was fueled by easy access to guns, especially high-powered automatic weaponry. Given the financial incentives of crack, drug dealers used the most powerful weapons available to protect their businesses. And, increasingly, those not involved in selling drugs, especially young black men who were considered part of the same age and gender demographic, felt they had to carry guns to protect themselves.

Neighborhood turf wars have a long bloody history in immigrant and working-class communities; tales of street peril among white male immigrant youth over 100 years ago bear a striking resemblance to descriptions of today's invisible neighborhood boundaries and the dangerous street conflict they give rise to. But what really escalated this situation was the emergence of the highly lucrative crack trade and the flooding of poor urban communities with guns, especially semiautomatic ones. (Geoffrey Canada's book *Fist, Stick, Knife, Gun* chronicles the impact of the availability of this increasingly deadly weaponry and its impact on adolescent male violence.) Few young men fifty years ago lost their lives in street skirmishes, bloody and frequent though they were, as access to deadly weapons was extremely limited then and the reasons for such turf battles were personal rather than wedded to the extremely lucrative high-stakes drug trade. Greedy high-level drug dealers and gun dealers, enabled both by the gun lobby and by terribly misguided and neglectful public policy, turned a long-standing problem into a life-threatening crisis of extraordinary proportions.

Government/Police Response: Incarceration over Rehabilitation

The 1980s "war on drugs" was really a war on the communities that bore the brunt of the drug crisis. The police and federal resource emphasis on low-level street dealers and the criminalization (rather than rehabilitation) of drug users resulted in the treatment of ravaged communities as war zones. The LAPD, for example, is considered legendary for its use of military strategies, developed during the war

in Vietnam, on U.S. citizens in South Central Los Angeles. This slash-and-burn approach, one that failed to address the roots of the problem and barely distinguished between the drug dealers and the communities as a whole, turned poor black communities into occupied territories. Helicopter surveillance and small tanks equipped with battering rams were hallmarks of the LAPD policing in South Central LA in the middle to late 1980s. Housing projects were equipped with police substations, and young black males were routinely picked up for "potential gang activity." Their names were placed in a database; many were intimidated and brutalized. And yet the government failed to enact effective community-building responses such as rehabilitation, meaningful and stable jobs, well-supervised recreational outlets, and social services to enhance the support networks around children.

The criminal justice system reinforced this warlike strategy by defining crack offenses as more criminal than other drug offenses, applying and effectively justifying longer sentences (especially those dubbed "maximum minimum" sentences) for crack users and dealers, who were poor and predominantly black, than for users of cocaine, a drug more often consumed by middle-class and white drug users. In fact, although crack and cocaine possess the same active ingredient, crack cocaine is the only drug whereby the first offense of simple possession can initiate a federal mandatory minimum sentence. Possession of five grams of crack will trigger a five-year mandatory minimum sentence. By contrast, according to the U.S. Sentencing Commission, "simple possession of any quantity of any other substance by a first-time offender—including powder cocaine—is a misdemeanor offense punishable by a maximum of one year in prison." Owing to the designation of drug users as criminals rather than as people in need of rehabilitation (and given the special targeting of crack users and dealers over all other drug users), the black prison population skyrocketed and so did the parolee population. In 1986, before mandatory minimums for crack offenses went into effect, the average federal drug offense sentence for blacks was 11 percent higher than for whites; four years later—after these harsher and

targeted laws were implemented, the average federal drug offense sentence was 49 percent higher for blacks. In 1997, the U.S. Sentencing Commission report found that "nearly 90 percent of the offenders convicted in federal court for crack cocaine distribution are African-American while the majority of crack cocaine users are white. Thus, sentences appear to be harsher and more severe for racial minorities than others as a result of this law." The extensive denial of the ways that race and racism shaped and consolidated violence, instability, and poverty continued to fuel misguided and mean-spirited policies that focused far more on emphasizing personal behavioral responsibility and punishment than on community support and collective responsibility.[11]

The "war on drugs" policy that favored punishment over other social responses was singularly responsible for the incredible expansion of the prison industrial complex and the heavy impact this had on poor black communities. Between 1970 and 1982 the U.S. prison population doubled in size; between 1982 and 1999, it increased again threefold. Within the United States today are only 5 percent of the world's inhabitants but 25 percent of the world's prisoners. Of the 2 million Americans currently behind bars, black men and women, who comprise around 12 percent of the national population, are profoundly overrepresented. Currently, black men make up 40 percent of prisoners in federal, state, and local prisons. Researchers anticipate that this trend will continue; based on current policies and conditions, they say that 30 percent of black men born today can expect to spend some time in prison. Among current black male prisoners, a disproportionately high number come from a small number of predominantly or entirely minority neighborhoods in big cities where aggressive street-level policing and profiling are heavily practiced. Over half of the adult male inmates from New York City come from fourteen districts in the Bronx, Manhattan, and Brooklyn, even though men in those areas make up just 17 percent of the city's total population. Numbers like these inspired the Justice Mapping Center to examine prison spending by neighborhood and by city block. Center founders Eric Cadora and Charles Swartz discovered what they dubbed "million-dollar blocks," neighborhoods

where "so many residents were sent to state prison that the total cost of their incarceration will be more than $1 million dollars." In Brooklyn alone, there were thirty-five such blocks. Rates of incarceration among black women have also risen dramatically and disproportionately. Almost half of the female prison population are black, and many of these women are locked up for nonviolent offenses (theft, forgery, prostitution, and drugs) that are directly linked to the forces of community destruction addressed in this chapter. The community-wide impact of these disproportionate and racially specific levels of policing and incarceration is staggering.[12]

These are the architectural signposts of today's ghettos. The violence that takes place within them has been created not only by racial discrimination long ago but also by assaults on poor black communities since the 1960s. The high levels of crime, police brutality, violence, drugs, and instability that define poor black urban communities are the direct result of chronic and high levels of concentrated joblessness, loss of affordable housing, community demolition, the crack explosion, the impact of easily accessible and highly deadly weapons used to defend the lucrative drug trade, and incarceration strategies that have criminalized large swaths of the African-American population. While not all of these factors were unique to poor black urban America, some were, and others were highly concentrated there. These recent conditions, along with compounding factors such as the long-term effects of economic, social, and political forms of racial discrimination, intensified the dramatic demise of working-class and poor black urban communities.

Hip hop emerged in this context, and thus the tales of drug dealing, pimping, petty crime, dropping out of school, and joining a gang are more aptly seen as reflections of the violence experienced in these areas than as origins of the violence. The drive to point out and criticize violence in rappers' stories as the cause of violence in poor black communities is often a disgraceful extension of the overemphasis on individual (decontextualized) personal behavior and the deep denial of larger social responsibility for creating and fostering these contexts.

The violent stories that characterize many hip hop lyrics are tales from this landscape, told from the ground-level perspective of circumstances as lived experience, not historical or sociological analysis. When we understand the depths of this reality, the actual destruction and violence that these societally manufactured conditions have fostered, then the violent lyrics take on a different character.

Why is it so difficult to understand that this highly vulnerable and dismantled community of chronically poor and racially-discriminated-against young people is in need of protection and advocacy? Why are we turning youth (through attacks on rap) into the agents of their own demise, seeing black kids as the source of violence in America while denying the extraordinary violence done to them?

My foregoing summary of the five causes of destruction of black communities—*chronic joblessness, loss of affordable housing, drug-trade expansion, automatic weapons and the drug economy,* and *incarceration instead of rehabilitation*—is not meant to encourage a blithe reaction to violent stories in hip hop, nor to cause readers to say, "Well, this is their reality." The prevalence of such stories in hip hop and the fact that they too often valorize violence (sometimes even serving as seductive tales of predatory action against other poor black people) are signs of a crisis for which the nation as a whole is responsible; the stories and rhymes themselves are not the primary source of the crisis. Attacking the rappers individually—calling them thugs and criminals while studiously avoiding the state of poor black urban America, or, worse, blaming these conditions entirely or even primarily on black people themselves—is a disturbing aspect of the hip hop wars. This stance reflects a long-term drive to deny the continued power and influence of institutional racism, sustains a racialized "us" versus "them" philosophy that enables the maintenance of racial and class inequality, and, in effect, extends the very logic that drove many of these mean-spirited and disempowering urban policies in the first place.

Culture is a means by which we learn how to engage with the world, and thus constant depictions of violence can have a normative effect. While this effect is not direct and absolute, there is ample evi-

dence that people are deeply influenced by their surroundings and the social conditions impinging on them. Compared to children growing up in secure and stable environments, those who live in violence- or crime-ridden communities are at greater risk for exhibiting criminal and violent behavior.[13] Our visually mediated culture is a large part of the surroundings and social conditions that shape us. If we are treated in violent ways, if we are forced by circumstance to survive in places where violent conflict is a matter of everyday life, and if we consume many violent images, we are more at risk—not only for exhibiting higher levels of violent behavior but, more important, for experiencing less trust and intimacy, increased fear, and a greater need for self-protection.

So, hip hop's extensive repertoire of stories about violence, guns, drugs, crime, and prison is compounded by everyday life for those who have little or no option but to reside in the poorest and most troubled neighborhoods and communities. Such stories become more powerful in this context, providing an image of everyday realities that can overemphasize the worst of what young people in these places face. On behalf of these kids, not the ones who listen vicariously from afar, we should be concerned about how and how often street crime and the drug trade are depicted—not because they represent the infusion of violence in American culture but because they sound an alarm about the levels of violence and social decay created by policies, public opinion, and neglect.

We must pay close attention to violence in hip hop, but we should not treat the tales of violence in hip hop in dangerous isolation from the many crucial contexts for its existence. Decontextualization—taking the violence expressed in hip hop lyrics and storytelling and examining them out of context—has a number of problematic effects both for the art form and for black people in general. Not only are the larger nonblack cultural reasons for these violent themes ignored but, worse, these reasons are attributed to black people themselves. So, the issue, once decontextualized, becomes violence as a black cultural problem, not violence as a larger social problem with tragic consequences for the most vulnerable. This approach does nothing

to help us think through and reduce violence in black communities or in American society more broadly, nor to reduce our collective appetite for violent entertainment or our use of violence as a means to achieve success and secure opportunity. It does, however, contribute to the further targeting and criminalization of poor black youth; it helps us imagine that this is "their problem," which only "they" can fix by acting right.

Another negative effect of taking hip hop's lyrical tales of violence out of social context is that their distinctive style of expression overshadows all similarities between them and other styles of violent storytelling. Because the particular *brand* of poor urban black and Latino male street culture that many rappers detail in their rhymes is unfamiliar to many whites (who because of continued patterns of residential segregation do not live in these overwhelmingly black and brown neighborhoods), these unfamiliar listeners often equate black style of expression with content. Although tales of violent street culture have various ethnic and racial origins, the fascination with black versions of such street culture creates the illusion that violent street culture is itself a black cultural thing.

Poor white ethnic neighborhoods have long had their own forms of violent street culture, but the fact that their slang, style, and rhetoric are not generally perceived as racially distinctive contributes to the misreading of black street crime and street culture as a cultural matter rather than as an outgrowth of larger social patterns. This lack of local familiarity with black style among white fans adds to the allure of its expression in hip hop. It also encourages a false sense of black ownership of street culture and crime among blacks. Thus, black language, clothing, and other distinctions in style override the deep similarities between black and other ethnic (white and nonwhite) forms of violent street culture. The lack of regular day-to-day contact between races (facilitated by sustained housing and school segregation) enhances this miscue. Many white fans come to "know" these neighborhoods and their residents through mass media portraits (Hollywood film, television programming, news coverage, rap music lyrics,

and videos), which only reinforce the fixation and reduce the recognition of cross-racial examples of violent male street cultures.

These factors, when taken together, create a web that looks something like this: We support policies that destroy black communities, and communities with great instability often experience more violence. Then, we rely on long-standing racist perceptions of black men as more violent, fear them more, and then treat them with more violence in response, which results in both more violence and more incarceration. Next, because we associate these men with violence, the stories they tell about violence are perceived as "authentic black expression," which activates a familiar kind of racial voyeurism and expands the market for their particular stories of crime and violence, which, in turn, confirms the perception that black men are more violent. This creates economic opportunity for performing and celebrating violent storytelling. Round and round we go.

But what is the actual role of violence in lyrics written by young people who live in communities that are struggling to stem the tide of real violence? Are these lyrics celebrations of the violence that shapes their lives—statements in support of the gangs, drugs, and crime about which they rap and rhyme? Or do they reflect a process of emotional and social management—a means by which these young people manage the lived reality of violence by telling their stories (a well-known process of healing in therapeutic and psychological circles)? Do these stories contribute to the violence these young people experience? Or are their stories about violence an outgrowth of the day-to-day threats they face, and do such stories relieve or reduce actual violence by responding to real violence with metaphor?

Or can *both* be true? Can violent lyrics and imagery reflect a real condition and at the same time contribute to creating it? The nub of the problem is this: At what point do stories that emanate from an overly violent day-to-day life begin to encourage and support that aspect of everyday life and undercut the communities' anti-violent efforts?

The question remains as to how we should examine and respond to the images and stories about violence that emanate from people who live in communities plagued by violence. We must continue to discuss whether we should attack the lyrics and the lyricists as causing violence or the conditions that foster violence. Clearly, we should challenge artists who have profited handsomely by constantly reinforcing the worst forms of predatory behavior against poor black communities. But to do so while denying the reality of their circumstances is mean-spirited and ineffectual.

In the song "Trouble" on the CD *Kingdom Come* (Roc-A-Fella Records, 2006), Jay-Z raps about his desire to stop hustling, but says he's only "pretending to be different," praying to god, in the chorus, because he'll never change. Both his longing to change and the bravado that accompanies his return to the game heighten the impact of the song. Jay-Z, a consummate braggadocio-style rapper, reestablishes his dominance over all around him. At one point he raps: "The meek shall perish." He goes on to say, "I'll roof you little nigga, I'm a project terrorist." His unrepentant character (self?) brags about being a person who rules with violent disregard and terrorizes people who live in the projects, an already terrorizing place to be. How should black poor people respond to this character? With pride? Affirmatively? Supportively? Since the song does not offer a critique of this "project terrorist," and given the charisma that Jay-Z imparts through his rhymes, one could perceive it as a glorification of a person terrorizing the most vulnerable members of black American society and demanding that we support his creative rights to profit from it. Why aren't street-level rappers like Jay-Z fashioning countless tales of youthful outrage at such a predator? This is a powerful example of how the art of bragging wedded to the icon of the violent street hustler—in communities where street hustling is a vibrant and destructive force—ends up having the power to celebrate predatory behavior.

In a 2007 *Rolling Stone* interview, Jay-Z acknowledged that the drug wars of which he was a part are hostile to black people and black communities: "When dealers are in the middle of it, they don't

realize what they're doing, they don't humanize the people that's us-
ing the drugs, they don't humanize the neighborhood. It's not until
you mature, and then you look back on it like, 'I was causing a lot of
destruction around the neighborhood.'"[14] But where are all the
highly commercially successful lyrics that make this crucial point,
that de-glamorize the drug trade, that reject gangsta worldviews, that
humanize black people? This is the central problem with the expres-
sions of violence and drug-dealer-turned-rapper stories in hip hop:
They do not publicly reinforce the transition from "project terrorist"
to "project humanist." Far too much pleasure, fame, style, and cele-
bration go to the game, to the hustle, to the dehumanizing rhetoric
of taking advantage of black people.

Without making overly blanket, ill-informed generalizations about
the creativity in hip hop, we need to be alarmed about storytelling
that offers little critique of violence against black people. There are
brilliant stories in hip hop that capture the day-to-day reality of deal-
ing with violence but do not seem to glorify it. Consider, for exam-
ple, the lyrics for Nas's "Gangsta Tears," which tap into the pain, loss,
and seemingly permanent cycle of retribution. But such sorrowful
tales are a decreasing proportion of what sells records in hip hop,
serving instead as "alternative" fare on corporate radio. Far too many
of the most financially successful lyricists in hip hop—Jay-Z, 50
Cent, T.I., and Lil' Wayne, among others—overemphasize and glo-
rify violent tales and gang personas because these are profitable.
They no longer tell tales from the darkside, with the hopes of con-
tributing to a devaluing of "the life" and producing radical, empow-
ered youth. Instead, there is too much getting rich from the
exploitation of black suffering.

Despite the wrong-headed, decontextualized, and unfairly tar-
geted claims about hip hop causing violence, there is some truth to
them. It is silly to claim that what we consume, witness, and partici-
pate in has no impact on us as individuals and as a society. When a
society turns a blind eye to violent behavior and allows its culture and
politics to be saturated in violence, it will normalize violence among
its citizenry and perhaps also indirectly contribute to violent behavior

among some of its citizens. And if we are going to rail about violence
in hip hop, we should rail twice as hard about the depths of violence
young black people experience, seeing them as the recipients and in-
heritors of violence rather than solely as its perpetrators. Where is all
the media-supported outrage about this?

The combination of denial of the larger forces and the self-
congratulatory story of hyper-individual responsibility most readily
expressed by white middle-class leaders is more than dishonest; it is
itself a form of social violence against the young people who are most
vulnerable and who need all of us to make a real and serious commit-
ment to restoring the kinds of institutions and opportunities that keep
chaos, violence, and social root shock at bay. The refusal to acknowl-
edge our national culpability for these conditions continues not only
the legacy of denying the deep injuries done to African-Americans
but also the long-standing use of the expression of black pain from
these injuries as "evidence" of black people's own responsibility for
these larger circumstances. The depths of the commercial success as-
sociated with violent, gang, and street culture as "authentic" hip hop
has given violent black masculinity a seal of approval, thus encourag-
ing these behaviors among the kids who are most at risk, and who
"need" to embrace this model if manhood is to survive. What began
as a form of releasing and healing has become yet another lucrative
but destructive economy for young poor black men.

The day-to-day violence that plagues poor communities must be
taken into account both as a crucial context for explaining some of
what we hear in hip hop and as a reality that compounds the power
of violent storytelling. The allure of celebrities whose cachet depends
partly on their relationship to a criminal/drug underworld is surely a
form of social idolization that might encourage already-vulnerable
kids to participate in the lucrative drug trade in neighborhoods where
good-paying jobs are nearly nonexistent. A good deal of 50 Cent's ini-
tial promotional campaign relied on the fact that he sold crack, that
his mother was a crack user, that he was shot nine times and wore a
bulletproof vest to protect him against enemies. We can't constantly
make violence sexy for young people who find themselves mired in

violent social spaces that are mostly not of their making and then ex-
pect them not to valorize violent action.

Some of this impact is going to be behavioral, and the behaviors in
question should be vociferously challenged and rejected. Black
people do not need "project terrorists"! The projects and "million-
dollar blocks" are bad enough. Of course, the drive to pathologize
black people (and to make pathologized blackness the only "true"
and profitable blackness) makes such criticism of black behavior very
tricky. But we must confront this dilemma with courage and honesty.
Our efforts to support, sustain, and rebuild black communities must
permanently join the five major causes of destruction I've listed
above to their individual and collective consequences. Neither social
responsibility nor individual responsibility should be talked about in
isolation. Focusing on hip hop as a cause of violence is just as irre-
sponsible as defending it by pointing to social conditions as a justifi-
cation for perpetuating gang, gun, and drug slang, iconography, and
lifestyles in the music. Despite the finger pointing, both positions in
the hip hop wars propagate the myth that black people are them-
selves violent, and both downplay the violence done to them. Both
seem to accept the larger social context as it is; neither challenges
American society to change the playing field.

Unbiased, socially just forms of concern about violence will and
do focus on directly helping communities reduce violence rather
than pointing the finger at and railing about lyrics and images as the
cause. Working as many local leaders and community groups do in
the communities most directly affected by street crime and other acts
of daily violence, activists don't advocate more force, violence, and
policing but, on the contrary, strongly advocate for nonviolent con-
flict resolution in schools, at home, and in other places where chil-
dren spend a great deal of their time. They also call for access to
resources for families to help resolve conflict. Indeed, our response to
youth crimes should result in extensive conflict resolution counsel-
ing and other highly supervised programs designed to reverse their di-
rection, not placement in ever more violent adult incarceration
facilities.

The most effective way to enact concern over violence is to (1) express this concern for black youth, and the real violence they face, in the form of activist social change; and (2) stop being hypocritical about violence. In other words, we must avoid the duplicity involved in expressing outrage at hip hop's violence while remaining virtually silent about the ways that our society condones violence and uses it both as social policy (internationally and at home) and as entertainment. This effort would have to address head-on the social worlds this nation has formed by creating, maintaining, and exacerbating the conditions in ghettos. It would have to confront violence against black youth—direct and indirect—that is part of everyday life but all too often goes unchallenged as a crisis for *our* society unless it spills *out* of the ghetto. Until this happens, those who rail about hip hop's violence but refuse to take into account the forces working against these communities do so not on behalf of the thousands of kids and young adults who have been left to fend for themselves but, rather, against them.

2

Hip Hop Reflects Black Dysfunctional Ghetto Culture

What is unique about this country's civilization? Its economy? Its pornography? The social welfare system that has created an African-American subculture that embraces poor English, illiteracy, sexual conquest, violence and drugs? (Lest I be accused of generalization and racism, I am just more or less describing rap music and hip-hop, or put another way, paraphrasing the comedian-actor turned outspoken social critic, Bill Cosby.)

—David Yerushalmi, president of the Society of Americans for National Existence, *The American Spectator,* April 27, 2006 (*The American Spectator* is an established conservative magazine, and the Society of Americans for National Existence [SANE] is considered a radical anti-Islamic organization.)

The solution to poverty, therefore, doesn't lie in a collective movement. It lies in the will and discipline of the individual people who dedicate themselves to living moral lives, striving to improve their circumstances, and providing greater opportunities for their children. By that measure, the great betrayer of African-Americans is not their government but their groins.

—Mark Goldblatt, *The American Spectator,* October 17, 2005

I ain't saying Jesse [Jackson], Al [Sharpton] and Vivian [Stringer] are gold-diggas, but they don't have the heart to mount a legitimate campaign against the real black-folk killas.

It is us. At this time, we are our own worst enemies. We have allowed our youth to buy into a culture (hip hop) that has been perverted, corrupted and overtaken by prison culture. The music, attitude and behavior expressed in this culture is anti-black, anti-education, pro-drug dealing and violent.

—Jason Whitlock, FOX sports journalist, in response to the Imus incident, *Pittsburgh Post-Gazette*, April 16, 2007

HIP HOP HAS BEEN ROUNDLY CRITICIZED for representing and celebrating what many critics, scholars, and media talking heads consider a black underclass urban "culture of dysfunction." Although hip hop is not always considered the origin of this "dysfunction," it is often perceived to be its greatest contemporary promoter. For some pundits and scholars, the crisis of dysfunction must be addressed because it negatively impacts black people (Comedian Bill Cosby and journalist Jason Whitlock, both black men, are examples of this approach); and for others (including many whites), the issue is that this black cultural problem is infecting larger society through the popularity of hip hop.

Criticism of this so-called culture of dysfunction revolves around the notion that poor urban black people have themselves created and perpetuated a "culture" of violence (which includes crime and prison culture), sexual deviance/excess, and illiteracy. Around these three pillars, the critics of hip hop dump many other cultural insults such as the kinds of names black people give their children, their everyday behavior and what they wear, their so-called fixation on conspicuous consumption, their slang phrases, their attitudes, and so on. The once-isolated issue of violence in hip hop has been folded into the larger idea that hip hop reflects a generally dysfunctional black urban underclass culture, and thus the moderate brush stroke of violence in hip hop became a paint-bucket dump of hip hop as "proof" of black urban underclass dysfunction.

This disturbing claim—especially its now wide-brush cultural basis—is class and racially motivated. It is also a powerful means by which to silence hip hop supporters, since it is hard to defend some of the specific behaviors identified in lyrics that can be lumped under this gross claim. The inability to "defend" the prevalence of lyrics like Lil' Wayne's "Shut up Bitch, Swallow" or David Banner's song "Like a Pimp" in which he says "Fuck it, show your pussy lips, you go to Tougaloo, but I know you still flip, bitch don't trip" becomes, for some observers, "proof" of the larger claim that hip hop is a reflection of and booster for black urban dysfunctional culture.

There are four troubling problems with the grossly simplistic idea of poor black people as culturally dysfunctional: (1) Contemporary claims about black cultural dysfunction are not new; they represent an old and oft-used argument against black people. (2) Newly created black cultural expressions have always been seen as a threat to larger American culture. (3) The cultural dysfunction argument collapses behavioral responses to structural conditions into fictitiously self-generating cultural patterns. (4) This argument also distorts and undermines decades of research efforts to prove the distinctive value of black cultural expressions and practices.

In the next four sections, let us consider each of these in turn.

Black Cultural Dysfunction
as an Argument Against Black People

Many of those who claim that black people are culturally deficient suggest that this deficiency is based on relatively new circumstances. Some critics assert that so-called black dysfunctional culture has its origins in programs (affirmative action, granting of black Americans access to existing welfare programs) that emerged out of civil rights movement efforts and centuries of racial and class-based discrimination. The idea is this: When what many conservatives call "the welfare state"—but what I would call an income aid program to assist the very poor—was extended to poor black

people (whites were recipients for decades before blacks were deemed eligible), a culture of entitlement, a victim status consciousness, and cultural dysfunction among black people were the results, marked especially by the so-called black matriarchal family structure.

This false point of origin for the belief that poor black people have a debased and dysfunctional culture that emerged from civil rights efforts and programs (and that black women's family leadership was a key reason for such dysfunction) hides the fact that the very same argument not only was a cornerstone of the means by which African-Americans were deemed suitable for enslavement but also formed the basis for maintaining slavery. Myths of black cultural dysfunction have served as a key explanation for racial inequality throughout most of the twentieth century.

Many contemporary black critics of hip hop want to recall a glory period when black culture was generally perceived as both noble and decent. However, even the imagined "good old days" of black cultural expression and everyday life were discussed in much the same way we talk about the black ghetto today. Forms of cultural expression such as jazz, blues, and black youth style, slang, and attitude have all been considered major threats to society and evidence of black cultural dysfunction, sexual excess, and violence.

For most of the nineteenth and part of the twentieth centuries, black people were considered devoid of any cultural traditions, and thus their "inferiority" was said to be based on presumed racially determined biological differences in intelligence. The overall idea was that slavery wiped out African approaches to sound, language, movement, food, space, time, and so on, and that black Americans were not as evolved as whites and therefore represented a culturally clean slate. Hallmarks of black culture were considered to be deficient attempts at mimicking Western cultural traditions rather than proof of existing traditions. Of course, today, most serious scholars of culture agree that African-American cultural traditions such as black religious practices, dance, and music—the blues, jazz, gospel, R&B, and

even hip hop—are fusions, hybrids, and cultural combinations of African and European influences.[1]

Nevertheless, during all of the nineteenth and well over half of the twentieth centuries, the general belief among Western intellectuals was that African societies and cultures were inferior to Western culture; thus, black Americans' retention and revision of African cultural traditions was not considered valuable. In fact, it was often perceived as an impediment for black Americans' developing civilization. African cultures were considered primitive, deviant. The key proof of this was the imputation of sexual deviancy and violence onto enslaved African-Americans. To some sociologists and anthropologists, the idea that black Americans might have been made "cultureless" because of slavery was considered an opportunity for black Americans, over time, to fully absorb Western, European-derived values and such cultural approaches as modesty and civility. Thus, slavery was often perceived as a blessing, as a benevolent institution.

Few would defend slavery today, nor would many serious observers claim that slavery created a cultural clean slate for the enslaved. The issue of black culture and its relationship to American culture remains central to our public conversation and grows out of this deep historical legacy. The claim that black people have a sexually excessive and violent culture and that they lack proper values has remained a fundamental vehicle for the denial of centuries of compounded structural discrimination and institutional racism as the real sources of self-destructive behaviors. To overly identify specific kinds of so-called deviance within black people, even though these behaviors exist throughout society, is a long-standing factor in the process by which racism is reproduced. Denying the roots of this process misses the bigger and much more important image of black deviance as a function of the apparent excesses of hip hop. We can't say, on the one hand, that those who made virtually the same argument about poor black people sixty or seventy years ago were racist and then, on the other, claim that "we are right" when we make this

argument today because, now, poor black people *really are* dysfunctional. Racist reasoning is a shape-shifter; the previous manifestations are always highly visible, while the current ones are often invisible to us.

Black Culture Seen as a Threat

Black cultural expressions such as dance, art, style, poetry, and, especially, its recent musical developments were considered constant threats to larger American society during their early years, even as many whites appreciated and participated in them. In nearly every case, once these highly popular and visible musical forms ceased to be the sound of the current youthful generation, they were accepted, celebrated, and tamed, no longer considered threats. Blues music, for example, was considered the "devil's music" during its heyday in the 1920s. In the parlance of early-twentieth-century language this phrase referred to the way the blues lured people into unacceptable behavior and explored risqué and taboo subjects, especially about sexuality, poverty, injustice, and violence. But now, of course, it is perceived as a quaint, charming artifact of a golden black age and embraced nearly universally as a valuable American musical form. It is credited for being the point of origin for jazz, rock and roll, and rhythm and blues.

Similarly, throughout its first several decades jazz music was considered musically debased and dangerous. As jazz historian Kathy Ogren notes, critics in the 1920s "exhorted listeners to resist the evil or wicked powers that jazz could exert over human behavior, especially the young."[2] Fears that the music would lure middle-class whites into unsanctioned sexual and other behaviors deemed a threat to acceptable society helped justify many efforts to limit, contain, and police "jungle music," as it was called since it was thought to be a primitive, dangerous African-based influence on American society. Its black performers and black fans were considered criminals, drug addicts, and representatives of black cultural inferiority and vice. Eventually, jazz was tamed and its brilliance discovered,

and today it is considered by many to be the greatest American music of all. It no longer represents a threatening cultural influence, and it isn't associated with black cultural dysfunctionality, sexual excess, and violence. The pattern of responding to new black expressive cultures as dangerous invasions while venerating older ones is a pillar of contemporary racism even as it appears to be evidence of racial tolerance.

Fictitiously Self-Generating Cultural Patterns

All culture is both created and reinforced by environmental and social contexts. When we think of society's structures, too often we consider only political and economic systems, neglecting to include culture. Culture is not an independent, self-generating set of transitory behaviors and values. It is part and parcel of our society's structures. As Cornel West has rightly argued, culture is "as much a structure as the economy or politics; it is rooted in institutions such as families, schools, churches, synagogues, mosques, and communication industries (television, radio, video, music). Similarly, the economy and politics are not only influenced by values but also promote particular cultural ideals of the good life and good society."[3] Because culture is so rooted in the institutions that shape our society as a whole, it is absurd to talk about black cultural dysfunction as if black people reside in total cultural and social isolation from all the main institutions in American society.

Yet this approach has dominated some of the most celebrated forms of sociological inquiry into black life and the problem of black poverty. Examples include the work of early-twentieth-century sociologists of race such as Robert Park and of sociologists associated with the 1960s War on Poverty such as Daniel P. Moynihan, whose 1965 U.S. Department of Labor–sponsored "Moynihan Report" is now infamous. This approach is perpetuated by today's social scientists, who, under the rubric of terms like "the underclass," continue to attribute a presumed pathology and dysfunctionality to black urban culture.

The black dysfunctional culture argument identifies widespread cross-racial behaviors such as violence, nonmarital sexual activities, reproductive choices, and conditions like illiteracy—which are direct results of individual responses to highly complex and difficult social contexts (including sustained racial, gender, and economic oppression as well as high rates of black male incarceration)—as independent, self-propelling black cultural traits and traditions. As this argument goes, poor urban black people are violent and sexually deviant, and they choose illiteracy; no matter what we do, that's their culture. This confusion of behavior and culture and the isolation of specific negative behaviors above all other kinds of behaviors that are also regularly exhibited by the vast majority of black people—social support of others, hard work for little reward—paint a lopsided, distorted portrait of people who have few legitimate spokespeople.

A key element of this so-called black cultural dysfunction is the interpretation of black female–led families as pathological. In fact, the Moynihan Report referred to the problems facing poor black people as a "tangle of pathology" and cited black female–led families as the central cause. The pathology is alleged to be marked both by the matriarchal status of these families (in a patriarchal society, men are supposed to be in charge of the family while women are supposed to be subordinate—and this is considered "normal") and by the assumption that unwed mothers, because they have had children outside of the institution of marriage, reveal their sexual deviance (women are supposed to have sex only within the confines of heterosexual marriage). This piece of the presumed black cultural dysfunction puzzle contributes to the association of black women with sexual deviance and has helped make popular the hypersexualized images of black women in hip hop.

Beyond this, black women's role as lead parent in single-female-headed households is considered a mutation of the larger patriarchal idea that women, in their role as childcare givers, are responsible for the moral development of their children. Since this moral education is understood as a key element of mothering in a two-parent and male-led family, then black mothers who parent outside of traditional

patriarchal families are imparting immoral values, thus perpetuating black dysfunctional culture.

Undermining of the Value of Black Cultural Expressions

Calling black culture "dysfunctional" overshadows a vibrant tradition of revealing the cultural contributions of African-Americans. These creative energies have been a powerful antidote to the systematic denial, devaluing, and disregard of black people and their contributions. It took immense political, social, and intellectual effort in the face of daunting resistance to produce the current belief that black American people have many distinct and valuable cultural traditions that are both part of the U.S. cultural fabric and yet based partly on African and African-Diasporic cultural traditions.

Black cultural expressions such as blues, jazz, gospel, dance, language, style, and religious and visual culture that emerged from new-world transformations of African-based traditions are now considered by many people (though not all) to be culturally valuable and distinct. And yet this victory of "proving" the existence of black American cultural traditions is being subtly and not so subtly undermined by the equation of black culture with the so-called black cultures of poverty and dysfunction. The long history of considering blacks violent, sexually deviant, and stupid has been maliciously fused with the black-propelled effort to reveal and examine the depths of the important cultural traditions that black people have contributed to American culture and the world in general. This process has turned the behaviors of some who grapple self-destructively with insanely powerful forms of social oppression into black cultural traditions, twisted black people's own radical efforts to prove that black people have created valuable cultural traditions in America, and then reduced and equated those extraordinary musical, verbal traditions to the claims of cultural dysfunction that have been leveled against black people for decades.

So, hip hop and its commercialized decline are being used to confirm and cement two key aspects of America's racial problem: (1) the

tradition of denying the deep and continued practices of racial dis-
crimination and its impact on black people as well as American soci-
ety as a whole; and (2) the tradition of imagining black American
culture as separate, self-propelling, and dysfunctional. Comprehend-
ing the creation of forced racialized ghettoization and consistent
forms of societal destruction of poor black communities is crucial to
understanding the kinds of behaviors that have been deemed "cul-
tural." Some behaviors are "pathological" only in the context of the
unjust terms of "normalcy." Do we still have to make the case that
presumed male authority inside and outside the family is a form of
gender injustice? Black women as heads of households are not patho-
logical or sexually deviant. Both parents should be sharing the duties
and responsibilities attached to parenting, and obstacles that inter-
fere with this joint project should be removed. But joint parenting
does not have to happen via heterosexual marriage, nor should it in-
clude installing men as patriarchal heads of families.

Other behaviors that seem to be understandable (if deplorable) re-
sponses to a given situation, when applied to poor black people,
somehow become a black cultural problem, one generated entirely
by black people. The national policies that created black urban ghet-
tos produce similar conditions for survival and self-destruction in
Chicago, Detroit, Philadelphia, Cleveland, Oakland, Washington
(D.C.), New York, and other major cities. Yet the continuity of policy
that has created nearly the same Petri dish of implosion and corro-
sion gets read the other way around: These black people, although
scattered all over urban America, seem to create the same conditions
everywhere they go. Their humanity becomes unrecognizable; the
orchestrated and accumulating conditions confronting them recede,
and their responses to what seem to be invisible forces appear self-
generating.

Such a dislocated kind of reasoning seems insane in other con-
texts. Children raised in war-torn regions who become involved in
youth guerrilla outfits, who behave in ways that would be considered
troubling and self-destructive, are understood as being profoundly

shaped by their environment, not as cultural or genetic incubators for violence. But this obvious point of comparison falls away from consciousness in our own national context because we seem incapable of facing the ways our nation has orchestrated a war on poor black people.

Some might fear that criticizing and rejecting the dysfunctional black culture thesis will result in supporting the images of street crime and underground economies that overly define commercial hip hop today. Is drug dealing in poor communities "okay"? Is the glorification of predatory behavior—directed primarily against other African-Americans—desirable? Are prison-derived behaviors and socializations a good model for nonincarcerated community development? Of course not. Should young black men and women, boys and girls, be emulating street hustling as a way of life? No. Should black fathers leave all parenting responsibilities to black mothers? No. But we have to admit that these are real problems in the iconic core of commercial hip hop songs. The power of these songs is not only reflective (mirroring the actions and points of view of those who are already invested in street culture and criminality) but seductive as well (in that they encourage young people to emulate the facets of underground street economies such as drugs, gangs, and sex trades.)

The expansion of street economies has created more space for the values associated with them. There is no question that once-illicit street economies fill the void left by the racially compounding effects of deindustrialization; the values of such economies take up more and more social space and prestige. The use of prisons to warehouse young black people who are shut off from any real opportunity and the continual underfunding of schools and other social support institutions that support poor families only intensify this trend. But those who imagine that the modeling of prison culture or other street economy–derived attitudes is a form of black culture have collapsed the context in which black people find themselves into the people themselves. The accusation that poor young black people are agents

of their own demise is pervasive indeed. As noted, virtually all the highly visible supporters of the claim that "hip hop reflects black dysfunctional culture" deny society's overall role in creating the conditions that foster problematic or self-limiting behaviors. Since this position tends to rely on the fiction that individual behavior determines opportunity, why should society get involved? Real opportunities must include a forthright and unflinching recognition of contemporary racism as it occurs structurally, not just at the level of individual belief. Many supporters of the idea that some or all of black culture is dysfunctional deny this reality, focusing instead on personal choice and negative behavior.

Such denial is the distorted public conversational context for comments like the one by Whitlock quoted at the outset of this chapter: that black people—especially as represented by hip hop—are their own worst enemies. They are "the real black-folk killas," he says, without mentioning any of the powerful—and unjust—forces that shape and define the lives of the black urban poor. To say this—given both the reality of deep structural racism and the increasing reluctance of many in the larger society to admit, let alone confront, it— is to lay the blame only at the feet of the most vulnerable and poorest urban black residents themselves.

Somehow, so-called black dysfunctional culture has become its own self-fulfilling prophecy, even though the power and seduction of hip hop images—for blacks and everyone else—is significantly driven by the desire, voyeuristic pleasure, and consumption of middle-class whites. Why are these consumers, who are key to the creation of a larger and more profitable market for hip hop images and street styles, not considered part of a "dysfunctional" culture, too—and why are they not charged with being some of the "real black-folk killas"?

No reasonable person thinks that a dominant black youth cultural expression—one that is widely consumed and shared—should be saturated with negative representations of underground street economy or criminal behaviors and attitudes. Rather, the issue is how we explain *and then address* this situation.

Dysfunctional Defenders Gone Wild

Increasingly, too many of hip hop's supporters point to structural racism to explain the origins of the problem but refuse to link these structural forces to individual action and to the power of media seduction. By failing to posit a progressive strategy for responding to negative behavioral effects, these pro–hip hop spokespeople actually fuel the "dysfunctional black culture" thesis.

The ascendance of the black gangsta, pimp, and ho in commercial hip hop is not a reflection of some imagined black dysfunction. It is the result of (1) the structural racism that grew out of the spatial and economic conditions of black ghettos in the post–civil rights era; (2) the hyper-marketing of hip hop images by major corporations, including black industry moguls, to promote and satisfy white consumer demand (indeed, this is one means by which racist ideas saturate and propel racial expectations and associations) as well as to sustain black "street credibility"; and (3) insufficient and Johnny-come-lately progressive critique of this direction in hip hop among hip hop fans, leaders, and artists themselves, especially the refusal to deal with hip hop's racially specific brand of violence and sexism.

Some defenders of commercial hip hop are in essence refusing to criticize the ways that many commercially successful rappers use the high market value of images of black criminality for their own gain. Few are willing to confront the fact that popular icons not only *reflect* the legacy of structural conditions but *shape and define* popular responses to it. The more prominent, creative, and charismatic artists are, the more likely they will be to generate desire for and imitation of the styles, personas, and ideas expressed. This is especially true of those who find the most lived-experience connection to such images. When the street economy icons—the gangsta, pimp, and ho—are celebrated and exaggerated in mass media, and when they represent local forms of prestige in areas with chronic and exceptionally high levels of joblessness and educational disarray, an already overwhelming situation is compounded. Some of hip hop's supporters spend far

too much time criticizing the black dysfunctional culture thesis while deflecting emphasis on the modeling impact of these images. By denying or underplaying the seduction and power of mass-mediated black criminal iconography for black youth, progressive supporters wind up co-signing a vicious cycle—and even then, without disabling anti-black ideas about black culture. They might, in fact, be encouraging them both.

Behaviors that destroy community, prevent people from taking advantage of real opportunity, and foster despair and nihilism should be fought and rejected. But if the terms of these challenges confirm the hateful stories used to justify racism, then they, too, should be challenged. There is no question that proper encouragement along with stern admonishment to reject self-destructive paths—*along with creating real opportunities*—will produce the kinds of healing and generative results that can turn the devastation around. This combination strategy means acknowledging the deep connections among behavior, context (past and present), and circumstance. But the strategy further admits that the structural changes required to bring about this legacy must include a serious form of behavioral transformation for those who have internalized and begun to reflect the destructive conditions in which they find themselves.

3

Hip Hop Hurts Black People

No amount of money or strategy will close the gap as long as black children are raised in an environment that devalues education. . . . Rap music, poverty and pop culture celebrities combine to create an alluring "cool-pose culture of self-destructive behaviors."

—Policy Bridge (an African-American-led think tank based in Cleveland, Ohio)

The black community has gone through too much to sacrifice upward mobility to the passing kick of an adversarial hip-hop "identity."

—John H. McWhorter

While racism remains a potent force in American life, it does not hold the malignant power of gangsta culture.

—Cynthia Tucker, journalist

MANY WRITERS, LEADERS, social critics, and cultural commentators claim that hip hop hurts black people—especially poor black youth, who can least afford it. Among the injuries they suffer are lower levels of academic and economic achievement, for which there are three primary explanations: self-destructive anti-education attitudes, emphasis on violence, and misogyny. Some claim that hip hop is fueling (if not instigating) a self-destructive, anti-education attitude that reduces chances for already at-risk, economically fragile youth. Others argue that it promotes violence, thus contributing to crime rates and black social decline by encouraging and glamorizing those

disposed to committing petty or violent street crime. And regarding misogyny and representations of hyper-sexual and exploitative behavior, language, and imagery targeting black women, hip hop is considered the key societal culprit. Some critics claim that hip hop fosters negative interactions and exploitative relations between young black men and women, in ways that degrade black women. Finally, some claim that hip hop is self-destructive, that it is black people's own worst enemy, and that paying attention to the myriad other reasons underlying the conditions that plague poor black communities, especially young people, is misguided. It's really the "enemy within" that is destroying black people and limiting opportunity—or so the argument goes.

Unlike many other claims made against hip hop, the idea that it hurts black people tends to come from black critics such as Bill Cosby and those quoted at the outset of this chapter. Despite my many concerns with how, where, and why this argument has been made, it is completely understandable that observers, fans, and leaders would be concerned about the content of commercial hip hop. And there is some important truth to the notion that the direction commercial hip hop has taken over the past ten years especially hurts young black people. Even some strong supporters of hip hop could be coaxed into agreement with this point. Writers such as Bakari Kitwana, Joan Morgan, T. Denean Sharpley-Whiting, Ewuare X. Osayande, and others in the hip hop generation have grown increasingly concerned over the massive changes that have taken place in hip hop. Some even say that hip hop as they once knew it is dead.

The sheer abundance of lyrical, stylistic, and iconic references to violence, gang activity, drug dealing, verbal and sexual abuse of black women, and homophobia in hip hop cannot be denied, defended, or explained away as *only* a reflection of actual lived experience. Surely these references are fundamentally connected to the devastation of black communities and thus emerge from some aspect of reality. But the state of hip hop isn't entirely about reality; it also ties into the social prestige and market power associated with these versions of black reality. Few thoughtful observers would make favorable claims for a

constant barrage of misogynistic street hustling as a perpetual meta-phor for black cool. Poor black kids are definitely not helped by heavy consumption of constant negative and mean-spirited sexist im-ages and lyrics that distort black masculinity, or by stories that glorify violent confrontations with other black teens and celebrate predatory behaviors and the necessity of selling drugs to one's neighbors.

Yet despite the substantive merits of the claim that hip hop hurts black people, there are significant problems with the overarching idea and the way this idea is expressed. These problems revolve around three issues: (1) *unfair generalizations* made through sweep-ing claims and overblaming; (2) *the tone of disdain and disregard* that is smuggled in under "outrage" and gets misunderstood as tough love; and (3) *what's left out*—that is, the extraordinary absence of col-lective responsibility for what's happened to hip hop and the silence among many critics about structural racism and its heightened im-pact on the black poor. Given the flawed tone and limited scope of this claim, what appears on the surface to be an effort to help protect and support black youth ultimately contributes to the harm done to them.

Unfair Generalizations

The claim that "hip hop hurts black people" is based on the notion that *all* hip hop, not merely commercially dominated and controlled hip hop, harms black kids. This is an undifferentiated and sweeping indictment that obscures profound corporate involvement in com-mercial hip hop and refuses to acknowledge and embrace the facets of local, enabling, and progressive hip hop. Few critics come right out and say that "commercial hip hop and its hyper-presentation of violence, gangs, and misogyny hurt young black people." This is not a matter of semantics. The bulk of the kind of hip hop that promotes the worst of what we find in the music and imagery is commercially promoted, encouraged, produced, and distributed by major corpora-tions. Images and ideas that reflect good will, love of community, and a diverse range of black experiences are relegated—no matter the

quality of the rhymes or beats—to the underground or to the com-
mercial margins of youth culture. Young fans are far more influ-
enced by images and ideas in heavy media rotation—and rappers
themselves cannot be held solely responsible for this.

Many critics who talk about hip hop hurting black people are too
quick to overlook the vital, dynamic, and heroic—albeit marginalized—
voices in hip hop such as The Roots, Common, Immortal Technique,
Akrobatik, and Zion I, to name just a few. In The Roots's song
"Star/Pointro" (*The Tipping Point*, Geffen Records, 2004), Black
Thought raps about the distorted quest for status and fame produced
in society at large and its particular brand expressed in poor black
communities. At one point he says: "Kids call theyselves killers let
they hammers do the talkin', don't even know the meaning of life,
ain't seen a thing." Akrobatik's song "Remind My Soul" (*Balance*,
Coup d'Etat Entertainment, 2003) is a mournful yet inspiring song
about the legacy of black resistance to hatred that produces self-hate.
In one place he raps: "So why we killin' for crumbs when there's so
much at stake?" Later he says: "Harriet Tubman would be turning in
her grave. Like remind my soul."

The one-dimensional but highly visible claim that hip hop hurts
black people refuses to shine a light on these less exploitative artists
and aspects of the music—where critiques of society as well as human-
izing and contextualized internal critiques of black community–
destroying behaviors are the norm rather than the exception. The
repetition of this one-sided strategy contributes to the marginality of
hip hop's better self and reflects a complete disregard for the gifts that
hip hop has bestowed on world music. Furthermore, when critics
overly generalize and neglect to mention those who work against the
destructive commercial grain of hip hop, they lose the attention of
youth who know that there are worthy aspects to the music and cul-
ture. Blanket criticism against something people feel such a powerful
connection to often falls on deaf ears.

Too many attacks use hip hop as an easy scapegoat for much larger
social issues—issues that require our sustained empathetic attention
and commitment. Angry railing at the music without serious attention

to the contexts for its creation and evolution generates an illusion that hip hop is a primary cause of urban social ills. This scapegoating happens frequently when it comes to the educational component of how hip hop hurts blacks. Critics suggest that the anti-education "cool pose" represented by hip hop, which some say has "gripped" poor black youth, is the central explanation for black educational failure as revealed by high drop-out and unemployment rates. For example, as quoted at the outset of the chapter, Policy Bridge—a black think tank in Cleveland, Ohio, founded and run by three local black professional men, all of whom attended Cleveland public schools—has produced a report claiming that "no amount of money or strategy will close the gap as long as black children are raised in an environment that devalues education." Rap music, poverty, and pop culture celebrities combine to create an alluring "cool-pose culture of self-destructive behaviors." Similarly, John McWhorter has argued that "the attitude and style expressed by the hip hop 'identity' keeps blacks down." Indeed, he goes so far as to suggest that the opportunities he personally enjoys are available to everyone and that all these black kids have to do is give up their bad attitude, gestures, and behaviors, and a world of opportunity will be open to them.[1]

So, rap music and pop culture and their emphasis on the "cool-pose culture of self-destructive behaviors" (a stylish form of unflappability and feigned disengagement) not only rank with poverty as the central problems facing poor black youth today but also, according to Policy Bridge, account for two-thirds of the whole problem facing poor black youth today! This is bad enough, but even worse is their claim that "no amount of money or strategy" will have a meaningful impact until this cool-pose attitude (held solely responsible for devaluing education among some black youth) is defeated. It's as if rap attitude is responsible for all the ways that race and class discrimination affect poor black youth. So, following this logic, there is no point in making policy changes, creating school improvement plans, expanding job training programs, enhancing economic opportunity, or relying on rehabilitation over punishment and criminalization—at least not until rap music and popular culture change.

This oft-repeated position—that the cool-pose attitude now associated with hip hop and black popular culture hurts black people—denies two key facts: (1) This type of self-protective, male response preceded hip hop by decades, and (2) the cool pose itself functions as a survival strategy in the face of crushing oppression and violence against poor black youth, especially boys and men. It is indeed a form of protection against their actual and perceived long odds in society. For example, an important and award-winning study on job application discrimination done by Princeton University sociologists Devah Pager and Bruce Western concluded that "black job applicants are only two-thirds as successful as equally qualified Latinos, and little more than half as successful as equally qualified whites. Indeed, black job seekers [who have not gone to prison] fare no better than white men just released from prison."[2]

The post–civil rights era brand of racism that creates these realities operates under a rhetoric of already achieved racial equality and has thus generated a unique kind of disillusionment among racial minorities. How are rejected black job candidates like the ones in Pager and Western's study supposed to respond to the ongoing reality of unjust limitations on opportunity, no matter how well they achieve? Perhaps a motivation for the cool pose that youth sometimes present reflects an effort to appear undaunted by this reality, to seem untouched by the real effects of racial injustice that continue to be underaccounted for in our analysis of why some black children lag behind others. Or perhaps the study explains why the merits of an investment in educational achievement might be difficult to sustain under conditions of class, racial, political, and social oppression. If these well-performing job applicants, who likely focused on school and made all the necessary sacrifices, still were only *half* as successful as equally qualified white candidates, what is the point of their effort and sacrifice?

The idea that a cool-pose attitude is a free-standing black cultural disposition that is hurting black people, and not a response to hurtful, discriminatory environments, makes the social condition of injustice appear "normal" and pathologizes the response to it. Public

attention to this issue has uncritically and selectively adopted the re-
sults of research such as S. Fordham and J. U. Ogbu's 1986 study
"Black Students' School Success: Coping with the Burden of 'Act-
ing White,'" which concluded that one significant reason for under-
achievement among black youth is a broad cultural devaluation of
educational attainment. Oppositional research and other details
from this study—most significantly, the role of social, economic,
and political subordination of African-Americans in producing con-
ditions that spawned an oppositional identity—are excised from
public conversation.[3]

In the popular media and in conservative think tank circles, hip
hop and oppositional cool-pose behaviors are the reason for the un-
warranted emergence of an "anti-education culture" that has sprung
up out of the depths of some strange black alternative world. The
point of origin and significant power ascribed to this anti-education
cool pose are both incorrect and problematic. The pose is overwhelm-
ingly cited as the source of devastatingly high African-American high
school drop-out rates. Acting cool in ways that are anti-educational is
so widespread and influential that, to quote Policy Bridge once again,
"no amount of money or strategy will close the gap as long as black
children are raised in an environment that devalues education."
Worst of all, this reading of young black men and women helps us
wash our hands of any collective responsibility or empathy while ob-
scuring the forces working against these young people. From this an-
gle, young black people are not our kids in pain brought on by us,
who need our love, guidance, defense, support, and resources, but,
instead, an alien bunch who just seem to refuse to get with it. So, as
the argument goes, nothing "we" can do will make it stop until they
help themselves.

The poorest among us, especially those who are nonwhite, seem to
be permanently and deliberately left behind. The conditions in
which they are born and asked to survive are brutal and terrorizing,
and they are often left to their own devices as to how to make it
through. And with "friends" who tell you that despite all the odds
stacked against you a good attitude will solve all your problems, who

needs enemies? The brutal irony of this assessment—that no amount
of money or strategy will succeed until the cool-pose attitude ends—
is that the opposite is actually true: It won't end until we make the
proper kinds of investment in young people. And this investment in-
volves attending to the internalization of despair (rather than treating
despair as a cause) and creating meaningful, accessible opportunity.

Tone Speaks Volumes

Bill Cosby, himself a high school dropout, has received a great deal
of attention over several comments he has repeated regarding poor
black people's dysfunctional behavior and actions, which he has
claimed explains their conditions. While some of his ideas share a
long history of black conservative strategies for self-empowerment,
he trades on the popularization of racial stereotypes about poor
black people. At a speech he gave in 2004 at the DAR Constitution
Hall, he said that "the lower economic people are not holding up
their end of the bargain. . . . These people are going around stealing
Coca-Cola. People getting shot in the back of the head over a piece
of pound cake and then we run out and we are outraged, [saying,]
'The cops shouldn't have shot him.' What the hell was he doing
with the pound cake in his hand?" A few weeks later, Cosby simi-
larly addressed a group of black activists in Chicago at the
Rainbow/PUSH Coalition's annual conference. He suggested that
poor young black people's behavior (some of which is closely associ-
ated with hip hop style and attitude) is what's keeping black youth
from succeeding, and he said it in deeply insulting ways, designed to
injure and disparage: "Your dirty laundry gets out of school at 2:30
p.m. everyday, it's cursing and calling each other [the N-word] as
they're walking up and down the street. They think they're hip.
They can't read. They can't write. They're laughing and giggling,
and they're going nowhere."[4]

John McWhorter, in the same article in which he declares that
black youth are kept back by their own behavior, disdainfully de-
scribes what is decidedly problematic behavior by some kids in a Ken-

tucky Fried Chicken restaurant in Harlem: "So completely was rap ingrained in their consciousness that every so often, one or another of them would break into cocky, expletive-laden rap lyrics, accompanied by the angular, bellicose gestures typical of rap performance." His tone is what emotionally drives the argument:

> The arm-slinging, hand-hurling gestures of rap performers have made their way into many young blacks' casual gesticulations, becoming integral to their self-expression. The problem with such speech and mannerisms is that they make potential employers wary of young black men and can impede a young black's ability to interact comfortably with co-workers and customers.

He challenges hip hop supporters, Michael Eric Dyson in particular, to point out "just where, exactly, the civil rights–era blacks might have gone wrong in lacking a hip-hop revolution. They created the world of equality, striving, and success I live and thrive in. Hip-hop creates nothing."[5]

Unfortunately, it is completely socially acceptable to talk publicly about poor young black people as a group, in the context of hip hop, with such a pejorative tone. This tone, which communicates the sense of holding one's nose at the stench coming from dirty laundry, arises frequently in public conversations these days. Finding belligerent, antisocial black boys to serve as examples for all black boys reveals the subtext, the real political point of this argument. Surely there were other young black men in the same Harlem KFC that McWhorter was visiting; some probably actually prepared his meal and at least a few probably listen to hip hop, despite their cooperative, appropriate behavior. We should challenge the worst of what commercial hip hop has become, but not with this tone, not with this political subtext. Beneath what could be progressive outrage at the way that hip hop has mutated is a deeply problematic, nearly laughable argument suggesting that the successes of the civil rights movement created a world of opportunity for all those who behave properly.

By contrast, it is worth noting the kind of approach that addresses behaviors that might have a good reason for emerging, yet still rejects them as self-destructive. Not surprisingly, these constructive critiques come from activists who have sustained, community-based professions and thus are able to see the world from the perspectives of poor young black men and women. Geoffrey Canada, founder and director of the Harlem Children's Zone, has spoken out eloquently and powerfully against the ways that behaviors taken up by some young black men and women undermine achievement and enable a social world where violence and criminality thrive. His comments were related as well to the death of rapper Busta Rhymes's bodyguard Israel Ramirez, a student Canada mentored, and the refusal of Busta Rhymes and others to give information to the police about Ramirez's killer. He responded passionately to this "no-snitching" attitude that enables crime to go unpunished in poor communities, thereby undermining community values of anti crime, pro-community stability and growth:

> It's like we're saying to the criminals, you can have our community. Just have our community. Do anything you want, and we will either deal with it ourselves or we will simply ignore it. . . . I just think of him, being shot, falling down, probably thinking, this might be it. And I just wonder, who held his hand? Or who caressed his head? . . . Who stayed with him? Who made sure this man didn't die alone for nothing?[6]

So, this argument isn't just about whether criticism should be made; it's about the tone of the criticism, what damage is done in its wake, and how publicly popular comments can be distinguished from empathetic, historically informed critique that also rejects self-destructive behavior.

What's Left Out

The notion that hip hop harms black people is often couched in a language that implies that hip hop today—despite its contemporary

role as a corporate-dominated product—is a home-grown, local-black-ghetto cultural phenomenon, one that can be understood as emerging organically and autonomously from some imagined un-commercialized, all-black recreational space. The general attitudes, style, language, and behavior of black kids invested in hip hop serve as "proof" that this is a "black thing," made by and for black youth. The crux of the idea that hip hop hurts black people is that hip hop represents social problems that result from behaviors generated by blacks. The charge begins with hip hop as the key source of injury to black people and ends with the idea that black behavior alone will fix the problem.

The operative illusion is that truly "black" images and styles can-not be products, regardless of the degree to which corporate power defines, shapes, and promotes them. This fiction allows us to imag-ine that the core of commercialized hip hop emerges entirely from poor black youth themselves. Yet, the bulk of the kind of hip hop that promotes the worst of what we find in the music and imagery is com-mercially promoted, produced, and distributed by blacks, whites, and others for a predominately white audience.

Many who claim that hip hop hurts black people conveniently leave out (or at least remain silent about) the extensive role of corpo-rate power and white desire as key ingredients in creating the central-ity of self-destructive ideas and images in commercial hip hop. What we hear and see on commercial radio, on cable TV, and in maga-zines are products of global corporations whose employees work night and day to generate sales of their products. Once a highly ex-pensive music video is produced (a process that can cost as much as a half-million dollars), that song is promoted via every means neces-sary, including paying off television and radio program managers who assist in high levels of airplay to help encourage sales. And now that the global corporations have realized that black death (as Chuck D has put it) is a highly profitable black product, they do what they can to make money on it.

Radio-station program managers and record-label executives who promote the gangsta-pimp-ho trinity often claim that this is what

sells, so, in effect, they pretend to be slaves to audience desire. They shrug their shoulders and say: "What do you want from me? If we don't play (fill-in-the-blank-rapper), then we lose record sales and listeners. We'd love to play more Talib Kweli, but we gotta pay the bills!" Meanwhile, rappers say they are trapped by contracts to sell records, that what they do is a business. As Nelly noted during BET's *Hip Hop vs. America* forum: "When you get done it's a business. You sign a contract to sell records. You don't sign a contract to state your feelings and hope that everybody else understands it. . . . [Y]ou have an agreement to sign this contract to sell records, therefore if I don't sell records [for the record company] then, I'm out of a job."[7] These positions are profoundly disingenuous because they evade the widely known fact that radio stations are regularly compensated for playing the artists chosen for high-rotation airplay by record labels. Fan requests rarely determine programming. Many of these larger conglomerates own multiple radio stations and determine the playlists for all of them in a given urban radio market. Record labels hire promoters to pay off these radio programmers, who now have more power than ever to shape national listening habits. And this process ensures that most of the singles and the artists that record labels have decided to promote get regular airplay. Why isn't this corporate-based, unethical, socially irresponsible behavior, which impacts millions, criticized and held up for disdainful commentary with the same frequency, the same levels of disdain, as the "cool pose"?

Multimillion-dollar corporations with near total control over the airwaves and playlists, which never release objective and complete information about callers and song requests, refuse to openly discuss how they determine their playlists or explain the cozy and illegal relationship between many record companies and radio stations uncovered by various investigations over the years. They want us to believe that we, the listeners, determine what gets played. And they give the impression, through sometimes rigged call-in segments and other contrived listener-based contests, that we, the listeners, determine what gets played. Yet, even people who have little content criticism of the songs heard on commercial black/urban contemporary radio

think that there is too much constant repetition of a depressingly short playlist. Most people tolerate the hyper-repetition; few are happy about it. The sense that songs are being played more often these days is in fact quite true. In the early 1990s (prior to the Telecommunications Act of 1996) programmers played popular songs an average of 40 times each per week. By the end of the decade that number had jumped to 140 plays per week.[8]

This means that the constant marketing, distribution, and playing of commercial hip hop that reflects negative images and ideas actually cultivates these images and ideas. The cool pose, the black thug, the black ho—these are *brands* being hawked and overemphasized, touted as the way out of the ghetto. Given that there are few alternative ways out, black youth, especially males (who make far more money than black women do from "investing" in hip hop), see this as their ticket to economic independence and wealth.

Thug life is a product, and given our history of racial stereotypes, young black men are the ideal sales force for it. So if we're going to talk about investment and opportunity, we have to admit that there is a large market for these images and attitudes, a market far bigger than black people can be held responsible for. In a way, thugging has enhanced the financial opportunity for many young black men. Hip hop moguls like Damon Dash often defend their thug-reliant products, claiming that they are businessmen providing jobs for the community and serving as entrepreneurial role models. During his appearance on *The O'Reilly Factor*, Dash defended the content of the material he promotes by suggesting that his success as a businessman is paramount: "We don't promote entrepreneurship? We don't promote positive and ownership of your company? I'm making it cool to be smart. I'm making it cool to be a businessman."[9] This kind of reasoning is precisely why our conversation has to be driven by a larger set of progressive questions that go beyond helping poor black men and women "take advantage of America's economic opportunity." Thugging/mugging for the camera in hip hop is doing just that.

White consumption—the biggest market for hip hop since gangsta rap emerged as commercial hip hop's front runner—didn't just mean

a bigger market for hip hop; it also pointed to the fact that what soon became the most profitable and desired images in hip hop reflected the ideas about black people most commonly held by its audiences. This shift reflects how mainstream images and desires for some representations about black people overshadow others. Whites do not consume all black musical genres equally, so the level of popularity of black music among white fans is not a given, based solely on racial demographics. Hip hop is by far the most disproportionately white-consumed popular black music genre.

While white consumption of black musical genres always outnumbers black consumption, differences in proportionate racial consumption can influence which groups' desires and preferences shape the direction of the genre. So, for example, in 2002, whites made up 54.3 percent of total consumers of R&B while black consumers made up 41 percent. Similar proportions apply to gospel music: White consumers made up 58.1 percent while black consumers made up 39.7 percent. (This shifted to even greater parity in 2004, when whites comprised 53.7 percent and blacks 41.7 percent.) For hip hop, however, white consumption is significantly higher than black consumption: In 2002 whites made up 64 percent while blacks made up 31.9 percent. Over the next four years, this racial consumption gap in hip hop widened: In 2004, whites were 60.6 percent of the consumers and blacks were 24.8 percent; in 2006, whites were 60.1 percent and blacks were 25 percent. The racial consumption gap for hip hop was 32.1 percent in 2002, 35.8 percent in 2004, and 36.1 percent in 2006. By contrast, for R&B, the gap was 13.3 percent in 2002, 8 percent in 2004, and 3.1 percent in 2006.[10]

Although black and white consumers have different tastes regarding R&B, they have a nearly equal chance of impacting corporate-sponsored artist content, since they are nearly equally important to the overall sales of the genre. This is not the case for hip hop, since following the tastes and concerns of black consumers over and above those of white consumers has the potential to alienate two-thirds of total consumers while retaining only a quarter of them.

Proponents of the "hip hop hurts black people" claim often re-main silent about the profitability of images that derive from white desire and consumption. The cycle looks like this: Mainstream white consumers drive hyper-demand for these images (whites are raised on images of black thugs—images that appeal and seem authentic to whites), thereby fueling higher sales given the size of the white con-sumer market, which then encourages unscrupulous corporations to demand more of these images to make greater profits. This in turn encourages black youth, who are also raised on images of black thugs as a primary source of power, to tailor their image to suit market needs. For the most part, only gangstas and their promoters make it to the tippy top of hip hop power and wealth. Given this domino effect, the key issue is how consistently profitable some images of black people remain. The idea of black men as gangstas, thugs, and pimps and of black women as hoes and tricks feeds long-standing myths about black people, and this normalized racist history is largely what makes such images popular.

If injuries to poor young black people are the main issue in the claim that hip hop hurts black people, where is the sustained outcry about all the evidence we have for the existence of powerful forms of racialized inequality and discrimination and the ways that our nation as a whole has retreated from solving these problems? The issue isn't just the sometimes hostile form of tough behavioral love; it is also the deafening public silence about the stark and brutal realities that our society has created and continues to direct against poor black people. When Bill Cosby appeared on *Larry King Live* with Harvard social psychologist Allen Pouissaint, he claimed that he has long been an outspoken critic of racism in American society.[11] Perhaps there is some truth to this, but it's difficult to find critiques of racism from Cosby expressed with the same outrage, anger, disdain, publicity, and consistency with which he has responded to what he perceives as dys-functional black behavior and attitude.

If this conversation were really about injury to black people, it would have to include mention of the importance of housing dis-crimination and its role in maintaining white wealth, which accrues

at a rate ten times greater than black wealth—a gap that is primarily the result of accumulation of white institutionalized racial privilege. It would also have to emphasize the research showing that black men live not in the state of constant bravado displayed by hip hop images or the cool pose some claim determines their behavior but, instead, in a state of serious fear. Sociologist Al Young's extensive interviews with young black men in their 20s revealed stories of isolated young men "living in fear of being victimized, of dropping out of school because they were afraid to go, of spending considerable time figuring out how to avoid joining gangs."[12] Illuminating the injuries to black people would highlight how the lack of affordable, accessible child care in poor black neighborhoods forces poor working parents to leave their children in undersupervised environments—a situation that researchers have shown increases the risk of sexual abuse of young women and children. How is it that so many of these disgusted critics have virtually nothing to say about the depths of this kind of structural racism? Why are so many critics, black ones included, so outraged about black behavior and yet so very blind to, and bored with, the reasons for black pain and alienation?

If black middle-class leaders and celebrities want us to believe that this focus on the injuries for which hip hop is presumed to be responsible is really about helping "the lower economic people," as Cosby calls them, then they might want to consider giving quite a bit of additional public airtime to the many more powerful forces that have created the conditions in which far too many poor black kids live. This wouldn't deemphasize behavior so much as properly locate it. Without drawing attention to these powerful and extensive forces, critics who lambaste hip hop let society—and themselves—off the hook and feed stereotypical ideas about black people that generate racist policies and minstrel-like hip hop images and lyrics. They represent a mean-spiritedness that has long been leveled at poor black people, especially youth.

Having listened to too many critics of hip hop, one could come away with the dangerous and hurtful belief that racial discrimination in American society is a thing of the past, that it plays no meaningful

role in the life choices and opportunities facing poor youth today. Black folks didn't look at a map and say, "Hey, let's migrate to the ghetto, that's a good place to live. It reflects our cultural values." Ghettos have been created and maintained by structural forces beyond the control of individual parents, teachers, students, and local businesses; they produce the bulk of the conditions we see and have been designed to destroy the spirit of their inhabitants. The brilliant essayist James Baldwin understood this; in his highly acclaimed book *The Fire Next Time*, he included a letter to his nephew in an essay titled "My Dungeon Shook: Letter to My Nephew on the One Hundredth Anniversary of the Emancipation." Here, Baldwin warned him of the intended purpose of the ghetto and its relationship to the larger operations of white supremacy:

> This innocent country set you down in a ghetto in which, in fact, it intended that you perish. Let me spell out precisely what I mean by that, for the heart of the matter is here, and the root of my dispute with my country. . . . You were born into a society which spelled out with brutal clarity, and in as many ways as possible, that you were a worthless human being. You were not expected to aspire to excellence: you were expected to make peace with mediocrity. . . . You have been told where you could live and what you could do. . . . Please try to remember that what they believe, as well as what they do and cause you to endure, does not testify to your inferiority but to their inhumanity and fear.[13]

The Rock and the Hard Place

It seems crucial that we find a way to address the relationships between personal behaviors and structurally maintained inequalities based on race, gender, and class that diminish opportunity and skill and damage the possibilities for a truly democratic society. Many black writers, leaders, and critics have been arguing for decades in favor of attention to both sets of "reasons," as they are deeply intertwined. The problem comes into focus when a particular black behavior is isolated, made to

appear as the single point of origin, demonized, and overemphasized, and when the long-standing denial of racial inequality and the maintenance of white privilege and power in contemporary society serve as the silent backdrop for this attack. This is why we should not only keep our attention on the partial truths inherent in the claim that "hip hop hurts black people" but also examine the powerful contexts in which such comments are made and the way they serve larger agendas that really do hurt black people. To put it more bluntly, those who insist on making public, hostile attacks on some of the most vulnerable, least powerful people in society while at the same time neglecting to offer the same kind of vitriol against institutionalized racism, economic oppression, and sexism contribute to the very inequality they claim behavior should fix. They should begin with a deeper examination of their own behavior before moving on to that of anyone else.

All of this having been said, behavior, attitude, and worldview do matter. They can reduce or enhance one's chances; they can build community or tear it down. Progressive youth, parents, teachers, leaders—indeed, all citizens—should be asking hard questions about why commercial black youth culture as represented by hip hop has become a comfortable home to nihilistic attitudes that devalue the kinds of investment in self that create nourishing and sustaining community and how we can change it. Fighting despair and fighting for justice also require youthful artists and leaders who have hope, who are willing to sacrifice for the larger good, and who have a fighting spirit for creating better and stronger communities. This isn't just a matter of helping kids achieve personal success; if it were, we would have no way to challenge the "I need to get paid" philosophy of creating personal wealth that has gripped society at large and taken root in hip hop, too. The future of black grassroots leadership's ability to fight structural oppression depends on winning the war against the current national embrace of profits over people.

Efforts at the level of individuals are not sufficient; they can't be effective without far more serious investment in stamping out *systemic* injustice. Publicly beating up on those who have the shortest

end of the stick without exposing and keeping our eye on the deep forces working against black people contributes to our collective denial about the profound role of discrimination in our society, and may even end up "justifying" it.

On the other hand, it is silly to think that we can address the role of personal behaviors and responsibility "after" racial, gender, or class discrimination ends, as some hip hop defenders claim. Jay-Z takes this position in his song "Say Hello," in which he says to tell Al Sharpton that "I'll remove the curses if you tell me our schools gon' be perfect, when Jena Six don't exist, tell him that's when I'll stop sayin' bitch, bitch" (*American Gangster*, Def Jam Records, 2007). While we should certainly keep our attention on structural racism, sexism, homophobia, and class oppression in all of their crushing manifestations, we cannot pretend that *how* we live with these realities, *how* we behave, what choices we make—especially when such choices are so very limited—have no impact on our lives.

There is no way to claim that constant commercialized promotion of thug-inspired images won't negatively impact black youth, race relations, and society in general. The force of this impact is tied not only to images that repeat a history of associating black people with crime and violence but also to the available counterimages, which are limited at best. At the same time, we must provide a meaningful visible space for creative expression of suffering and marginalization; we can't pretend that silencing such expression—especially in the form of stories that use humor, style, and powerful critique—will make the origins of the suffering go away. The question is how to provide space for these tales while guarding against their easy morphing into minstrelsy and "proof" of black inferiority.

We need to develop a progressive position on the role of behavior and worldview in enhancing as opposed to reducing opportunities, especially for those most impacted by oppressive or discriminatory conditions. We must cultivate enabling behaviors and attitudes but tether them to impassioned removal of structural racism and discrimination. Behaviors don't just flow from larger social forces; they also help

change them. Divesting from an ethos of "get mine at all costs" makes room for behavior fueled by a radical love ethic, a commitment to reducing violence and stamping out hunger, a national investment in affordable housing, access to healthcare for the poor, meaningful wages, and better schools.

4

Hip Hop Is Destroying America's Values

I think that nothing less is at stake than preservation of civilization. This stuff by itself won't bring down civilization but it doesn't help.

—William Bennett, former secretary of education,
former director of the Office of National Drug Control
Policy, quoted on the PBS series *Culture Shock: The TV
Series and Beyond*

One of the greatest threats to American family values is the way our popular culture ridicules them. Our music, movies, television and advertising regularly push the limits of decency, bombarding our children with destructive messages of casual violence and even more casual sex. . . . I think we have reached the point where our popular culture threatens to undermine our character as a nation.

—Bob Dole, Republican presidential candidate, *Los
Angeles speech*, May 31, 1995

Unless we speak against this [rap music] it will creep continually into our society and destroy the morals of our young people.

—Reverend Calvin O. Butts III, pastor of the Abyssinian
Baptist Church and president of SUNY (Old Westbury
campus), quoted on the PBS series *Culture Shock: The TV
Series and Beyond*

The attacks of the killer culture are relentless. From the commercials, to the gangsta and street-walker clothing styles, to the

*movies, magazines, games and music marketed to teens, de-
cency is under attack. . . . I awake every morning with a simple
prayer, "Lord, please help me today to uphold the values and
standards my husband and I have set for our family."*

—Rebecca Hagelin, a vice-president of The Heritage
Foundation (an established, very conservative think
tank), "The Culture War: A Five-Point Plan for Parents,"
August 9, 2005, available online at www.heritage.org

PROBABLY THE MOST HYPERBOLIC EXAMPLE of blaming hip
hop is the idea that it is destroying America's values. This claim
is made in a variety of ways, but the key strategy lies in the use of a
narrow set of conservatively defined values to represent a much larger
group of diverse and often competing American values. As the above
quotes demonstrate, the American values that rappers are most ac-
cused of destroying are "decency" and "morality." Both of these val-
ues are frequently subsumed under the fuzzy but recently politically
resonant concept of "family values." As the earlier quotes also reveal,
hip hop is accused of contributing to the demise of Western civiliza-
tion and of fueling anti-Americanism, both internally and abroad.
Proponents of this position claim that the major threats to American
values are conveyed through cultural expressions of violence, lawless-
ness, and sex outside of heterosexual marriage—all of which they as-
sociate with hip hop.

Those who profess fear that American values are under assault
owing to the negative influence of rap music are part of a much
larger movement to align morality with conservative values—a move-
ment that involves crafting a very short list of values (about which
there has never been any unanimous agreement in U.S. society) and
defining them narrowly. This explicitly moral value–based form of
cultural politics has dominated popular politics over the past twenty-
five to thirty years, basically paralleling the emergence and ascen-
dance of hip hop, and powerfully affecting how the public has
perceived it. Partly because of its historical timing, hip hop has be-

come a central figure in the culture wars, conveniently standing in for all that has gone wrong in our society. Yet conservatives' definition of what does and does not constitute American values studiously avoids other equally if not more compelling American value systems that challenge the apparent priority of (as well as their definition of) decency, sexual morality, and lawfulness.

It seems dramatic to claim that a youth music or culture, particularly one heavily peddled by corporate America, could significantly contribute to the decline of Western civilization (unless capitalism is itself considered part of the problem, too). The misinformed characterizations of popular culture, especially rap music, as "killer culture" have gotten a good deal of traction. There are at least five explanations for why this has happened: (1) the long association of black people with violence; (2) youth cultural challenges empowered by the development of modern society; (3) fears associated with the vast economic, political, and social changes that have taken place over the past fifty to sixty years; (4) the singularly dramatic impact on American society of the social movements of the 1960s and 1970s; and (5) the profound shift from an industrial to a postindustrial service- and cultural-products-driven economy.

First, as I described in Chapters 1 and 2, there is a long and entrenched history of associating black culture and black people with violence, lawlessness, and deviant sexuality. These associations have been fabricated to justify and maintain various forms of racialized and gendered oppression and inequality of black people throughout U.S. history. This history, although not necessarily in the forefront of citizens' consciousness today, is embedded in our collective unconscious and deployed within the rhetoric of race that is still in cultural and political circulation. This historical "common sense" reinforces and overly identifies black expressive culture such as rap with these tendencies.

Second, during the early part of the twentieth century, when mass entertainment became accessible, youth began to challenge aspects of traditional family-oriented leisure that previously determined youth socializing. Enhanced by the shift from family-based socializing

venues to mass entertainment venues, youth cultural spaces developed more freedoms to create, consume, and participate in a variety of music, dance, and other amusements away from direct adult supervision and in other social and cultural networks. This shift was also responsible for creating what is now considered a highly profitable market: youth culture. The anxiety that youth will be corrupted and that society will be undermined by sexuality and vice is fundamentally linked to modern society and the emergence of youth culture. Much of this anxiety is intertwined with fears about the influence of black culture on society as a whole.[1]

In the Jazz Age of the 1920s, young white middle-class urban residents who went into black, racially segregated neighborhoods to listen to jazz were cause for considerable concern among establishment religious and social leaders. The fears of moral decline resulting from race mixing and from the spread of black culture among whites were quite similar to the ones being expressed today, as were the general contours of the polarization between modernists (today called liberals) and traditionalists (conservatives) over this issue. Modernists were excited by the dynamic contributions that jazz was making to modern music and urban culture. Traditionalists, however, feared that decency and sexual morals would be destroyed by uncivilized and dangerous influences like the blues and jazz. And many publicly argued that black music would bring down society if allowed to "spread."[2] (Traditionalists registered similar concerns about allowing women to enter public drinking establishments and drove prohibition laws and other socially conservative agendas.) While not all of these fears revolved around black cultural influence, many did, and this parallel is worthy of note.

Third, some of the recent hyperbole about rap's role in bringing down civilization and corrupting youth morals involves a fear-based response to the vast changes in the U.S. economic, political, and social spheres over the past fifty or so years. These fears have been stirred up and misdirected by conservative political movements. Like the shift from an agrarian society to one dominated by industrial pro-

duction, which produced many tumultuous changes, the economic shift out of industrial production into a service, consumer-based economy caused a great deal of social and economic upheaval. This latter transition, from industrial to postindustrial economy—one heavily based on knowledge, information, and consumption rather than on production of material goods—resulted in high levels of unemployment in previously stable and profitable industries such as steel and other base-goods. It was exacerbated by anti-union policies that undermined unions and other vehicles of protection of labor, wages, and job stability for working families while the rising costs of living, healthcare, and childcare were unfunded by the government and passed on to workers. These changes in economic direction reduced the value of living wages for many families. All of this has had a profound impact on workers' stability and sense of security. In keeping with the long history of moral panics, the fears and uncertainty these changes produced have been channeled away from structural conditions and toward a corruption of morals, especially as imagined by the influences of black music and culture.

The increasing attempts among far-right commentators to connect hip hop to Islamic terrorism and nonwhite hostility to Western society reiterate a legacy linking fear of infiltration, decline of society, and economic insecurity to black culture. Lorenzo Vidino, writing for the *Terrorism Monitor*, makes these presumed connections crystal clear:

Many young, often European-born Muslims feel a disturbingly intense sense of detachment from, if not sheer hatred for, their host societies and embrace various antagonistic messages. . . . Many youngsters from the Muslim-majority ghettoes of various European cities adopt several behaviors typical of Western street culture, such as dressing like rappers, smoking marijuana and drinking alcohol, yet watching jihad videos and having pictures of Osama bin Laden on the display of their cell phones. Any individual who attacks mainstream society becomes a hero to these teens, be it Abu Musab al-Zarquawi or the late American rapper Tupac Shakur.[3]

Fourth, social movements in the 1960s and 1970s contributed to this extended period of tumult and challenged normalized forms of gender, class, racial, and sexual inequalities and discriminatory laws and customs. As crucial as such challenges are to improving democracy, they often serve as fodder for traditionalists who overly emphasize the value of order above all else and rely on a nostalgic and conservative view of the past to undermine the necessity of the unrest that making such changes entails. Challenges to unjust social arrangements that threaten the American values of equality and democracy are often misinterpreted as negative forces rather than as agents for the advance of the democratic promise. Thus, even socially conscious rap and its constant attention to festering injustices can be interpreted as creating instability rather than revealing its source. I am thinking here of rhymes such as "the white unemployment rate is nearly more than triple for black" and "sixty-nine billion in the last twenty years spent on national defense but folks still live in fear," from Mos Def's powerful and funky song "Mathematics" (*Black on Both Sides*, Priority Records, 1999).

During the 1960s and 1970s, many thousands of women and people of color, whose social, political, and economic contributions were undervalued, took great risks to further the necessary and long-overdue extensions of the democratic promise to all citizens. These changes were wrought by the courageous citizens who participated in the civil rights movement, the antiwar movement, the labor movement, and the women's and gay rights movements. These movements attempted to bring the American values of egalitarianism, genuine equal opportunity, inclusion, access to financial and social resources, and justice into full practice both here and abroad.

The social movements to end racial, gender, and other forms of institutionalized discrimination contributed to the transformation of social norms and workplace relationships, especially inasmuch as whiteness and heterosexual masculinity were no longer automatically given gender and racial protections and advantages. These changes also called for the inclusion of the collective experiences of women, people of color, workers, religious minorities, and gays and lesbians in

our national memory and educational institutions. Expansion and re-
vision of our historical sense of self shed previously extinguished light
and fire on the injustices maintained by violent repression, marginal-
ization, and dehumanization. They helped pave the way for demo-
cratic improvement. Yet these changes were resisted, and racial, class,
and gender privileges were protected by traditionalists who under-
mined efforts to transform public- and private-sphere relations and op-
portunity. This contributed, for some, to further feelings of insecurity
and upheaval in American society over the past fifty years. For others,
it has been a sign of real democratic possibility, an example of the best
of American citizens' investment in democracy and in America itself.

A central element in the attacks on such democratic expansion is
the devaluing and marginalizing of alternative and resistive cultural
expressions, especially those that have received some form of institu-
tional legitimization. Writing in the *National Review*, Candace de
Russy offers a disdainful rejection of hip hop in terms that reiterate
both the fear of diseased invasion associated with black popular ex-
pression and the need to de-legitimate it in the interests of intellec-
tual and national security:

> Higher education's elevation of pop culture and transmission to youth
> of all things countercultural (hip hop and rap, nihilism, etc.) as seri-
> ous "study" can only be fueling the growth of this cancerous subcul-
> ture. Analysis of cross-cultural, cyberspace-influenced trends should
> focus more on the influence of Western higher education on world-
> wide jihad networks.[4]

This argument basically contends that studying how youth music re-
sponds to conditions in society—as opposed to the reality of injustice
and discrimination themselves—encourages unrest and conflict and
threatens national security, thus contributing to the destruction of
American values and society.

Despite the many successes of the social movements, visible con-
servative attacks on their cultural gains (such as expansion of the edu-
cational curriculum) belie the maintenance of long-standing societal

structures, such as high levels of economic consolidation and power among the few. Wealth (defined as the value of everything a person or family owns, minus any debts) has always been highly concentrated in the hands of a very few at the top, but over the past forty years it has increased to what can only be considered indecent levels. In fact, the wealthiest people were able to augment their share of the wealth immediately following those times when efforts to create more egalitarian access were at their most intense. For example, in 1976, a year when all of the above-mentioned movements were making meaningful strides in the interests of justice and equity, the richest 1 percent of the citizenry commanded 19.9 percent of the overall wealth of the nation. Any gains in equity were short lived, especially in relation to wealth. By 1998, that same 1 percent controlled 38 percent of the wealth, insulating themselves from changes designed to ensure fairness and real economic justice for the average American citizen. This insulation was provided by laws and government supports that favored the hoarding of resources among the wealthy and large corporations and encouraged the repression of wages for the 80 percent of the population who, in 2001, shared only 16 percent of the national wealth.

This grossly imbalanced system, especially the gargantuan tax loopholes that have been continually widened for the wealthiest people, left middle-class workers with an unfair burden. Indeed, those 80 percent who share only 16 percent of the national wealth have disproportionately carried the costs associated with making democracy work for all. Tax shelters and loopholes allow those who can most easily afford it to avoid paying the taxes that support programs that help ensure equal pay for women; prevent racial and sexual discrimination at work and in housing; provide aid to the poor, the elderly, and veterans; and level the highly unlevel playing field for blacks and other people of color. As of 2000, net worth differences based on race remained staggering: The median net worth of white households was $79,400, while that of Hispanic and black households was $9,750 and $7,500, respectively. Similarly, women, who in 1964 (the year of the Civil Rights Act, which banned workplace dis-

crimination based on race or sex) earned only 59.1 cents on the dollar compared to men, continued to lag behind by 23.1 percent in 2006, earning only 76.9 percent of what men earn.[5]

Given these numbers it seems logical that much of our conversation should revolve around how to reduce clear markers of structural inequality and injustice rather than how to modify cultural values or sexual behaviors. But anxiety about feeling as though one has little personal control over the broadest contours of one's life fuels both denial over massive gender, class, and racial differences and an effort to view these differences as a matter of personal behavior rather than structural discrimination. In many ways, rappers like Mos Def serve as a constant unwelcome reminder of these buried but familiar facts. Crafting rappers as a cause of the demise of American values instead of seeing them as a reflection of the betrayal of America's promise temporarily relieves the anxiety and justifies status and privileges for those who have been awarded the longer end of the social and economic stick.

Fifth, the shift from a society of industrial production to one of service and information technology dramatically expanded the cultural products–based aspect of the U.S. economy, making culture one of America's primary products at home and abroad. An expansion of the cultural products arena, along with the emergence of multiple niche markets, gave cultural expressions greater visibility, and corporate interests' efforts to cash in on music, style, and other youth-culture trends escalated and intensified. This shift also mainstreamed black youth culture, which, up until the late 1980s, was a marginalized facet of mainstream American youth culture. Black music and style have had disproportionate and expansive audiences throughout the twentieth century, but until the last fifteen to twenty years, the latest black youth expressions were not given such extended prime-time coverage or marketing attention. During the 1990s, black youth culture, especially hip hop, became an important mainstream fixture in the record and other youth-culture industries. This centering of black youth culture helped fan the flames of the American-values moral panic because it imparted

greater influence to a cultural form considered part of the threat to mainstream society.

Cultural outrage over a sense that things are out of control often accompanies periods of larger economic and social change; during these times especially, culture, race, sexuality, and challenges to traditional family formation serve as easy scapegoats. The sphere of sexuality is especially vulnerable to moral panics. As Marvin M. Ellison, author of *Erotic Justice*, points out: "[A]lthough fears about the disappearance of marriage and family are largely unfounded, anxiety persists in a time of rapid social change. . . . Moral panics, whether focused explicitly on family or on sex and eroticism, gain momentum by associating sexuality with disorder, filth, disease and danger."[6]

These larger social conditions, economic forces, and entrenched racial stereotypes not only fueled the corporate growth of hip hop but also helped usher in the decline in the depth and range of its expression. In the throes of these conditions, the most violent, sexist, and stereotypical images and stories began to outsell all other kinds of rap music, making what some call "gangsta rap" the most profitable sector of the genre. As Jeffery Ogbar notes, "Many consumers know of Mos Def, Common, and Talib Kweli, who have all gotten moderate exposure in hip hop magazines, though none has gone platinum. Though not the darlings of the Northeast-based hip hop magazines, Chamillionaire, Trick Daddy, and Three 6 Mafia have all gone platinum with the help of droves of eager black consumers."[7] Given the extent of chronic joblessness, poverty, and community dismantling and abandonment described in Chapter 1, it should come as little surprise that so many rappers signed up to tell tales of street crime and gangs. In many ways, gangsta rap music is a postindustrial black culture industry with job openings and a chance for upward mobility.

"Family values" rhetoric also emerged in the 1990s, helping to galvanize inchoate beliefs—eliciting a fear response from these larger structural changes—that a patriarchal, two-parent (only heterosexual), and "decent" family would somehow restore order and create a sense of stability for society. Virtually all social problems for which there is ample structural cause—high levels of unemployment, edu-

cational failures, racism, gender inequality, drug addiction, consequences related to high concentrations of poverty (e.g., street-based crime and homelessness)—were reconfigured as personal behavioral problems capable of resolution through the application of stronger "family values." These were not neutral family values; they were family values based on an authoritarian-father model that emphasized discipline, punishment, and personal responsibility. Structural conditions that shape behavior as well as alternatives to punishment (such as rehabilitation) were considered excuses that undermined discipline and authority and were nearly erased from the palette of public discussion. And commercial hip hop, which began emphasizing and sometimes celebrating anti–law and order values and nonstate-authorized violence, became a valuable target to reinforce this vision of family values as national policy.

The politically conservative campaign to define an American value system has been successful in galvanizing the efforts of those who believe in socially conservative values and the elevation of some values over others, such as discipline and self-reliance. As many liberal and progressive writers have argued, values such as equality, fairness, and justice are also bedrocks of the American value system. Linguist George Lakoff has argued that both conservative and liberal value systems have moral foundations, so this isn't about morality versus immorality, despite what conservative pundits often suggest. Rather, it is about competing national conceptualizations that revolve around different visions of family formations. The centrality of how we envision an ideal family shapes our political values. Conservative political values are based on what Lakoff calls a "strict-father model," which emphasizes discipline, punishment, protection, authority, individualism, and one-way/top-down communication. By contrast, liberal and progressive political values stem from a "nurturant-parent model," which emphasizes freedom, compassion, fairness, trust, community-building, and open, two-way communication.[8]

The success of conservatives' version of what constitutes morality is partly due to liberals' failure to embrace and promote a moral and emotional language on behalf of liberal values. Lakoff contends that

explicit moral and emotional language is key to connecting with the proponents of these values. After such seemingly debatable terms as "family values," "decency," and "morality" were claimed and reinforced by conservative values, what alternative version could easily stand in direct opposition to them? Who wants to stand up for *inde-cency*? Or *immorality*? Who wants to appear to be against the family? By claiming the terrain of the family, a central organizing metaphor for all political discourse in the United States, conservatives elevated their vision of the family—the strict-father model—to the ideal national standard, thereby creating a fiction that it is equivalent to all family values. This, Lakoff claims, is a case of framing: "The words draw you into their worldview. That is what framing is about."[9]

This conservative framing colonized the definition of ideal family forms and helped stymie opposition to confining, punitive, and authoritarian definitions of proper families, decency, and morality. Over the past thirty years, such framing also overdetermined the conservative direction of visible criticism of hip hop and shaped the progressive silences that surrounded it, even when many progressives were troubled (for their own reasons) by some of the politics in commercial hip hop. For example, when a rap lyric reflected values that liberals or progressives might consider unjust—such as those related to hustling vulnerable people for personal profit—but also used what conservatives might consider "indecent" language to describe said hustling, the "indecent" argument was more easily folded into an already energized American family values movement that could reiterate its blanket rejection of hip hop. Liberals, on the other hand, were reluctant to render progressive criticism of rappers who engaged in unjust anti-community forms of predatory behaviors, because to do so would appear to energize the already stoked conservative engines of punishment and authoritarianism (e.g., more police, more jails, longer sentences) that are in full force, especially in black communities. Too many hip hop critics with progressive values were left trying to draw important distinctions between types of politics in hip hop; focusing on racial inequality as the only identifiable progressive value, they wound up looking as though they were splitting hairs and

making excuses. Yet a sufficiently decisive indictment of rap's worst kind of attacks on the black community itself could not be offered on progressive terms. In short, the conservative family values frame became the dominant lens through which nearly all criticism of hip hop is filtered.

The irony of this values-based battle in the hip hop wars is that, despite the blanket rejection of hip hop by most conservative pundits and the frequent defenses by liberals, commercial hip hop actually reflects and rejects both liberal and conservative values. This unexpected rejection of both sets of values combined with the emulation of portions of each has added to the confusion besetting the hip hop wars and has produced a significant divide among hip hop fans.

Hip hop is known for embracing certain "strict-father"-based conservative values, such as a patriarchal, aggressive, sometimes violent masculinity; and priority is given to individualism and personal success over community empowerment. But hip hop politics also broadly embraces three liberal, progressive ideas: a general language of justice-based politics, especially regarding antiracism; freedom of expression; and community-building and service to the community.

Although conservative values proponents sometimes talk about violence as if it is some kind of external threat to American society, violent behavior is, in fact, at the heart of the American value system and has been for some time. Throughout the twentieth century especially, violence was wedded to mainstream visions of manhood. And, more recently, celebrated forms of masculinity have become increasingly empowered by the use of aggression and violence, as a primary means not only of settling conflicts but also of establishing economic dominance, maintaining control over women, and disciplining children. The pro-violence, celebratory air associated with military action and action heroes and the fascination with mobsters and other American gangsters, hunting, and the regulated violence that fuels boxing, football, and hockey have saturated American culture. In every case, these expressions of American values celebrate the male who is able and willing to challenge others to battle and be entirely prepared to act violently. As Michael Eric Dyson has noted, "In fact,

national self-expression and violent masculinity are virtually con-
comitant; they came about at the same time, and they often mean
the same thing. In the history of the American social imagination the
violent male, using the gun to defend his kith and kin, becomes a
symbol of virtuous and redemptive manhood."[10]

The symbolic resonance of Hollywood-action-hero-turned-
Republican-governor-of-California Arnold Schwarzenegger's re-
peated use of the term "girlie men" to deride opponents—nearly
making it a Republican battle cry—epitomizes the links between
manhood, sexism, homophobia, and machismo. Schwarzenegger
used the phrase in 1988 to deride Democratic opponents of George
W. Bush, repeated it during the 1992 election, and employed it in
2004 to challenge opponents to show their courage and then to char-
acterize opponents in the California state legislature. What is the
substantive difference between rappers' use of rhymes about men
who are called "bitches" to signal male opponents' inferior masculin-
ity and their own superior masculinity, on the one hand, and conser-
vatives' embrace of Governor Schwarzenegger's use of "girlie men,"
on the other? Rappers' aggressive, sexist, and confrontational style of
masculinity reflects a core American value, not an aberration of one.

Another conservative value embraced by commercially powerful
artists and moguls in hip hop is the focus on individual and financial
success. Hip hop has generated some of the most extraordinary exam-
ples of entrepreneurial energy, of pulling oneself up by the proverbial
bootstraps, in recent times. Hip hop moguls such as Russell Sim-
mons, Master P, P. Diddy, Damon Dash, and Jay-Z have used their
considerable business instincts to create individual empires with sub-
stantial accumulations of wealth through hip hop. Unlike many oth-
ers who have such wealth and business power, these men began with
nearly nothing—virtually no money, little education, a lack of early
access to high-level financial mentorship—and created veritable cul-
tural empires. In the conservatively valued standard of personal suc-
cess and entrepreneurial spirit, these men should be lauded. Since
few businessmen or corporate success stories emphasize liberal values
concerned with how such money was made and what impact personal

accumulations of wealth have on an already hyper-privatized model of wealth hoarding, these men should be celebrated. When rappers apply very similar strategies of success that define the often ruthless models of American capitalism (which, in itself, is frequently offset by well-publicized philanthropy), they are viewed as threats, not as proponents of such American values as hard work, enterprise, and self-sufficiency. Not surprisingly, they defend themselves by adopting conservative values of personal success. Damon Dash, for example, has responded to critics by defending his hip hop–related business successes in fashion, alcohol, film, and music (including his visible promotion of gangsta rappers like Jim Jones), totaling hundreds of millions of dollars. Dash says: "[N]o one talks about the jobs we create, no one talks about the things we do within our community, and no one talks about the businesses we've done, how we've opened the doors and shown people that it's cool to be smart, it's cool to be a CEO. . . . I can't see how that could ever be considered a negative."[11]

In fact, if rappers are the threat to society's values that some conservatives claim they are, then record industry corporations that garner the vast majority of the profits generated by rappers' products should be the prime targets of conservative ire. Without them, there'd be no real threat at all. Instead, it seems that what really matters to conservatives who attack the influence rappers have earned via their entrepreneurial success is who belongs and who doesn't: If you are "in," then what you say in public overshadows what you do and what impact those actions have. As long as insiders present a "respectable" image (no matter the violence done on their watch), they can profit from and undermine democracy and even conservative values all they like.

Hip hop's association with progressive values is more easily seen, as many writers and critics have identified the legacy of justice-based lyrics and activism and community building in hip hop. Songs with lyrics about the effects of economic and racial oppression are highly respected elements in hip hop storytelling, although most of these songs are relegated to the commercial margins. Earlier hip hop giants like Public Enemy, Queen Latifah, and KRS-One are obvious

examples of the political roots of hip hop, but more current artists such as Mos Def, Talib Kweli, The Roots, Lupe Fiasco, Akrobatik, Zion I, The Coup, Jean Grae, and The Fugees are also known for creating highly political content focused on various forms of injustice. However, emphasis on injustice (a liberal value) does not preclude the embrace of "strict-father" patriarchal brands of masculinity (a conservative value) characterizing those who are willing to act violently in the name of justice and community protection.

Freedom generally, and especially freedom of expression, is commonly expressed among hip hop artists and defenders, revealing hop hop's strong liberal tendencies. Given that early efforts to censor rap music were directed against rappers who challenged unjust authority through stories of violence, the embrace of freedom was also a direct form of resistance to oppression. As stories of political resistance in hip hop gave way to far more commercially visible and celebrated stories of criminality, sexual domination, and black-on-black crime, the use of freedom of expression to defend hip hop began to contradict the liberal values of justice-based imperatives and community service for which it had been known.

As the quotes at the top of this chapter reveal, the success of conservative framing in the public sphere has encouraged a tendency to define rap and other "nihilistic" popular expressions as alien subcultures that threaten to "creep continually into our society." They are imagined as infiltrating forces—not as outgrowths of, participants in, or internal responses to society itself. Mainstream society is posited not only as a conservative one but also as one in little need of change and improvement. What kinds of traditions does this status-quo attitude preserve? The calls for maintaining law and order under conditions of grave inequality is a call to continue inequality, to normalize it. Is that the kind of "order" we want?

Contrary to the vision of hip hop as a dangerous outside influence, it profoundly reflects some of the most celebrated American values on both sides of the political divide. Hip hop's own internal battles over its future political trajectory represent some aspects of the battle in larger society over which American values will serve as the primary guides for

our national actions and agendas. Conservative value–based defenses of hip hop like Dash's that embrace any forms of capitalist entrepreneurship as models of success should be challenged by hip hop progressives just as vigorously as are conservative attacks. Will we allow capitalism that sells out the community to overshadow the justice-and-care imperatives that anchored black activism and once made America the beacon of democracy around the world? Will we allow fundamentalist politics to reinforce one vision of tradition and undermine the modern expansive, inclusive, and tolerant vision with which it competes? Will market capitalism's enticement to consume and discard continue to be lauded, or will hip hop reconnect more fully with its own legacy of commitment to the nonmarket values of sacrifice and common good?

A progressive hip hop response to the current tenor of the American values debate involves not only emphasizing other crucial American values for which hip hop is known, such as justice and striving for equality for all, but also redefining what we consider indecent, immoral, and violent. Sexist, homophobic, nonconsensual, exploitative sexual displays are indecent. Consensual, nonexploitative expressions of the wide range of human sexuality are decent. Hunger, abject poverty, and active aid in the redistribution upward of wealth, power, and security in a nation with the amount of resources America has at its disposal, while gutting efforts to create meaningful educational, social, and economic opportunity for all people, are indecent. Relying on and sanctioning violence, policing, incarceration, and military might as models for national policy and international relations are indecent and immoral. A powerful progressive emphasis on the destruction of foundational American values such as equality and justice has the potential not only to successfully respond to conservatives who use rappers as an easy target but also to challenge rappers to live up to the progressive values that highlight and work to change the unequal environment out of which hip hop has emerged.

5

Hip Hop Demeans Women

We've had people who've said they are going to wait us out. . . .
Well, my brothers and my sisters, they've got a long time to
wait. Nearly 15 years ago, Dr. C. Delores Tucker and the Na-
tional Congress of Black Women saw where this disrespect for
women, disrespect for Black people, saw where this was going
and decided then that enough was enough. . . . We've been get-
ting beaten up for 15 years. We've been getting talked about,
but we're still standing. We want you to throw your arms
around your pastor, because we know he's been getting a tough
time too. He's been getting threats just like we have. But I want
you to know, we can stand up to whatever goes on out there. I
want you to keep on coming every Saturday until they stop the
filthy talk, stop putting down Black people, stop putting down
Black women in particular.

—Attorney Dr. E. Faye Williams, president of the National
Congress of Black Women, "Protestors Picket Home of
BET President," www.FinalCall.com, October 26, 2007

As two of the so called "Nelly Protesters," we feel compelled to
speak after the egregious presentation of the Hip Hop vs.
America forum on BET. Though purportedly trying to redress
the sexism, misogyny, and materialism of hip hop videos, the
program actually reified all of these by not engaging with fem-
inist women panelists, or panelists that did not invoke a kind
of celebrity worship. Once again the voices of young black
women were marginalized in preference for a largely older
black male voice of authority. Even the women panelists were
talked over and addressed less.

—Moya Bailey and Leana Cabral, letter to BET CEO
Debra Lee, October 2, 2007

HIP HOP'S SEXISM IS VISIBLE, vulgar, aggressive, and popular. In 2003, Lil' Jon and the Eastside Boys scored a second-most-played song in the country with their song "Get Low." The hook for this bawdy sex song includes the following lines: " To the sweat drops down my balls (my balls) To all these bitches crawl (crawl) to all skeet skeet motherfucker (motherfucker)." "Skeet skeet" refers to ejacula-tion. 50 Cent collaborated with Snoop Dogg on his 2003 song "P.I.M.P." In it, Snoop Dogg's chorus explains how a "bitch" can't get anything from him and later raps, "yea bitch I got my now and later gators on, I'm bout to show you how my pimp hand is way strong." In one of 50 Cent's lines he brags, "see I was born to break a bitch." In 2005, the Ying Yang Twins' "Wait (The Whisper Song)," which dominated urban radio, included in its hook and chorus the following lines repeated several times: "Ay bitch! Wait til you see my dick. . . . I'm a beat that pussy up."

Given this, it should not be surprising that commercial hip hop has developed a large and growing anti-fan base. Clearly, the issue isn't *if* hip hop—as it has evolved in the commercial arena over the past dozen years or so—promotes sexist and demeaning images of black women as its bread-and-butter product. The fact of hip hop's primary trade in explicit and sustained sexist images cannot reason-ably be quibbled over (although some misguided defender of all things hip hop is surely working on crafting a defense). Instead, we are left with other questions and concerns about this hotly debated is-sue, ones that can reveal what we are really talking about when we talk about sexism in hip hop. Unfortunately, it isn't usually about sex-ual justice or gender equality for black women.

Those who take on sexism in hip hop can generally be divided into two broad groups: (a) those who use hip hop's sexism (and other ghetto-inspired imagery) as a means to cement and consolidate the perception of black deviance and inferiority and advance socially conservative and anti-feminist agendas; and (b) those liberals and progressives who are deeply concerned about the depths of the sexist imagery upon which much of hip hop relies, but who generally sup-

port and appreciate the music, and are working on behalf of black people, music, and culture.

Members of group (a) rarely speak about the need to prevent discrimination against black women, nor do they offer support of feminist agendas. Their goal has more to do with protecting America from hip hop and deviant black people. The issue of respect dominates this groups' rhetoric, not women's rights or the discriminatory nature of patriarchal culture. The disrespect shown to black women by some black men is, for them, a sign of insubordinate black masculinity and thus needs correction and containment. Group (b) members challenge misogyny against black women and perceive hip hop as a particularly pernicious homegrown version. They worry about the influence of hip hop's commercial vision of black women as sexual objects and how a constant diet of these images and stories might affect black communities.

The political differences between these two groups is not absolute, however. Although the language of disrespect, the emphasis on degradation of women (because it thumbs its nose at patriarchal men's role as protector of women), has roots in white conservatism, it also has solid roots in black religious and patriarchal conservative values. To further complicate matters, the long history of America's refusal to consider black women worthy of patriarchal protection and respect encouraged the development of a strand of black feminism that emphasized what Evelyn Brooks-Higginbotham has dubbed the "politics of respectability." This strategy was designed to counter the mainstream idea throughout all of the slavery era and well into the twentieth century that black women were sexually excessive and deviant as a class of women. Black female resistance to this perception encouraged a culture of black female sexual repression and propriety as a necessary component of racial uplift.[1]

The intertwined strands of these disparate agendas and motivations play themselves out in today's wars over hip hop, and the overlap between these two groups' positions on sexually degrading images in the music has increased as criticism of and public protests against

commercial hip hop have significantly escalated and broadened. Sometimes this is the result of unlikely collaborations; at other times conservative critics attempt to co-opt progressive agendas. For example, conservative writer Myrna Blyth—whose own book, *Spin Sisters: How the Women of the Media Sell Unhappiness and Liberalism to the Women of America*, attacks what she considers the negative impact of liberal media women's spin—spins *Essence* magazine's progressive challenge to sexism in hip hop into a conservative one. Writing in the *National Review*, she applauds their "Take Back the Music Campaign," saying: "When I told Michaela [a campaign representative] that *Essence* was to be commended for expressing a very appropriate—and conservative—point of view, she didn't want to agree." Attempts, such as this one, to reframe progressive concern have combined with the need for collaborative activism to tackle the brazen racial brand of anti-black female sexism and have thereby given conservative language greater visibility and traction.[2]

R.E.S.P.E.C.T.—But Not the Kind Aretha Franklin Had in Mind

Tonight I propose a three-year [faith-based] initiative to help organizations keep young people out of gangs, and show young men an ideal of manhood that respects women and rejects violence.

—President George W. Bush, State of the Union Address, February 3, 2005

Why do we as a nation produce and embrace a pop culture that glorifies rap and hip hop music that teaches men to prey upon women and engage in senseless violence and that is now, according to the Kaiser Family Foundation's recent survey on media and youth, the number one music choice of teenagers from all racial backgrounds and socio-economic status? . . . Mind you, I'm not advocating government censorship, but rather pleading for social and parental rejection to replace the

current proliferation and acceptance of such barbaric and de-
structive messages.

—Rebecca Hagelin, a vice-president of
The Heritage Foundation, "Throwing Out the Thugs,"
www.heritage.org, September 6, 2005

DISCOURAGE MEN from preying upon women. Show young men, especially those in gangs, an ideal of manhood that respects women. On their face, these seem to be reasonable goals, desirable even. Who wants the preying of men on women or the disrespect of women to be considered positive signs of male identity? But to properly address the issue of male disrespect we must ask: Where does this problem come from? Many, like Hagelin (quoted above), suggest that hip hop's predatory treatment of women and related street gang culture are somehow a return to a long-ago barbaric stage of precivilization. In fact, her article (which is actually about the New Orleans social crisis that took place in the aftermath of Katrina) opens with the example of heroic civility and honor associated with men on the sinking *Titanic* in 1912. She claims that these men, who called for the rescue of "Women and Children First" (her opening line), were more interested in civility and honor—in "protecting" women and children—than in their own survival. She then argues that the acts of lawlessness exhibited after Katrina hit (as contrasted with the heroism of the white middle-class men on the *Titanic*) were due to the negative way of life sponsored by gangsta rap. If Katrina had "occurred in a culture that had daily practiced the Golden Rule," she says, "rather than the Gangsta Rot, we would have seen more scenes of neighbors helping neighbors."

Far too often, critics suggest that vulgar disrespect of women in hip hop is part of a larger decline in American society, as if things were better "before" when society was more "civilized." This is the basic argument in the article by Hagelin. Let's reframe this imaginary respectful, civilized masculinity a bit. In 1912, the year when the *Titanic* sunk and men apparently expressed their chivalry and respect

for women, women could not yet vote. (Women's permanent right to vote was granted in 1920; black men's right to vote was granted at the time of their Emancipation from slavery, but was almost entirely thwarted.) Women suffragists' efforts to secure women's right to vote was a long and difficult battle against which many men, and some women, fought. (And I am referring only to white women's voting rights, as all black people's voting rights were being denied throughout this era and for many decades beyond it.) Is this how we want to show our respect for women? Bush (also quoted above) similarly suggests that gang-invested kids are operating outside the bounds of acceptable male American culture that "respects" women. The problem with statements of this kind is that they imply that hip hop and young black men represent the decline of civility, honor, and good manhood.

Both of these comments and many others like them rely on the fiction that American mainstream models of masculinity are nonviolent, "respect" women, and reflect a history of civility, honor, and justice. This is, of course, a widely held fiction that denies the fact that mainstream ideals of masculinity have consistently celebrated male violence as a necessary means for conflict resolution. Despite important improvements in gender equality, mainstream masculinity continues to treat women as fundamentally less valuable than men (albeit worthy of protection as an expression of male responsibility and power); keeps women less powerful in social, economic, and political arenas; and tries to control, label, and, at times, exploit women's sexuality. It assumes that men should rightly be the primary leaders of their families and of society at large. These kinds of male dominance in all the important arenas of society are what add up to that dreaded term: "patriarchy." Patriarchal mainstream masculinity is what we have inherited and continue to treat as ideal.

It is true that the bulk of commercial hip hop images and lyrics treat black women with disrespect and contempt—so these framing words are not entirely wrong. This is why they resonate across the political spectrum, but also why using them is so dangerous. Phrases like "respecting women" and "fighting degradation and filth" are key

elements of the conservative framing language that undermines progressive politics and diverse, empowering, feminist representations of black women. Think of the situation in reverse: Lyrics and images that show respect—that elevate black women instead of demeaning them—do not ensure gender equity, or empowerment. In fact, respectful, elevating images and phrases remain a central means by which black women's complicit subordination to respectful patriarchal power has been secured: "be respectable," "stand by your man," "look pretty," "be modest," and so on. Respect for women is part of an exchange that rewards women who follow these rules. It is distinct from, say, the need to show respect for all people. So, respecting women, in this worldview, has nothing to do with advocating and respecting women's full equality or encouraging challenges to a society organized around male power and privilege. Indeed, this call for "respect" is a Trojan horse, in that it undermines what real respect for women requires: an active commitment to women's equality and gender justice.

The most visible representations of black women in hip hop reflect the hallmarks of mainstream masculinity: They regularly use women as props that boost male egos, treat women's bodies as sexual objects, and divide women into groups that are worthy of protection and respect and those that are not. Thus, hip hop does not break from the fundamental logic of mainstream masculinity so much as convey it with excess, bravado, and extra insult. The depths of disrespect and sexual vulgarity in hip hop seem a category away from this chivalrous mainstream ideal that Bush wants our faith-based leaders to instill in young men. In fact, though, as long as patriarchal definitions of mainstream masculinity are embraced, we will continue to produce both the polite and insidious expressions of gender inequality and sexism that we currently hear *and* the excessive margins where these ideas are most harshly represented, as in hip hop.

American popular culture, along with most of the mainstream political and religious leadership, continues to reflect a deep investment in many of these long-standing male-dominant, sexist facets of ideal manhood; the intertwining of religious, moral, social, and political

means controlling women continues along traditional lines but today looks quite different. Visible religious leaders in black communities are getting on the "respect"-black-women bandwagon and, given the absence of any commentary on the distinctive ways that black women are discriminated against, confirm a polite form of control and domination of women and male authority along with it. So, while Jesse Jackson and Al Sharpton properly challenge the constant peddling of corporate-sponsored "disrespect" of black women, this protest does not generally include a black feminist analysis. Nor does it properly attack other, equally significant places where black women and men are regularly indoctrinated in male-dominant (female-subordinate) ideals. As Michael Dyson has pointed out so eloquently:

> So that's when I mentioned to my friends, Reverends Jesse Jackson and Al Sharpton, instead of in the aftermath of Imus, protesting record companies, how about smashing the sermons of some of those preachers who stand up in church on Sunday mornings in Black America. 75–80 percent of those churches are attended by black women, the minister is not calling them the b-word or the h[-word] or a skeezer or a slut, but he is reinforcing a gospel that subordinates them to the interest of men and therefore he is much more seductive, he's got a bigger pulpit, he's got a bigger platform, and he's got god on his side.[3]

Protests against the "disrespect" of black women rightly suggest that the major record labels are primarily responsible for peddling, promoting, and profiting from hip hop images and lyrics. This is largely true: Although these companies often set limits on what they will distribute, they don't seem all that interested in doing so when it comes to the troubling, mean-spirited, and sexist representation of black women. During a Manhattan rally in May 2007, Al Sharpton pointed out this contradiction: "We're not asking for censorship. But there is a standard in this business. They have a standard. They had a standard that said Ice-T can't rap against police. They had a standard that said you can't rap against gays, and you shouldn't. They had a

standard against Michael Jackson saying something anti-Semitic. Where is the standard against 'n—,' 'ho' and 'b—h'?"[4]

The attacks made on corporations often leave out the fact that artists, especially the very powerful ones, are generating and happily spewing these images and ideas, and millions of Americans are buying them. So, it's compelling for protestors and leaders such as Dr. Faye Williams to say that they'll "keep on coming every Saturday until they stop the filthy talk, stop putting down Black people, stop putting down Black women in particular." But the erasure of these images won't address the long-standing, day-to-day normalcy of sexism in black communities that fuels some rappers' attitudes and lyrics. After all, gangsta rap isn't just a corporate fantasy, nor did it create sexism in the black community. Creating systemic change means implementing a progressive racial, gender, and sexual justice project in schools, in churches, and in the mass media.

Despite the appearance of what seems like proper outrage about women being disrespected, far too much of the criticism coming from those who have gotten on the anti–hip hop bandwagon completely avoids any larger analysis of how gender and racial inequalities affect black women in particular. It's as if one is saying: Once imagery and music are "respectful," order will be restored. Few are making the connection between the entrenched forms of polite sexism and acceptable patriarchy being touted by most religious figures and most middle-class leaders.

But there are important exceptions. I am especially happy to see progressive ministers who are joining with various groups to protest what has happened to hip hop. The "Enough Is Enough" campaign, led by Revered Delman Coates, pastor of Mt. Ennon Baptist Church, has resorted to picketing the home of BET CEO Debra Lee and the New York corporate offices of Viacom, primarily because less-public challenges and concerns had been deflected. Coates has invited people from across the political spectrum to join his group, and he has carefully crafted his criticism to avoid an anti–hip hop, anti–black youth message. During the protests he organized outside the January 2008 BET Honors awards show, he explained his agenda: "We are

here to protest the corporate sponsorship of messages and images that degrade Black and Latina women, images and messages that glorify drugs and criminal activity and that negatively stereotype black and Latino men as pimps, gangsters and thugs. I want to be clear: our campaign is not an anti–hip hop campaign. I grew up on hip hop. This campaign is about those elements of commercial rap which I distinguish from hip hop. Those elements that we deem, as a community, offensive. . . . What we are fighting for is the fundamental equality of black people in the public square."[5]

Public, coalition-based challenges such as this one are vital and growing. However, the urge to rely on existing and media-friendly conservative framing language has the potential to solve one problem but reinforce another. Conservative language about women needing to be respected as part of a larger patriarchal agenda needs to be re-framed so as to highlight women's agency, fight sexism against black women, and promote the need for human respect. Progressive protest must develop clear, anti-sexist, gender-equality language about sexism in hip hop. Otherwise, we will continue to deny the ways that sexism is lived beyond media images, and we will trade a degrading form of male power over women for a "respectful" one.

Explicit Isn't Always Exploitative

Far too often, charges of "filth" and "degradation" draw no distinctions between sexist forms of degrading sexual culture and sexually explicit culture. In fact, too much of the rhetoric against sexism in hip hop ends up being very compatible with an anti-sexual-expression agenda, one that associates any and all explicit sexuality with filth and immoral-ity. The level of sexual insult found in much hip hop makes this slope toward an anti-sex agenda even more slippery. Yes, we should protest sexually degrading imagery, but when pro-sex and sexual-agency lan-guage is not advanced in its place, then the whole arena of sexuality (especially outside marriage and beyond its role in procreation) faces the threat of being painted with a shameful, dirty brush. This places women's own sexual freedom and autonomy at stake.

Once the issue of sexism is married to "filth" and "degradation," women's ability to deploy empowering but sexually explicit language in their own way, as a form of resistance to sexism itself, is endangered. Sarah Jones, a black feminist performance artist and poet, wrote a powerful song—"Your Revolution"—that directly criticizes the sexist portrayal of black women in hip hop by using common phrases from some of hip hop's more sexist lyrics in reverse. For example, she says: "your revolution will not be you smackin' it up, flippin' it, or rubbin' it down, nor will it take you downtown or humping around . . . because that revolution will not happen between these thighs." This is as a clear statement of women's sexual empowerment.

In response to the 1999 airing of her song on KBOO, a radio station in Portland, Oregon, the FCC issued the station a $7,000 fine. Only her song and one by Eminem received this fine, and only her song made the FCC's final list of songs deemed offensive. Their notice said: "The rap song, 'Your Revolution,' contains unmistakable patently offensive sexual references. . . . [T]he sexual references appear to be designed to pander and shock."[6] Two years later, the decision was revoked and the fine rescinded. But what message did the earlier notice send? What effect did it have on black women's ability to respond to a constant barrage of sexist lyrics designed to dominate, to respond in a way that claims the sexual arena rather than rejects it? This wasn't just a matter of free speech; it was, given the incredible range of explicit and sexist sexuality expressed by men and women in American commercial culture, a direct attack on independent, feminist sexual empowerment cloaked under the language of "decency."

Explicitness isn't always exploitative, but it sure can be. Not all black women's sexually explicit material is feminist, anti-patriarchal, or empowering. In fact, the women who have been elevated as mainstream commercial rappers over the past ten years generally follow the larger pattern of hypersexualized, objectified terms reserved for black women in the genre. Highly visible rappers like Lil' Kim, Trina, and Foxy Brown use the black female–required sex card in hip hop; their stories of so-called sexual power generate from using their sexuality as the basis for their image. That in itself

is part of the very trap they claim to have escaped. Kim herself admitted that she uses her identity as Lil' Kim to get money, "a character I use to sell my records."[7] Yet even when such performers seem to be expressing women's sexual power, they use sexually exploitative images and stories and sexually dominating personas similar to those expressed by many male rappers. They are hustlers instead of victims, but the male-empowering terms of hustling, victimizing, and sexual domination as legitimate power remain intact. And they also rely on and promote male sexual fantasy–based images of women as sexually voracious and talented in their ability to please men. In the 2003 duet Lil' Kim performed with 50 Cent, "Magic Stick" (a song that reached the number-two position on the Billboard Hot 100 list that year), she says she can "sex a nigga so good, he gotta tell his boys." Don't challenge her skills, she brags, "cause my head game have you head over heels, give a nigga the chills, have him pay my bills." Even less sexually self-exploitative women artists like Missy Elliot and Eve have had to figure out how to embody forms of femininity empowered by masculine standards in order to express their power. Given the highly marginal place that black women rappers have been given throughout the past decade, it is completely understandable why those who survived the commercial demands have relied on the product reserved especially for black women: sexual excess.

"Free the Girls": Hip Hop's Betrayal of Black Women

My daughter can't know that hip-hop and I have loved harder and fallen out further than I have with any man I've ever known. That my decision to end our love affair had come only after years of disappointment and punishing abuse. After I could no longer sacrifice my self-esteem or that of my two daughters on an altar of dope beats and tight rhymes.

—Lonnae O'Neal Parker, "Why I Gave Up On Hip Hop," www.washingtonpost.com, October 15, 2006

*I guess I just try not to listen to the words; I just want to have
fun come the weekend. I don't want to get into all of that [what
the words are about], so I just try to block it out. I know it's not
good though.*

 —Latina student in my college class on hip hop music
 and culture, October 2007

*I don't even listen to contemporary hip hop anymore. My col-
lection ends, like, about ten years ago.*

 —Black female student in my college class on hip hop
 music and culture, October 2007

*In the office we were all grumbling about this. We kept saying
it has to change but it is not going to change on its own. We
have to do something about this.*

 —Michaela Angela Davis, editor-in-chief of *Honey*
 Magazine and founding committee member and
 spokesperson for *Essence* magazine's Take Back the
 Music Campaign, www.nysun.com/article/7604, January
 12, 2005

*We are tired of trying to defend hip hop when it becomes inde-
fensible. We are tired of hearing music that assaults our very
humanity.*

 —Moya Bailey and Leana Cabral, letter to BET CEO
 Debra Lee, October 2, 2007

ON THE MARGINS of the public outrage over the images and mes-
sages about black women in hip hop are fans, progressives, and femi-
nists who support the music and its less destructive elements and
artists, but who are hurt, angry, and worried over the constant por-
trayal of black women as objects of male sexual use in what has be-
come the most visible of venues. The particular perspective from
which these women make their critique often gets lost in the public
discussion on sexism in hip hop.

Progressive writers, scholars, activists, journalists, fans, and stu-
dents have been making noise about the increasing number of sexist

portrayals of black women in hip hop, drawing attention to the fact that these images have escalated with every year that rap's audience has grown, along with corporate interest and control. Others challenge the artists directly, asking why—since these artists claim to represent black youth—black women are so terribly portrayed. Even some black women who have been listening to hip hop since its early years feel betrayed by the hip hop of today.

Some say that they have to let it go, likening it to a love affair gone bad. Lonnae O'Neal Parker's quote at the outset of the section relies on this powerful metaphor. Joan Morgan, journalist and author of *When Chickenheads Come Home to Roost*, also poignantly equates her love of hip hop, despite its increasingly misogynist attitude, to that of women who stay in abusive relationships:

> *So I tell them how good you do that thing you do. Laugh and say I'm just a slave to your rhythms. Then I wax poetic about your artistic brilliance and the voice (albeit predominantly male) you give an embattled, pained nation. And then I assure them that I call you out on all of your sexism on the regular. That works until someone, usually a sistafriend, calls me out and says that while all of that was valid that none of it explains why I stayed in an obviously abusive relationship. And I can't lie Boo, that would stress me. 'Cuz my answers would start sounding like those battered women I write about.*[8]

Another pioneering black female journalist, Dream Hampton, has written a poignant article on the limited future for empowered women in hip hop. Hampton, too, identifies with the sense of pain that is too often generated by hip hop. Like O'Neal Parker, she comes to it through watching her daughter. In an essay titled "Free the Girls: Or Why I Really Don't Believe There's Much of a Future for Hip Hop, Let Alone Women in Hip Hop," Hampton relays this exchange she had with her daughter while passing by someone loudly playing an uncensored version of an x-rated song by Ludacris:

"They're hurting me, Mommy," my daughter yells dramatically. "I know baby, sometimes a lot of bass in the music make your chest hurt, like it's stretching."

"No," she insists. "They're hurting my feelings."

I want to tell her all the ways hip hop has made me feel powerful. How it gave my generation a voice, a context, how we shifted the pop culture paradigm. How sometimes it's a good thing to appear brave and fearless, even if it's just posturing. I want to suggest that maybe these rhymes about licking each other's asses are liberating. But I can't.[9]

The pressure young black women feel to defend black men against racist attacks, even at their own expense, is a new variation on the centuries-old standard for black women's race loyalty. This community-wide standard—which asks women to take the hit (metaphorically and literally), to be content with dynamics in which they sacrifice themselves and care for others' interests over their own—mimics the terms of an abusive relationship. As bell hooks has pointedly re-minded us, although we should avoid demonizing black males, "[b]lack females must not be duped into supporting shit that hurts us under the guise of standing beside our men. If black men are betray-ing us through acts of male violence, we save ourselves and the race by resisting."[10]

More and more progressive women such as these are acknowledg-ing that they have to break their silence and are rewriting the terms of the necessary criticism hip hop must face. In fact, Michaela angela Davis has begun some of her workshops on Essence magazine's "Take Back the Music Campaign" by apologizing to black women for wit-nessing the extended assault on them in the music but doing nothing about it. In doing so she shows solidarity with black women but also acknowledges that women who have loved hip hop have an impor-tant leadership role. They can and will set new terms for these attacks on black women, offering direction, protection, and affirma-tion to young women and men who have come up in the hip hop we have today.

The public battle over hip hop, characterized by the foaming-at-the-mouth "outrage" and corresponding defensiveness that are so prevalent in today's media, keeps these powerful, smart, well-informed black women on the margins of the conversation. In this climate, one comment too many about hip hop's sexism by any of these progressive writers could be interpreted as an anti–hip hop voice. Yet, at the same time, if they don't sufficiently challenge the sexism in hip hop and constantly refer to other areas in which it arises in American culture, then they become apologists, serving the agendas both of the artists with the worst records of insulting women and of the corporations generating profits. This dynamic has contributed to the marginalization of many progressive black feminist voices that would otherwise force us to attend to sexism, not simply complain about disrespect.

Despite the marginalization of black feminist women in the hip hop wars, many women are working locally to create change. Organizations like Black Girls Rock!, a mentoring outreach program for "at-risk teenage women of color," also reflect the channeling of black feminist energies toward progressive change in hip hop. This organization, founded by Beverly Bond, began as a direct response to the one-sided images of black women in hip hop. It includes mentorship programs designed to empower young women of color and to "encourage dialogue about the images of women in hip hop music and culture, as well as promote analysis of the ways women of color are portrayed in mainstream media."[11] Similarly, Tonya Maria Matthews (aka JaHipster), a spoken-word poet from the Baltimore area, has launched what she calls the "Groove Squad," a group of two dozen or more women who go to clubs and enjoy the hip hop music until they hear a song that is openly offensive or derogatory. Then they walk off the floor en masse. This is a powerful statement because it joins women who love the music into groups, not just as a protest but as a form of musical affirmation. By collectively turning their backs on offensive hip hop, they reject music that "destroys the groove," tell other club goers that something is really wrong, embarrass others if they stay, and deprive the party of a large group of

women.[12] These kinds of response to hip hop's sexism (other than anti-sexist education) have the greatest potential to eradicate sexism and the appetite for it. (See Chapter 12 for other examples of activist organizations.)

These types of strategies, though, involve actually listening to the music and its progressive critics, not simply getting on board with mainstream "outrage" that stands in for serious consideration and conversation. This listening has to involve a direct and sustained challenge to sexism, not just public defense of hip hop with an admission that it is also sexist. Too often in our public debates the whole thing turns into a "blame or explain" festival. One side attacks and blames, and the other side explains.

But neither of these positions actually works toward educating people about sexism, and neither gives young women activists the central place they deserve in this conversation. When they speak on these issues, black male scholars, leaders, and media figures should mention the young women involved in organizations like Black Girls Rock! and "Groove Squad." They should demand that more black women activists and writers who work to eradicate sexism and study gender and sexuality (not just black women who work in the media) be placed at the heart of the conversation.

Beyond this, visible male social critics who defend hip hop need to hold the artists with whom they are in apparent dialogue to a very serious standard. There are many veteran artists such as Jay-Z, Snoop Dogg, and Nelly who continue—despite their access to numerous kinds of knowledge and resources—to promote and defend the sexism in hip hop music and their own participation in it. These artists must be seriously and publicly challenged—not just by "haters" of hip hop but also by people who have expended a good deal of energy and public space defending it. To continue to make general statements against its sexism but then show public love and support for artists who are unrepentant for their blatant and constant sexism is to support their sexism and encourage others to do the same. We cannot have it both ways, given how far this gleeful assault on black women

has gone. Too much cozy association with unreformed artists who seem uninterested in undoing, rejecting, or challenging the excessive sexism they have contributed to hip hop is a tacit approval of it.

Protesting an individual artist alone does not address the fundamental issues and can even backfire, creating sympathy among some fans for the rapper attacked by "haters." However, sometimes it is very useful to make a clear example of both a popular artist who regularly participates in sexist performances and the powerful community support that sexism receives. This is what happened in the case of Nelly and his infamous song and video for "Tip Drill." The Spelman College women who demanded a conversation with Nelly before his visit to campus for a bone marrow drive, his refusal to meet with them, and the protests that ensued would likely have been much less powerful were it not for the specificity of his example. We are going to have to draw a clear line in the sand with the most powerful hip hop celebrities and all who pander and cater to them. The celebrity allure surrounding them has begun to overshadow the destructive force of their lyrics and videos; it's almost as if there are two celebrities in one: the cuddly, friendly one for mainstream sales pitches, and the one that maintains street credibility by celebrating "the game" and bragging about "f-ing bitches." Artists who are this sexist, this hateful, toward black women should become radioactive to listeners and, thus, inactive on radio. They should become pariahs, not messiahs. And their performances should bring them shame, not fame.

This scenario cannot be limited to artist responsibility, though. During a recent BET awards show, many grown, middle-class black men and women were dancing merrily in the aisles to "Crank Dat Soldier Boy" by the artist Soulja Boy, a song most noteworthy for a steel drum–inspired, catchy (but simple) beat that has generated a brief dance craze. What's the driving story of the song? And what are the key lines in the chorus? "Soulja Boy off in this hoe . . . watch me crank it . . . watch me Super Man dat hoe." Many middle-class white men and women revel in the same types of lyrics and images;

some have sponsored "pimp and ho" or "gangsta" parties at colleges across the country, energized by the celebration of sexually exploitative stories and images of black women in hip hop. It will take a good deal of sustained force to make corporations more responsible, to reveal the workings of sexism, to unpack what is wrong with this kind of portrayal of black women in hip hop, and to create the proper conditions to reject it. This problem will be solved not by making patriarchal appeals for "respecting" women but, rather, by educating everyone about the subtle workings of sexually explicit sexism and the reasons it has been so profitable—especially since this success has come at the expense of black women.

So the challenge is threefold:

1. To develop and promote a serious, progressive attack on sexism in hip hop without patriarchal, conservative religious, or anti–black youth politics as its guide.
2. To encourage, promote, and support those young black women and men who are embedded and invested in hip hop music but who also want to fundamentally challenge the sexism that defines the music.
3. To educate all youth, both boys and girls—especially those with the least access to ideas about gender equality—about sexism: how it works, why it works, and how to "keep it real" without it.

6

Just Keeping It Real

Kanye West raps about being a college dropout, and that's what he knows. I rap about what I know. College kids listen to his music, ghetto kids listen to me.

—T.I., rapper, during BET's *Hip Hop vs. America* forum

There's a bad part because the kids see that and they mimic you. That's the part I haven't figured out yet. . . . To me it's like, when I sing, "I live the thug life baby I'm hopeless," . . . I'm doing it for the kid that really lives a thug life and feels like it's hopeless. So . . . when I say it like that it's like I reach him. You understand? And even if when I reach him it—it—it makes it look glorious to the guy that doesn't live that life. I—I mean, I can't help it, it's a fact, you know. . . . I think I am being responsible, but it's hard.

—Tupac, interviewed in *Tupac: Resurrection*

Rap music is the voice of the underbelly of America. In most cases, America wants to hide the negative that it does to its people. Hip hop is the voice . . . and how dare America not give us the opportunity to be heard.

—David Banner, rapper, quoted at congressional hearing titled "From Imus to Industry: The Business of Stereotyping and Degradation," September 25, 2007

Although we take our standards and practices role seriously, we also believe that it is not our role to censor the creative expression of artists whose music often reflects the pain they've suffered or seen in their lives and communities.

—Philippe Dauman, president and CEO of Viacom, Inc., quoted at congressional hearing titled "From Imus to Industry: The Business of Stereotyping and Degradation," September 25, 2007

O NE OF THE MOST COMMON CLAIMS heard among rappers, their corporate managers, and fans of rap music is the idea that hip hop/rap music is *"just keeping it real."* This phrase can mean many things, but generally speaking, it refers to talking openly about undesirable or hard-to-hear truths about black urban street life. This popular phrase has also surfaced as a challenge to "unreal" images of hyper-consumption among rappers and hip hop fans who sport extravagant clothing, cars, and jewelry that emulate and suggest wealth levels light years away from nearly all hip hop fans, let alone the black inner-city ones. So, sometimes, keeping it real means rejecting all the bling bling.

But more often than not, the claim that hip hop is just keeping it real is usually made in response to criticism that hip hop lyrics are contributing to negative social conditions: encouraging violence, representing the criminal life, supporting sexism and homophobia. So, the primary use of the "keeping it real" defense of hip hop is to prove hip hop's role as a truth teller, especially the truths about poor black urban life that many people want to shove under the rug. Although rappers themselves are the ones most frequently heard making this claim, the head of a major media conglomerate—Robert Morgado, a former executive vice-president of Warner Communications—has also been quoted as identifying their role as reality's troubadours:

Rap music provides a window on our urban culture. Through it we can gauge the realities of life in our inner cities, which would other-

wise be obscured, realities that are deeply troubling. . . . To listen is to hear from a population desperately in need of attention, slipping headlong into despair and destruction. . . . The music can be frightening. It is angry and subverts aspects of order. It is violent and hard to understand, absolutely. Much of modern life is like that. Music and its lyrics reflect a reality that can't be censored. One can work to keep from being reminded of it, but there it is.[1]

Among these unpleasant "realities," revealed through rap music's "window on our urban culture," are black community street-based criminal lifestyles: drug dealing, hustling, gang-banging, hoes and pimping.

There is an important core truth to hip hop's "keeping it real" claim, despite its overall mendacity: A good deal of hip hop speaks and has always spoken openly and in depth about aspects of black urban poverty, particularly the grip that street culture has on many young people. Hip hop gives a ground-level view (though not the *only* view, or a *comprehensive* view) of what it might mean to live under what are nearly warlike conditions in communities that face myriad daunting circumstances. Sometimes, rappers' lyrics really do offer gripping tales of loss, sorrow, exploitation, rage, confinement, hopelessness, and despair about conditions that are denied in the larger society. It is important to admit that these powerful stories far too often uncritically reflect attitudes and beliefs that many would consider destructive to achieving a socially just environment. But it is also true that society at large only sporadically pays attention to the extraordinarily despair-producing conditions in which young black poor youth attempt to survive. Americans seem far more interested in being entertained by compelling portraits of horrible conditions than they are in altering them.

Young people who love hip hop understandably want to maintain and defend the spirit of "keeping it real." Hip hop remains one of the most accessible creative forms for those who feel that most if not all other avenues for telling their own life stories have been cut off by limits established in other genres. Beyond this, many fans need to

hold onto the idea that hip hop is a place for such personal portraits, even when this idea might be untrue. Despite its disturbing turn in the commercial realm, hip hop truly is one of the few creative and visible places where in-depth criticisms of society's failures (e.g., social injustice, corporate control of culture and media consolidation, racial inequality, class oppression, normalized sexism, and homophobia) can be expressed. Perhaps many hold onto this role for hip hop because they believe that if hip hop continues to be identified as a place where one can "keep it real," it might encourage more visible social commentary.

The notion of keeping it real is about both representing a particular black ghetto street life and being truthful about one's relationship to that life. So, rappers not only have to tell compelling stories about being in the life but also have to convince listeners that they know that life personally and intimately. Hip hop remains a genre largely valued for its seemingly autobiographical nature. Leading criminal lives seems to enhance artists' credibility, as has been the case for 50 Cent and T.I. Alternatively, some artists, most recently hip hop–inflected crooner Akon, have lost credibility not because they lack talent but because they were discovered to be telling lies about their criminal past or origins in "the 'hood."

Keeping it real has become a genre convention as much as a form of personal storytelling. I am not claiming that there was nothing real being said in 50 Cent's or T.I.'s lyrics, that they were entirely fictional, that none of them contained crucial elements of truth. Even if a rapper himself didn't exactly live the tale being told, it is not unreasonable to imagine that he witnessed many of the elements presented in a given rhyme, thus making it a socially real tale if not a fully truthful autobiographical one.

Comedian David Chapelle's second-season series of skits titled "When Keeping It Real Goes Wrong" is a brilliant satire of how keeping it real—defined partly as an exaggerated response to slights and small-scale mistreatments—can lead people to behave in destructive ways that ruin their lives. The skits are not directly about hip hop, but their scope as well as the series title signal that the "keeping it real"

brand of aggression made popular in hip hop has destructive conse-
quences. For example, the first skit involves a black club scene where
a man starts a fight with a champion of martial arts in response to a
mild comment made to his girlfriend. He ends up with massive hospi-
tal bills and has to move in with his grandmother. In another, a black
corporate director angrily rants in reply to a white coworker's off-color
use of black slang, ending his tirade with "Thug Life! Bark! Bark! Wu-
Tang!" In the next scene, he's seen working in a gas station, clearing
snow from car windshields for a living.

Chapelle's comic skits make a sharp-witted point. Keeping it real
is not just about telling one's truth; it is also about how a "keeping it
real" attitude is wedded to a valorization of aggressive and self-
destructive actions that have consequences—and how the attitude
itself often creates the conditions to which it claims to be respond-
ing. The defense that anything rappers rap about is truthful and
therefore valuable "ghetto" storytelling has been overused in ways
that are destructive not only to hip hop itself but also to black com-
munities and society at large. The claim that a rapper or hip hop in
general "keeps it real" has become a catch-all defense of everything
that comes out of a rapper's mouth, no matter how manufactured,
invented, distorted, or insanely stereotypical it may be. The illusion
that commercially manufactured rappers are unvarnished, gritty
truth-tellers has gotten completely out of hand. It has been used to
silence legitimate criticisms of the narrowing and increasingly paro-
dic images of black urban life that dominate commercial hip hop.
Indeed, saying that one is just keeping it real has become a kind of
vaccine not only for rappers but for many industry representatives
and corporate managers as well: This statement is a way of inoculat-
ing them from any and all criticism for their role in reducing and
narrowing the stories told by the same young people they claim to
represent—thus making commercial rap lyrics less real even while
they claim ultimate realness.

Rappers and corporate managers claim they are "just represent-
ing" or "mirroring" society. On September 25, 2007, during the con-
gressional hearing titled "From Imus to Industry: The Business of

Stereotypes and Degradation," Alfred C. Liggins III, CEO of Radio One, claimed that its urban contemporary radio stations played "hip hop music which often reflects the realities that many in the audiences face and observe in everyday life." His industry colleague, Doug Morris, chairman and CEO of Universal Music Group—which registers 25 percent of all music sales and houses rappers such as Lil' Wayne, Jay-Z, Snoop Dogg, Nelly, 50 Cent, Kanye West, and Busta Rhymes—said that "hip hop has always been one of the most reflective genres in our culture. . . . [Rappers'] words often reflect what they see and experience firsthand in their communities. Rap and hip hop may be the vehicle by which they escape lives of hopelessness, injustice and poverty. Their words reflect their lives, which regrettably, is often an unpleasant picture."

This logic has been able to mask what has been a reduction of creative space in commercial hip hop brought about by the claim that what we hear there (even when it is fully manufactured, limited, and contained) is the unmediated truth. We must listen, we are told, because it is real; and who wants to look prudish, or worse, who wants to appear to support the silencing of the already marginal and silenced? Who wants to silence or criticize the stories coming from poor young inner-city black men who are finally getting a chance to speak about their environment? Who wants to undermine their chances at relatively legitimate financial success?

However, there are five urgent problems with the "keeping it real" defense in commercial hip hop:

1. It refers to an ever-narrowing slice of black ghetto street life.
2. The constant commercial promotion of thugs, hustlers, pimps, and hoes reflects *and* promotes this aspect of street life.
3. It denies the immense corporate influence on hip hop's storytelling.
4. It contributes to the idea that black street life is black culture itself.
5. By reflecting images of black people as colorful and violent criminals, drug dealers, and sex fiends, this defense is intended

to protect the profit stream such images have generated; at the same time, however, it crowds out other notions of what it means to be black and reinforces the most powerful racist and sexist images of black people.

Let's consider each of these problems below.

1. The stories of black street culture—which are at the heart of "keeping it real" rhetoric—do not represent all or even most of black ghetto life. But by letting commercial hip hop become a nearly constant caricature of gangstas, pimps, and hoes, we've come to equate black poverty with black street life. This denies and silences a wide range of black urban ghetto experiences and points of view and venerates predatory street culture. The black male street hustler/gangbanger and his friends, across various regions and in different dialects, isn't the only reality to be told about black ghetto life. If radio- and television-promoted hip hop were really keeping it real— even in its portrayal of this narrow slice of black urban ghetto life— the perspectives on black street culture in commercial hip hop would be far more diverse. So, not only are these commercialized sources of hip hop not keeping it real in general, they're not even keeping it real about the narrow slice of black ghetto street life they claim to be representing. What might we hear if commercial radio and televised hip hop were really keeping it real?

If black ghetto street life were really being represented, we'd hear far more rhymes about homelessness and the terrible intergenerational effects of drug addiction. There would be much more urban contemporary radio play of songs about fear and loss, and *real* talk about incarceration. Prison is not a rite of passage; it is a devastating and terrorizing place to be. And the loss of potentially life-changing opportunities that define life after prison are rarely exposed in mainstream hip hop lyrics, despite the deep impact that incarceration has on the lives of young black men especially. Where are the conversations about the terrorizing acts of violence against men that are commonplace in prison life? Where are the stories about women

who work two and three jobs to keep their children fed while hundreds of thousands of black fathers languish in American prisons? Where is the outrage about white racism and the anger and frustration about police brutality, economic isolation, and unemployment that define too much of black ghetto life? Is this not keeping it real?

Why are there so few music videos or radio-played songs about the extraordinary sacrifices that neighbors, teachers, coaches, mothers, fathers, friends, ministers, and others make to help keep communities together, to keep kids from falling into life-destroying potholes? Where are the regularly played songs about kids who have made it through the minefield of growing up within conditions of racialized poverty but who *haven't* dealt drugs to their neighbors, *haven't* joined a gang and terrorized kids who are just like them—kids who have graduated from high school and tried to figure out a nondestructive way to survive and maybe even get ahead? Finally, where are the stories about community and romantic love and vulnerability, and the high-rotation songs that promote visions of love for the black community and an investment in trying to make it better? I'm not talking about telling countless tales on CDs about needing to sell drugs to folks who live next door and then using monies generated from those CD sales to "give back" in the form of philanthropy. Nor am I talking about finding a "gangsta bitch" to ride shotgun in one's car as a model for love. Love and intimacy require enormous sacrifice and sustained vulnerability; the models of black manhood promoted in commercial hip hop are allergic to both.

Not all commercialized hip hop finds the need to constantly represent the issues listed here. Indeed, there are exceptional, underground songs and voices in hip hop (tokenized on commercial radio airplay and marginalized on music video rotation) that deal with a wider range of elements of black inner-city poverty and everyday life. Several highly marketable artists have songs on their albums that move beyond the caricatures of the gangsta-pimp-ho trinity, but these songs—despite their lyrical creativity and infectious beats—never see the light of radio play and in no way define the genre or these artists'

careers. For the most part, these songs are the exceptions that prove the rule.

Consider Ludacris's number-one-selling single, "Runaway Love," which tells the story of young girls' particular kind of suffering and vulnerability to domestic violence and sexual abuse. In one verse, he raps about a young girl who runs away because her drug-addicted mother refuses to believe that one of the men she brings over is sexually abusing the daughter. When Ludacris appeared at the 2007 Grammy Awards presentation for winning Best Rap Album and Best Rap Song for "Money Maker" (a song encouraging a woman to shake her body "like somebody's bout to pay ya"), his acceptance speech included a challenge to those who say that rap has no content. Yet powerful songs like "Runaway Love" do not contradict the reality that mainstream representations are clearly dominated by highly seductive portraits of street hustling, sex for money, and gangsta life. It's as if the existence of *any* exception somehow negates the rule. Pointing to exceptions is a shellgame; it keeps the truth of the matter obscured and in constant motion.

The "keeping it real" rhetoric is also a cover for perpetuating gross stereotypes about black people—stereotypes that have deep roots in American culture. Commercialized hip hop's distorted and narrow focus on one aspect of black ghetto street life—under the guise of truth telling—exaggerates and perpetuates negative beliefs about black people and obscures elements of life in poor black neighborhoods that contradict these myths.

From listening to too much commercialized, highly visible hip hop, one could get the impression that life in the ghetto is an ongoing party of violence and self-destruction with "style," that street culture is an all-consuming thing, that poor black folks have chosen to live in the ghetto, and that they have created the conditions under which they live. Who needs conservatives' attacks on poor black people, when we rep their vision ourselves, with corporate sponsorship? The "keeping it real" line is far too often used to justify the way that rappers and corporate executives rely on voyeuristic fantasies

about black people as pimps, hustlers, and gang-bangers to sell records. The fact of the matter is that artists who consistently bring too much complexity or too wide a range of nonstereotypical images of black men and women to commercial hip hop are destined to end up at the margins of commercial success.

2. The commercially promoted depiction of this aspect of street life as stylized, fun, and cool doesn't just reflect the destructive aspect; it energizes, elevates, and promotes it. Much of what gets to count as "keeping it real" storytelling in hip hop isn't just journalistic-style reportage of actual lived experience; it also works as a form of affirmation and glorification. Once black street life takes hold in mainstream commercialized hip hop and becomes a part of widely distributed and promoted popular, celebrity driven culture, it can no longer be understood only as a reflection of some aspect of life. It is also an agent of creation and reproduction. All of this talk about "reflecting" reality in a genre that has garnered so much cachet and media glamour is a deeply dishonest argument. It is ridiculous to claim that video after video and lyric after lyric on black commercial radio and television are not also cultivating street culture.

Tupac Shakur understood this dynamic and worried about how his attempt to tell compelling stories to and for an already existing criminally involved subculture might encourage other kids to join the fold—or at least to emulate the style and attitude associated with it. This is the dilemma he fretted over, as reflected in his statement in the film *Tupac: Resurrection* quoted at the beginning of the chapter. When he said that it might make thug life "look glorious to the guy that doesn't live that life," he acknowledged how his celebrity made thug life "cool." And Tupac's stories of ghetto life were far greater in range and complexity, less glamorous and celebratory, and more expressive of pain and loss than those that populate mainstream commercial hip hop today. He admitted to worrying about his power to negatively influence his fans. Tupac wanted to speak to those kids who were already caught up in the system because he felt they were

herded there and discarded. Their stories and lives were considered unworthy of social recognition, and he wanted to give them social space and value. But he also knew that a compelling recognition of that life—without strong critique and without real-life options—can encourage the very actions and behaviors that get kids involved in crime and violence in the first place.

3. The "keeping it real" argument denies the capacity of corporate power over commercial mainstream hip hop to move this genre away from complex, diverse images of black youth and toward stereotypical ones. The defense of a much less evolved "reflection of reality" argument, as advanced by Russell Simmons and others, glosses over the fact that as more profits are generated from various "takes" on the black gangsta, hustler, and pimp, more artists are encouraged to redefine themselves to fit those molds. When Simmons defended rap's commercial content by saying that "[p]overty creates these conditions and these conditions create these words" or that "the rap community always tells the truth," he used the "keeping it real" argument to hide extensive corporate influence over product content. Together, vast consolidation as well as marketing and sales strategies have compounded the narrowing of what we see and hear, and are then used to prove that hip hop's stories are being entirely self-generated from the black community.[2]

Corporate record companies, while claiming to be mere middlemen distributors of authentic black ghetto tales, are product makers, and they really do steer public attention toward and away from ideas and images. They want to sell records and thus they promote, tailor, encourage, discourage, sign, and release artists based on two crucial factors: what they think will sell as many copies as possible and what they think won't cause too much negative attention, friction, or resistance from society and government. Such decisions are based not on whether a particular story is true but on what kind of story has been selling. It is also based on what kind of story has not been under profit-threatening scrutiny in larger society.

Previous versions of the "keeping it real" stories found in hip hop in the mid-1990s, about youth rage directed at police and racism, generated a great deal of real social pressure that eventually shut down the commercial promotion of stories that included references to killing cops or contained strong social critique. This public outrage against lyrics expressing anger at what was perceived as unjust authority (which was, by the way, greater than the public outrage about police brutality itself) had the potential to reduce sales since distributors were being pressured not to carry such records in their stores. That sort of truth telling was apparently keeping it *too* real. So, where was the corporate defense of the need to listen to stories about black rage against police brutality? Why wasn't this considered something that everyone needed to hear? When this rage and frustration threatened government authority, corporations feared they'd be regulated and would lose money, and thus they backed away, steering artists elsewhere. Apparently, black people shooting and killing themselves and insulting black women are profitable images and don't threaten society. So, they are defended, and we, as part of our democratic duty, are encouraged not to turn away—not to protest the exploitation they reflect—but, instead, to consume.

Ghetto street culture is the central brand of blackness for sale in American popular culture. As astute hip hop commentator Bakari Kitwana has observed: "[M]any rap artists, regardless of where they fall in the food chain, have succeeded in developing relationships outside the music industry and are cashing in on the image of blackness in the most significant way. Artists like Russell Simmons realize that their own image is a brand."[3] And a signature feature of this brand is the caricatured portrayal of the suffering of the bottom 20 percent of black America.

4. The distorted and exaggerated use of "keeping it real" to claim that today's commercial hip hop represents the truth of black ghetto life betrays the valuable history of black culture's role as a community-affirming means of expressing a wide variety of perspectives and lived

experiences. There is a long tradition in African-American culture of using music, poetry, dance, religion, literature, and other expressions to spread affirmation to counter a society saturated in racial hatred and to "speak truth to power." This is a strategy designed to prevent internalization and acceptance of hurtful mainstream ideas and to challenge injustice through speech. Speaking truth to power serves to unify people who feel that their points of view and life experiences are being overlooked, denied, and ignored. Hip hop comes out of this tradition, and despite the current state of commercial hip hop, many young fans, less visible artists, and activists are working to keep it alive. Furthermore, it is important to remember that not all of these wider, more complex portraits of black life are squeaky clean or politically progressive; hip hop has always included graphic and disturbing tales, and should continue to do so.

But the claim that today's commercial hip hop is the unadulterated reality that naturally comes out of inner-city communities too often amounts to a manipulation of black prophetic histories of speaking truth to power in service of corporate, mainstream agendas. The casual and dishonest use of "keeping it real" dishonors the longer tradition of speaking truth to power. Those who uncritically defend all of hip hop's commercial trading in ghetto tales tarnish this radical tradition and confuse young people who are less likely to see the difference between the two.

5. Other versions of black lived experience (no matter how broadly representative) don't satisfy larger society's stereotypes and fantasies about black youth and ghetto life, so record companies and their radio outlets don't support them nearly as strongly. Truth notwithstanding, these other images are not as profitable. Although many critics and fans consider Mos Def, Common, and Talib Kweli to be talented hip hop artists, not one of these three has gone platinum; by contrast, Chamillionaire, Trick Daddy, and Three 6 Mafia have all reached this important record sales milestone. Thus, as David Banner pointed out during his testimony at the "From Imus

to Industry" hearings:"The truth is that what we do sells. Often artists try to do different types of music and their music doesn't sell." So, aspiring rappers tell the stories many Americans *want to hear*. Stories that reflect the fullness of black life, humanity, and depth of perspective do not turn a profit the way stories of ghetto street criminality and excess do. And this problem is not limited to hip hop. It reflects a broader and ignored facet of what kind of blackness continually gets created, invented, and then re-created in American society. Keeping it real has gone really, really wrong.

Since hip hop's portraits of street culture reflect a real and legitimate aspect of many poor inner-city communities, their realness can't be completely denied, and rappers and corporate representatives manipulate this fact, denying legitimate challenges to the corporate processing of and profiting from black community destruction. As it stands now, "keeping it real" is a strategy that traps poor black youth in a repetitious celebration of the rotten fruits of community destruction. We can change this by expanding our investments in the principle of telling hard-to-hear undesirable truths that underwrite "keeping it real" to emphasize a full exploration of the historical and contemporary realities of economic, social, and political oppression that have created a definition of realness as equivalent to black criminality and street culture. Knowledge about this history will enable detachment from the street-based ghetto fictions that have become an industry formula. Then, the brand of "realness" being sold should be forcefully challenged as a form of containment that limits youth expression through its unreal emphasis on smaller and smaller aspects of everyday life. It should be rejected on the grounds that it normalizes and reiterates symbols of black community destruction as black experience. "Keeping it real" must also be exposed as a cover for satisfying the titillating temptation of listening in on seemingly "authentic" black life as criminality.

Finally, "keeping it real" has to be forced open to honestly reflect the full range of black youth's realities, experiences, desires, vulnerabilities, sacrifices for common good, demands for justice, longings,

and hopes. These, too, are realities that many refuse to hear; but unlike a repetition of ghetto hustling and criminality, they empower, they propel us toward a future that improves black life. Defined this way, "keeping it real" has the power to envision a new, more affirming world drawn from the lives of black youth. These are the realities worth keeping.

7

Hip Hop Is Not Responsible for Sexism

I think the rap community always tells the truth. And I think that it's important that we listen to their voices so we can have a roadmap, because artists—almost every single artist in hip hop, they paint a picture that is overlooked. The misogyny, the racism, the violence, the homophobia, these are things that we try to avoid instead of dealing with. All of that, I see it so often.

—Russell Simmons on *The O'Reilly Factor*, April 26, 2007

Some people push the limits, you know, but that's in everything. Some people push the limits on daytime television. Some people push the limits in the movies. . . . We [rappers] push limits. I don't really think that anyone is really out to demean women.

—Nelly, rapper, on *The Tavis Smiley Show*, May 26, 2005

The truth is, misogyny is not a hip hop created problem. Misogyny is a deep-seated problem that is embedded in the historical evolution of the United States as a nation.

—Dr. Ben Chavis, president/CEO of the Russell Simmons Hip Hop Summit Action Network, quoted in "Women's Media Center: In Defense of Hip Hop," www.ThugLifeArmy.com, May 22, 2007

THE WEBSITE FOR POWER 106 FM in Los Angeles, a highly influential hip hop/contemporary R&B station in a major media market, listed the top-five songs on their May 13, 2008, playlist as follows:

1. "Lollipop," by rapper Lil' Wayne
2. "Love in This Club," by Usher and rapper Young Jeezy
3. "What You Got," by Colby O'Donis and rapper Akon
4. "The Boss," by rappers Rick Ross and T-Pain
5. "Hypnotized," by rapper Gemini

Nearly all of the lyrics for "Lollipop" detail sex acts between rapper Lil' Wayne and a woman he hooks up with at a club. Lines include "She licked me like a lollipop" and "Shawty wanna thug, bottles in the club, Shawty wanna hump." "Love in This Club" is about how much R&B singer Usher and rapper Young Jeezy want to have sex in a club with a young woman they think is very sexually desirable. "What You Got" is about a beautiful but self-centered and materialistic girl who constantly talks about what she possesses. Rapper Gemini raps about his sexual attraction to a beautiful female in stiletto shoes at a club. He can't take his eyes off of her (he's "so hypnotized" by her moves), and tries to figure out how to "get with" her. "The Boss" is a standard gangsta rap style boast about Rick Ross being "da biggest boss dat you've seen thus far" who has power, fancy cars, and stylish outfits. Women are not the direct subjects of this song, but when they appear, they are mere sex objects and symbols of Ross's control and prestige. One girl loves him so much she tattooed his name on her body; as for another, "she leak da backseat just to freak in da magnum."

This lineup reflects a distortion of youth music's long-standing and perfectly acceptable focus on sex and courtship into sexist and objectifying tales of male conquest. The lyrics for these catchy top-five songs do not distinguish between male sexual desire and the sexual objectification of women. In these songs and many others, women are valuable only because they are sexually desirable and willing. These five songs are just an example of the context in which women

are frequently viewed. As noted by Gwendolyn Pough, a black feminist scholar who specializes in the topics of gender and hip hop, while hip hop has been a whipping boy, its images do affect women: "[M]essages in the music tell us what we should do to be desired and in some cases respected."[1]

When people criticize commercial hip hop's sexism, various explanations for its prevalence are offered. Six of the top defenses are that (1) society is sexist, (2) artists should be free to express themselves, (3) rappers are unfairly singled out, (4) we should be tackling the problem at the root, (5) listening to harsh realities gives us a road map, and (6) sexual insults are deleted from radio and video airplay. Each of these defenses evades the issue of sexism; none directly tackles the issue of sexist content. (Chapter 8 explores responses that "justify" sexist content.)

Society Is Sexist

The biggest claim made in attempting to explain hip hop's sexism is that society at its root is sexist, and that since it is a "deep-seated problem" in the United States it is well beyond hip hop's responsibility. This claim, that sexism is a larger, systemic problem, is entirely accurate. And it is also true that hip hop's sexism probably gets some unfair attention. But rap's stars and the corporations that distribute their songs get away with and have profited handsomely from highly vulgar and explicit forms of sexism specifically targeting black women—a fact that only encourages other up-and-coming artists to follow in their misogynist footsteps to get famous and rich. For all the recent and past outcry against the ways that hip hop generally depicts black women, this state of affairs has, for the most part (with just a few major challenges here and there), been allowed to expand and diversify mostly unchecked.

What is sexism?

Sexism has been described as the practice of domination of women. It is a practice that is supported in many different ways that are critical to

our socialization into our sex roles, and therefore makes this domina-
tion acceptable in society—through language, visual association, me-
dia representation, and stereotyping, especially on the basis of the
mothering/caring role of women. Sexism is important also because all
women experience it in different ways, depending upon their social
and economic situation—within the family and in jobs—and it limits
the ways in which women seek to actualize their potential. (*Oxford
English Dictionary*)

The special reference to mothering in this definition reveals the extra
scrutiny reserved for women's sexuality and the stigma attached to
improper or socially unacceptable kinds of sexual expression and re-
production such as prostitution, lesbianism, stripping, and unwed
motherhood. Sexist ideas often rely on labeling and controlling the
value and expression of women's sexuality as a central vehicle for
limiting women's potential.

Race is a critical aspect of this larger definition of sexism. Through-
out the U.S. history of white men defining women's status and value,
the systematic assumption that only white women would be able to
reach the highest (but still subordinate-to-men) role of womanhood
was a key element of women's oppression. Black women were not
afforded the status of "womanhood" in mainstream society, and they
were automatically less valued and more sexually stigmatized by
society.

Sexism against black women took place in racially specific ways in-
volving the labeling of their sexuality as automatically deviant and
uncontrollable and the claim that they were unfit as mothers. Key
sexual myths shape the three primary stereotypes about black
women: "The Mammy, Jezebel, and Sapphire stereotypes are de-
fined by their 'dysfunctional' sexuality and motherhood. The
Mammy is generally an asexual, overweight, and middle-aged figure
whose maternal qualities are expressed thorough her expert care for
white women's children (at the expense of her own). The Jezebel is
defined by her excessive, exotic, and unbridled sexuality. The Sap-
phire is the symbolic antithesis of the 'lady': loud, excessive, and irre-

pressible."[2] These racist and sexist evaluations continue to be powerfully and consistently reinforced in the legal system, in the cultural and social arenas, in imagery and language, and in popular media representations. Although revamped, these core, controlling stereotypes of black women remain powerful in society, and Jezebel and Sapphire, in particular, are constantly reproduced in commercial hip hop as well.

I've always been incredibly frustrated by the claim that hip hop isn't responsible for sexism because it's a long-standing problem and thus is "larger" than hip hop. It's worth showing the shell-game quality of this answer, since its inherent truth seems to silence legitimate challenges to commercial hip hop's role in amplifying sexism. The defense that hip hop didn't create sexism is valid, and thus often seems to silence and confuse fans who are critical of its sexism. How can we say that hip hop should be challenged for its sexism if sexism is everywhere and if its roots lie elsewhere? Is it unfair to target hip hop?

Sexism *is* everywhere; we know this. But should we simply accept it? Should we absorb as much of it as can be dished out just because it is around us? If we can't fight it everywhere, should we not fight it at all, anywhere? Should we not be concerned about how the sexism promoted by so many mainstream black youth celebrities affects black women and girls who are already facing oversized hurdles in our society? At what point are we responsible for our contributions to the state of the world? How can we hold others responsible—individually and collectively—for perpetuating ideas and perceptions that produce injustice and then decide we are never responsible for the impact of our words and images?

Clearly hip hop didn't create sexism, nor is it solely responsible for sexism. No one alive today created it, and there is nothing to which we can point that can be held responsible for all sexism. The power of gender inequality and sexual disrespect is its ability to be everywhere at once, to seem normal and inevitable. Thus, every fight against sexism (or against any systemic form of injustice, for that matter) is necessarily partial and incomplete; we cannot fight the entire

system all at once. Telling people that they should fight on another front is evading the issue and thus our own responsibility. If we look for one culprit and at the same time say that it is "everywhere," no one is responsible for anything.

I don't expect many of the young black men who are being challenged about their use of sexism as a career-boosting identity to be on the front lines fighting sexism. Many rappers and their defenders are products (if they are lucky graduates) of terrible urban schools that, among other problems, rarely if ever discuss any kind of structural inequality, let alone sexism, in regular educational contexts. Discussions of how we support sexism and homophobia through accepted definitions of masculinity and manhood (as when weak men are called "bitches" or "faggots," for example) are rarely on the curriculum either, but they really should be in order to cultivate gender equality and consciousness.

Society itself is saturated with sexist ideas and images, and without much outcry. Major corporations in nearly every arena peddle a staggering array of products using sexist imagery and ideas. So, the current climate is not a fertile ground for informed, progressive, anti-sexist personal development. But since rappers are the ones who are writing sexist lyrics and who claim they are speaking their personal truth, they make themselves targets for direct attack. If they were to admit that their images and content are partly determined by the very same corporations, they would give us important ammunition against corporate investment in sexism, but they would also deflate their own and other rappers' street credibility and reveal that many rappers are really doing the dirty work for these corporations and empowering themselves by insulting and denigrating black women.

Freedom of Expression

During their rare public statements and appearances, corporate executives such as Universal chairman Doug Morris, Warner chairman and chief executive Edgar Bronfman, Sony chairman Andrew Lack,

and Viacom president and CEO Phillipe P. Dauman have defended their role as distributors of intensely sexist content by subsuming sexism under artists' right to express themselves freely. But quite to the contrary, artist freedoms are actually constrained and channeled by media corporations; claims about freedom of speech are made to defend the bottom line, not artists' rights to speak freely. We must pull back the veil on corporate media's manipulation of black male and female artists and the impact this has on fans and the direction of black cultural expression. Mass media corporations profit extensively from promoting sexism and this is why they remain so quiet, letting rappers take the heat. In response to the outcry over BET's hypersexual brand of sexist videos that appeared on the now-defunct program "Uncut," BET spokesman Michael Lewellen said: " While we are sensitive to the concerns, let's not forget as well that we are running a business. . . . And somebody's watching 'Uncut.' Believe me, our ratings tell us that."[3] Because sexism and excessively sexist images of black women rappers sell, corporate executives are free to use rappers to promote sexism, but rappers are not nearly as free to express outrage at racism, challenge government policies, speak out against the war, or identify whiteness as an unfair advantage; these kinds of free expression are regularly discouraged or censored by the music industry so as not to offend white listeners, government officials, or mainstream institutions. As Lisa Fager Bediako from Industry Ears reminded the congressional subcommittee during the "From Imus to Industry" hearing of September 25, 2007:

> Freedom of speech has been spun by industry conglomerates to mean the b-word, n-word, and ho while censoring and eliminating hip hop music that discusses Hurricane Katrina, the Iraqi War, Jena 6, the dangers of gun violence and drugs, and songs that contain words like "George Bush" and "Free Mumia." In 2005, MTV and radio stations around the country self-regulated themselves to remove the words "white man" from the Kanye West hit single "All Fall Down." The lyrics demonstrated the far reach of capitalism by exclaiming: /Drug dealers buy Jordans, crackheads buy crack/And a white man get paid off

of all of that./ When asked why they decided to dub "white man" from the lyrics the response from MTV was "we didn't want to offend anyone."[4]

Rappers Are Unfairly Singled Out

Racism plays a role in the silencing of challenges to unequal racial power and it also contributes to the targeting of hip hop's sexism, but commercial hip hop artists make themselves massive bull's-eyes. Surely, many people attack hip hop to fulfill their own agendas; they want to restrict popular expression for reasons that are rarely progressive or democratic. Some also support policies that disproportionately hurt poor black people and help sustain disturbing stereotypes about black people. But this is not to sanction the ways that hip hop celebrates the disempowerment of black women as a means of pumping up black male egos and status. Sometimes one's enemies just might be right and still be wrong.

Civil rights leaders and anti–hip hop conservatives are not the only critics of sexism in hip hop. As I mentioned in Chapter 5, many young black women who are a part of the hip hop generation and have supported hip hop and black men have also challenged the direction hip hop has taken. Many of these women have grown increasingly concerned about how black women are being represented and what this might mean for both the music and the young people who consume it and identify with it. Their concerns are valid and thoughtful. By responding to the few rabid commentators who suggest that hip hop is responsible for sexism, too many hip hop defenders evade the crucial issue that hip hop critics, especially black women in the hip hop generation, are raising.

It's not as though black women who are frustrated with hip hop's increasing dependence on degrading images have been looking for a needle in a haystack, trying just to "bring the black man down." To the contrary, many have stayed quiet too long, letting artists, black media executives, and the music industry off the hook. This has been

the case primarily because attacking hip hop is read as attacking black men. And black women generally (despite the incredible emphasis in rap on gold diggers, bitches, hoes, chicken-heads, etc.) continue to be profoundly supportive of black men. As long as the equation between attacking sexism in hip hop and attacking black men remains in place, little critical commentary can occur within hip hop youth culture, and women and men will continue to be viewed as traitors for challenging it and for demanding less exploitative expression.

Instead of having a serious and sustained conversation about this issue, too many rappers and corporate music representatives interpret black women's concerns as an attack on all black men, a betrayal of hip hop. The "woe is me, I was attacked unfairly" argument (made by Nelly, for example, in the aftermath of the Spelman incident) turns the whole situation on its head. It turns an attempt to address sexist discrimination against black women into a moment about black male discrimination. It's as if the rappers are saying that *they* are the victims and should not be singled out, and thus one might guess that they should be given equal—even greater—rights to exploit black women! By this logic it is difficult to imagine that black male artists, magazine editors, and recording industry executives could themselves want to fight sexism and stand on behalf of the community as a whole when it comes to the treatment of black women.

The logic goes like this: Because sexism is all over society and media culture, and because somebody else—not you—created it, you can and should participate in it wholeheartedly, for great personal profit and prestige. Whatever happened to the adage "If you're not part of the solution, you're part of the problem"? All of this skirts the issue of what highly visible rap celebrities *are* responsible for—namely, what they do, say, and support. Without even asking them to fight sexism against black women, it seems fair to ask them to admit to the deep support of sexism that too many hip hop lyrics and images represent.

Tackle Sexism at the Root

While young black women are reduced to jiggling rumps and strip-ping, rappers can say that if we really want to get at this problem, we've got to tackle the big issue at its base, not focus on them. As rapper Nelly has said, "I just feel if you wanna get the roots out of your grass, don't cut it at the top. Dig down; you know what I'm say-ing? Dig down deep and pull it from the bottom if you really wanna get this situation resolved."[5] The fact is that although sexism is a sys-temic American problem, when it comes to the regular, sustained, celebrated misogynistic images of black women, hip hop stands cen-ter stage. It is the biggest black popular arena with the greatest num-ber of highly sexually exploitative and dehumanizing images of black women. Sexism is everywhere, but not all forms of sexism ex-ert an equal influence on black youth. Given its visible and influen-tial role among young people and the often repeated claim that hip hop emerges from lived experiences in marginal and disregarded poor communities, its hostility toward black women is an amplifying mirror.

The idea that hip hop "represents" these communities gives an added stamp of approval to its sexism; it gives its sexism false black cultural legitimacy and authenticity. As T.I. said in October 2007 during BET's *Hip Hop vs. America* forum, "This music is supposed to be about what we open our door go outside of our houses and see on our streets."[6] Surely hip hop didn't create sexism, but far too much of it glorifies and encourages its growth and maintenance. Unlike the sexism that we find in Hollywood or on television or in politics, the sexism in hip hop resonates with even greater influence on this black youth constituency since it serves as a part of its homegrown identity. It is to hip hop that so many young black men look for models of black manhood that connect with their generation and their experi-ences. It is to hip hop that many young black women look to find a place in which to belong in their peer group, to figure out how to get attention from men. During the *Hip Hop vs. America* event, pioneer female rapper MC Lyte described this dynamic very well:

For the most part, hip hop has always presented itself as real and that's where the problem comes in because kids are looking at this and thinking that every aspect of it is real. . . . it goes through videos, with the men having these cars and homes and three girls waiting in the bed for them when they come in the house. Like all of that is *not* going on to a certain extent, but yet you have young boys who think these are women they need to go after, you have young women that are wanting to dress like these girls that are in videos because now that's what's defined as sexy.

If commercial hip hop has a special role as a "voice of the downtrodden," then shouldn't those who want to create justice for black communities be deeply disturbed by the constant peddling of ideas, images, and words that support such hostility toward the women of these communities? Isn't the point that hip hop has a special power—because of its credibility—to influence and reinforce a positive vision of community for black youth?

A Road Map to Where?

Russell Simmons's quote at the outset of this chapter says the truths about sexism told in hip hop give us a roadmap: "it's important that we listen to [rappers] voices so we can have a roadmap, because artists—almost every single artist in hip hop, they paint a picture that is overlooked. The misogyny, the racism, the violence the homophobia, these are things that we try to avoid instead of dealing with." There is a grain of truth in this passage, but ultimately the logic fails us. There is no doubt that exposing the depths of sexism, homophobia, racism, and violence is overlooked and exposure of oppression is a fundamental part of eradicating them. What does he mean by this? What kind of listening are we to do? And where is the road map taking us? In what way are the rappers who rely so heavily on glorifying sexism and reflecting homophobic beliefs helping to dismantle sexism, violence, and homophobia? Simmons wants us to consider the words of rappers as mere observers who should be celebrated for

"bringing these problems to our attention." But he refuses to admit that these artists are not just mirrors of what is. Because of their status and influence, the content of their lyrics, and the lack of explicit progressive ideas from most of the most visible ones to serve as a counterweight, they reinforce the very ideas they express.

Lyrics that depend on expression of injustice without critique or challenge are reflecting them, not exposing them. Such use supports discriminatory beliefs while masquerading as truth telling. Some artists do a constructive form of truth-telling when it comes to the issue of violence, but when it comes to publicly standing against sexism and homophobia, and supporting this stance in their lyrics, the ranks are mighty thin. To tell the truth about just how much sexism and homophobia help create and support distorted and destructive forms of manhood and sustain injustice is not the kind of truth telling most of the commercially celebrated rap community to which Simmons refers is really interested in.

Hip hop is in desperate need of getting past this mapping impulse. "Representing" what is without critique, analysis, and vision of what should be is not a useful map. How can we figure out where to go if we are trapped in the act of representing, especially representing ideas that contaminate collective community action, mutual respect, and love for each other? Some have argued that you have to use recognizable language, attitude, and sentiment to reach otherwise unreachable youth. As T.I. put it during BET's *Hip Hop vs. America* forum, "If I have to throw some 'B's' and 'H's' in there to educate people, then so be it." But what kind of educating are we doing if we have to "throw some 'bitches' and 'hoes' in there"? When and how do we educate people—women included—about sexism? This kind of disjuncture, whereby women are asked to pay the price for destructive visions of community resistance, represents a tragic form of miseducation (to borrow a powerful term from Carter G. Woodson), which describes how oppression is maintained by keeping people miseducated about their condition. Former Fugee Lauryn Hill exposed the many facets of this miseducation on her brilliant album *The Miseducation of Lauryn Hill.*

This idea that we can successfully or meaningfully "educate" or "represent" poor black people while standing on the necks of black women is a fundamentally abusive form of community vision and education. It can create incredible levels of dissonance that lead men and women to think that one can promote the subordination and sexual exploitation of black women and still be politically radical. On Jay-Z's 2007 CD *American Gangster*, his song "Say Hello" boasts that he doesn't think Al Sharpton represents him—that when the public schools are fixed and when incidents like the Jena Six (a 2006 case in which people protested excessive criminal charges leveled at black male teenagers) stop happening, he'll stop using the word "bitch." When all structural and personal acts of racism end, *then* he'll stop promoting ideas that profoundly demean black women. This argument is blatantly illogical: Black women are not responsible for injustices in education and incidents like the Jena Six. If he's looking to punish those perpetrators, he ought to start talking and rapping about white racism and classism. Defending his "right" to call black women "bitches" because racial and class oppression exists represents a rage imploding on a community that pretends to be politically resistant. This is just the kind of sexism against black women that hip hop artists are responsible for, and it's the kind that we have to challenge and reject.

How do we transcend this madness if we must constantly represent it, reflect it, and reproduce it just to "get people's attention"? Russell Simmons's road map is a road map to nowhere. As Abiodun Oyewole, a founding member of the Last Poets (a political group of African-American poets and musicians many credit as a principal predecessor to hip hop), has said: "A lot of today's rappers have talent. But a lot of them are driving the car in the wrong direction."[7]

Bleeping Bitches and Hoes

Russell Simmons has made what is widely considered a courageous move in calling for record companies to voluntarily bleep out the words "bitch," "ho," and "nigga" from the songs distributed to

mainstream radio and television, thus keeping these words out of mainstream consumption. According to Simmons, this recommendation preserves his twin concerns: artists' freedom of expression (they can write whatever lyrics they want, à la freedom of speech) and the protection of mainstream consumers (which might "bridge the gap between the activists who are so angry and the hip-hop community that is disconnected").[8]

This is surely a good and long-overdue idea. I, too, worry that the frenzy to "protect" the public would shut down dissent—political, social, and cultural. I have never supported government censorship and think that especially now—when fears about one crisis or another are being whipped into a frenzy and used to encourage broad infringements on all rights (the Patriot Act is a major example)— such potential for antidemocratic governmental intervention in creative expression is higher than at other times in U.S. history. But we must distinguish—and Simmons has done so—between governmental censorship and responsibility to a broader public. Furthermore, with freedom of speech comes a sense of responsibility to this same broader public. The idea of eliminating "bitch," "ho," and "nigga" from mainstream distribution appears to straddle this delicate balance: On the one had, they are deleted from the airways, but, on the other, artists can still use and record them.

But to what degree does this bleeping-bitches-and-hoes strategy undermine the overall logic and sentiment behind these words? If a song's lyrics send the message that black women are sexual objects, what real and lasting effect can we expect from replacing "bitch" with something else? In the music video for Lil' Wayne's song "Lollipop," words like "pussy" and "ass" are electronically twisted to make them unintelligible, but exactly how does this alter the sexist terms on which the song is based? Another strategy has been the replacement of offending words with less offensive ones. Nate Dogg's song "I Need a Bitch" was altered for radio play. The "clean" version substitutes "chick" in place of "bitch." Here's the gist of the lyrics: Each of several lines begins with "I need me a bitch/chick," and then describes what would make this woman desirable. The opening phrase

is followed by phrases about her willingness to flirt, how she'll lift up her skirt in public places, how she's as important as his "crew," and finally how he intends to "pass on to my boys soon as I get through." How does changing the word "bitch" to "chick" really change the spirit and overall meaning behind these lyrics? It doesn't. Bleeping out or substituting words won't likely work against the driving force behind their use, nor will it fight the sexist intent of these stories. Furthermore, kids will spend endless time finding the "explicit" versions since these will be perceived as "authentic."[9] Snoop Dogg revealed this very dynamic in an *Esquire* magazine column, where he described his experience performing at a bar mitzvah: "They were singing my shit, they was cussin', they were singing the dirty version. I'm talking about twelve- and thirteen-year-old little white kids singin' this real gangsta shit. Man. I was shocked. I just gave them the mic and let them motherfuckers go."[10]

From a progressive social justice perspective, too, this strategy of deleting offensive words doesn't grapple with the bigger questions on the table—namely, fighting sexism in black communities, creating healthy and mutually respectful relationships between men and women, and enabling equal rights and social respect for everyone. If hip hop exposes widespread problems in society such as sexism, then we must actually address and support the development of anti-sexist, anti-homophobic ideas, not just make room for their increased expression.

The kinds of defenses that have been made regarding hip hop's explicit and constant sexism would be laughable and outrageous in this day and age if they were made in the context of racism. If, for example, racist images and lyrics were constantly repeated and celebrated in public and then defended with claims such as "this person or this film wasn't responsible for racism," "it's everywhere in society," "racism is a 'deep-seated' problem in America," "high-rotation songs that insult blacks on mainstream networks and radio stations are helping us deal with racism," nationwide marching and outrage would ensue. Yes, racism is a deep-seated problem, we know that; and this is a prime example of its pernicious effects. The issue would

be: How are we going to fight it if we are making it seem normal and not exposing it with a purpose to end it? Unless the description of the condition "sexism is everywhere in society" is followed up with "and we are going to work on its eradication" or "we need to educate people about how to reduce it and here are some ideas for doing so," then what appears to be an honest confrontation becomes an evasion of the problem.

Couldn't we use some percentage of profits generated by hip hop to develop progressive anti-sexist programs in public schools or in after-school programs? What about working with Clear Channel, Radio One, BET, MTV, and all the hip hop magazines to *regularly* feature stories and shows that educate people on sexism, how it works, how racism relates to it, and why it is a problem? Maybe for every ten hours of music video, each station should air at least one hour of well-produced, prime-time media literacy programming. How do images work? What stories do they tell? Why are some images so popular, and how do images emerge from and feed back into everyday life and society?

Encouraging progressive young people to focus on and fight hip hop's sexism—rather than attempting to tackle the entire field of sexist culture—is logical for two central reasons: (1) Doing so would powerfully resist the amplification of sexism among the younger members of black communities for which hip hop is largely responsible. And (2) such activity would educate young people about what sexism is and how it works—thus perhaps reducing its power—rather than just reflecting and reinforcing the sexism that already exists. And this, in turn, would reduce the currency of the sexist ideas on which hip hop relies.

In short, the crisis in hip hop is also an opportunity. We can turn this moment into something powerful for all young people, especially those who most need to be empowered (not by degrading others), educated (not miseducated), enabled (not enraged), and encouraged to reflect the best (not the worst) of what surrounds them. Progressive voices in hip hop and beyond have an opportunity to make this a project of investment in social change and community

building. Bleeping "bitch" and "ho" should not be simply a response to the expression of "black women's pain" or a strategic capitulation to mainstream pressure. It should be one small part of a larger and sustained commitment to creativity and justice and fairness for all. DJ Kool Herc, in reflecting on his years as a pioneering founder of hip hop street parties, said that kids who wanted to rhyme on the microphones at his parties had to find a way to be creative without cursing or promoting violence. These forms of negativity didn't support the community, and he wouldn't allow them at his parties. He felt that demanding that kids take a higher path when communicating with their peers was vital to creating the spaces that would support and nourish the community of which he was a part. There's no reason that we can't ask the same of the many creative minds that make up hip hop today.

8

"There Are Bitches and Hoes"

Are you familiar with politics? The President's number two man, who had to resign based on him using a dating service. Maybe he's hangin' out with hoes that we mention in the music?

—50 Cent, responding to a question raised during a press conference about whether he intended to change his lyrics in light of the 2007 Don Imus incident, nahright.com/news/2007/05/17

Three 6 Mafia took home the best original song Academy Award last night (March 5, 2006) at the Kodak Theater in Los Angeles. Drawn from the film "Hustle and Flow," the group's "It's Hard Out Here for a Pimp" also made history as the first rap song ever performed at the event.... "This is big for hip hop, but we're also representing for the black community, letting kids know you can do something positive and make it bigger than life," Three 6 Mafia's Jordan "Juicy J" Houston recently told Billboard.

—Jonathan Cohen, *Billboard* magazine, March 6, 2006

Bitches ain't nothing but hoes and tricks.

—Snoop Dogg chorus of Dr. Dre, "Bitches Ain't Shit," *The Chronic*, 1992

ONE OF THE SIGNATURE ICONS that drives commercial hip hop is the pimp. An important facet of urban street cultures and illicit economies, and once relegated to folklore, underground vernacular culture, and the margins of mainstream society, pimps

have become popularized and mainstreamed. Building on the glamorization of black pimp culture in blaxsploitation films of the 1970s and on the influence of raw sexual hierarchies exported from prison culture, many rappers began drawing from pimp culture, style, slang, and attitude as part of their identities. Rappers such as Too Short, Snoop Dogg, Ice T, now deceased Pimp C, Dr. Dre, David Banner, 50 Cent, Nelly, and Lil' Pimp brag about controlling women like pimps, being stylish like pimps, and about being pimps themselves; promote pimp-based products (e.g., Nelly's energy drink, Pimp Juice); and elevate former pimps like the Archbishop Don "Magic" Juan to cult-like status. Pimp culture has saturated commercial hip hop. As T. Denean Sharpley-Whiting has put it: "The 'g's up, ho's down' mentality of late 1980s hip hop laid the groundwork for the 'pimp-playa-bitch-ho' nexus that has come to dominate hip hop." Strippers and groupies, already praised and demeaned for their sexual actions, are now also being promoted and contained within this pimp-ho framework. Pimping style and attitude have migrated into other facets of mainstream popular culture, such as the car-customizing show *Pimp My Ride*, "Pimp and Ho" Halloween and theme parties, the film *Hustle and Flow*, and cable network programming exposing pimp culture. Pimping is everywhere these days.[1]

Despite the cuddly, fuzzy-hat image of pimps in some mainstream outlets and celebrated films like *Hustle and Flow* that attempt to generate sympathy for pimps, pimp ideology and its expression in popular culture are fundamentally exploitative to women. Dominating prostitutes and living off of their sex work, street pimps use physical violence (including rape) as well as emotional and psychological manipulation to control prostitutes. Phrases like Snoop Dogg's famous rap lyric "Bitches ain't shit but hoes and tricks" capture pimps' fundamental attitude: Women are bitches, and bitches are whores and prostitutes.

Taking a brash attitude in defense of these exploitative terms, most defenders of this trend in hip hop rely on the idea that they are talking about a reality of life and dare people to deny it. This was part of 50 Cent's strategy at a May 2007 press conference where he defended his lyrical talk of hoes, reminding the inquiring journalist that

a high-level government representative had used prostitutes: "Maybe he's hangin' out with hoes that we mention in the music?" Sometimes defenders extend the argument by concluding that, since prostitution is a fact of life, there are more important issues facing society.

These defenses can be categorized into four types of responses: "There Are More Important Things to Talk About," "Men Are Hoes, Too," "We're Not Talking About All Black Women," and "There Are Bitches and Hoes."

"There Are More Important Things to Talk About"

Reporter's question:

50, how do you feel in light of the whole Imus and Oprah thing?

"I don't feel . . . you know . . . it's not a tragedy to me that that's happening. I think for a moment, our country forgot that our country is at war."

—**50 Cent, at a news conference related to the 2007 Imus incident**

I honestly feel it's a lot more important things [to worry about], if you want to fix America, you have to start at George Bush and work your way down—you can't start at hip-hop and work your way up.

—**T.I., in an MTV interview, www.MTV.com, April 23, 2007**

FOR A LONG TIME NOW, rappers have tried to suggest that there are much bigger and more important things to talk about than sexism in rap music. Referring to wars, hunger, poverty, and Hurricane Katrina, among other disasters, rappers and their various representatives attempt to draw attention away from the apparently lowly topic of sexism, especially talk of hoes. Who, they seem to imply, wants to defend bitches and hoes anyway?

This is an easy deflection. Sure, it's important that we talk about crises like the war in Iraq and global warming. No one is saying that

we shouldn't talk about them. In fact, if commercially successful rappers produced as many songs about global warming and George Bush's war in Iraq as they do about so-called bitches and hoes, and if radio stations actually played these songs to any significant degree, those rappers could effectively address questions about global warming and the war.

But they don't. Often, the only reason they even mention the war is to deflect attention away from the question of how corporate-sponsored hip hop negatively represents women. Yet all the while, they posture as if they are interested in these larger issues.

Yes, the media drum up celebrity drama for ratings (focusing on Anna Nicole Smith and Paris Hilton, etc.). Television and Hollywood film producers seem addicted to hookers and strippers, relying on the hyper-exploitative sexualization of women to raise these ratings. And all of this distracts us from crises like the war in Iraq—which, without a doubt, receives inadequate media attention. But the distraction factory's sexism and war evasion—beyond rappers' participation in both—isn't the question on the table.

This answer—that there are more important things to talk about—and ones like it suggest a hierarchy of importance (e.g., that black male sexism against black women is less important than the war in Iraq). They prompt listeners to subordinate their concern over how black women are being represented by their own community's music and culture in the interests of a "larger" national threat of war. Ironically, rappers insult their own value when they deploy this evasive strategy. Are they saying that the issues brought up in their music are unimportant, less worthy of discussion? If there are so many more important things to talk about, why aren't they rapping about these more important issues far more often?

When the war is over, they'll find something else "more important" than sexism about which we should be concerned, and the portrayal of black women will remain unimportant. We can fight more than one "war" at a time, thank you. We must deal with the question at hand if we want to be taken seriously.

"Men Are Hoes, Too"

How can you say I'm degrading women, when I call myself a ho? I'm degrading myself! Look at me. I'm rich and successful, and I'm degrading the hell out of myself. . . . Rappers may degrade women, but we degrade men, too, so that pretty much cancels itself out.

—Ludacris, in a *Playboy* magazine interview, October 2006

SOME RAPPERS CLAIM that they refer to men as hoes too, so they're not just attacking black women. The logic is that *anyone* who has "too much" indiscriminant sex—for money or other perks, or just for personal fun—deserves to receive this label. *Please.*

The culture at large happily excuses, even rewards, male sexual promiscuity (as long as its heterosexual)! In black street parlance, that's what the exalted "playa" is centrally about: a man who gets lots of sex (and the power associated with getting lots of sex) from many different women, without risk or loss of power. The idea of a male ho requires that we interrupt the already positive status that men accrue from getting lots of sex from lots of women. If "ho" is going to be an insult for men, it has to convert male access to power into loss of power as a result of a busy sex life. In short, the negative label associated with women's sexual behaviors is needed to achieve this twist. The real purpose of calling a man a ho is to insult his manhood by using an insult for a woman who has had many sexual partners, thus turning his male sexual prowess into sexual weakness—a status that sexist worldviews usually reserve for women. Thus, men can be labeled "hoes" only if women are already attached to this term. (Yet male hoes are not equivalent to female hoes even when the same term is used.)

The same logic applies when men are called "bitches." It's a way of insulting their manhood, by carrying over an insult leveled at females—already presumed to be of lower status. So, the use of anti-female, sexist name-calling to insult men doesn't change the system

of sexist language that associates these insults with women. Rather, such usage just reinforces the system by adding a few men to the lowly ranks of sexually demeaned women. In no way does it affect men as *a group* in the way that constant name-calling against women does.

And in any case, the comparison itself isn't very realistic: The use of these labels to describe men is far less common in hip hop than their use to describe women. Again, this defense avoids what is actually taking place in far too many lyrics, where the power of language is used against black women.

We live and breathe in a world that normalizes sexism. But this does not excuse it, nor can reproducing it with consistency do anything but replicate it. Once one has a highly profitable career, with access to all kinds of resources—monetary, educational, intellectual, social, political—then remaining ignorant and squandering it to generate personal and corporate profit is tantamount to becoming the ultimate puppet. The biggest-selling, most-promoted rappers such as Jay-Z, 50 Cent, Nelly, and Lil' Wayne, who continue to depend on pimp, hustler, and playa street culture for their livelihood, have the legitimate excuse of their origins for a "hot minute"—but a few years after that, it's hogwash. (As legendary rapper Rakim once said: "It's not where you're from, it's where you're at.") By choosing to represent this sliver of black life at the expense of all the other modes of survival and growth that poor black people have devised, these rappers are choosing to continue to reinforce the most limited, destructive thinking and acting about women (for excessive personal—and corporate—profit) without taking any personal responsibility for it. Sexism sells, mostly because we refuse to fight sexism with any seriousness.

During the heated weeks following the 2007 Don Imus incident, when a disc jockey used what he claimed was regular slang in hip hop to "jokingly" refer to the nearly all-black Rutgers women's basketball team as "nappy-headed hoes," many media outfits seemed comfortable employing the "others do it so why should Imus get so much heat" excuse to create a "logical" framework for Imus's sexist and racist comments, and rappers railed at this misdirection, claim-

ing that Imus and MSNBC had more power and thus more responsibility for their actions. But many rappers, backed and distributed by similar corporations, do the same in self-defense. Both use the "sexism is everywhere" argument in one way or another to deflect attention away from their personal responsibility and their relationship to corporate complicity in its perpetuation.

"We're Not Talking About All Black Women"

(bitch) Sisters get respect, bitches get what they deserve.
Sisters work hard, bitches work your nerves. . . .
I love my sisters, I don't love no bitch.

> —"Bitches and Sisters," by Jay-Z (*Blueprint 2: The Gift and the Curse*, 2002)

SEXISM SOCIALIZES ALL WOMEN AND MEN; it is a group-based form of discrimination against women that can't be avoided by any of us unless it is challenged and reduced for all of us. To exercise the power to label others who are less powerful than you in one way or another—especially, as in this case, when these labels are part of a long-standing process of racist and sexist insults—is to participate in sexist and racist attitudes. So, to say "I am not referring to all black women when I use these terms" (which suggests that *some* women are "bitches and hoes") is sexist name-calling that normalizes sexism for all women, especially all black women.

The fiction of separation—good sisters over here/bad sisters over there—is one that some male rappers, fans, and other apologists use to justify their perpetuation of negative images and ideas about black women. This separation of black women into the good ones (the ones we are not insulting) and the bad ones (the ones we have the "authority" to label and insult) is a primary means by which sexism and other forms of discrimination work. (Remember "good blacks and bad blacks"? "Good immigrants and bad immigrants"? "Model minorities and problem ones"?) The idea is to establish negative

group terms for the dominated or discriminated group and then find the "good" members, the ones who wind up serving as exceptions. This proves the rule, thus perpetuating the group discrimination for everyone.

Some hip hop artists defend their endless self-aggrandizing talk about dominating "bitches and hoes" by saying that they are not talking about all women. But "bitches and hoes" are all the women they talk about. The valorization of the gangsta and pimp also highlights and celebrates the very women they degrade, encouraging young women fans to emulate the behaviors of "bitches and hoes" to get attention, to be desired, and to be considered sexy. Bitches and hoes get all the attention in hip hop. Of course, many women participate in the videos and other aspects of the culture that demeans them—and female fans emulate these behaviors, too. Some point to women's cooperation with sexism in hip hop to say that it cannot, therefore, be that bad and that women must not really mind. While being a black gangsta is the primary means of gaining recognition, money, and fame for males in hip hop, behaving in hyper-sexual ways is, for some women, the only means of making any gains at all. Men have gangs, drug dealing, and pimping; sex is the street economy open to women. Pointing to women's participation in a system that exploits them to prove it isn't sexist falsely assumes that sexism is sexism only when all women label it so. It also denies the power of socialization in creating our collusion with social relationships that hurt us. Again, since sexism socializes all men and women, we have to work against it; being anti-sexist doesn't come naturally in a system that rewards us for participating.

Because street culture and the exploitative culture on which it is based have become such key sources of black identity in the hip hop generation, many young black women parrot the sexist ideas that are so widely circulated in hip hop; it's a key to belonging. For many young black women, the language of commercial hip hop about black sexuality has influenced their understanding of black women, not just reflected it. Sexism works best when women are isolated

from and pitted against one another (as detailed in the song "Bitches and Sisters"). Isolation and conflict ensure that they will sustain and internalize the terms of insult and control used to keep things as they are. Women are rewarded by men for participating in this system.

Young women are also coerced into participating by the dictates of record-industry marketing. As noted by Glen Ford, a veteran radio and rap video programmer and current executive editor of the *Black Agenda Report*, the consolidation of these limited identities is directly related to corporate pressure:

> The term "street" became a euphemism for a monsoon of profanity, gratuitous violence, female and male hyper-promiscuity, the most vulgar materialism, and the total suppression of social consciousness. A slew of child acts was recruited to appeal more directly to the core demographic. Women rappers were coerced to conform to the new order. A young female artist broke down at my kitchen table one afternoon, after we had finished a promotional interview. "They're trying to make me into a whore," she said, sobbing. "They say I'm not 'street' enough." Her skills on the mic were fine. "They" were the A&R [Artists and Repertoire] people from her corporate label.[2]

Some young women who are angered by this hyper-sexism speak out, but many do not. To be publicly and strongly against sexism in the music industry is to guarantee one's marginality. And to challenge sexism in the black community (as in larger society) is to discourage public support; in fact, doing so is often perceived as an anti–black community action and can make one a target. For black women—who are already marginal in larger society—taking a stand in a way that might alienate them from their local community is painful and difficult and often not worth it. So, instead, there is a great deal of silence or skirting of the issue, as black women try to find ways to manage what is a hurtful, insulting, and discriminatory language of belonging. One such way is to agree that "there are bitches and hoes."

"There Are Bitches and Hoes"

J-hood: My goal down here is to have fun, and, get up on some of these girls, man.

Hurt: Do you have any problem, with like, rappers calling women bitches and ho's and stuff?

J-hood: Nah, cause to tell you the truth, some of them is bitches, see? You gotta realize that, you got the sisters, but then, the bitches. Huh, you look? You got your sisters. . . .

Hurt: Are you saying that those are the bitches? [J-hood is looking toward a group of women in bikini wear.]

J-hood: Uh-huh.

Hurt: What makes those the bitches?

J-hood: Them the bitches, cause—you see how they dress, just look how they dress, sisters don't dress like that. Huh? Look at that ass, look! I might go over there and smack it!

—Interview with J-hood at BET's *Spring Fling* in Byron Hurt's film *Hip Hop: Beyond Beats and Rhymes* (Independent Television Service, 2007)

IN THE SAME SCENE, Hurt asks these women what they have to say about being called "bitches." They reply that they consider themselves classy and say that the men who said this about them had a "personal problem within themselves." Unfortunately, it's more than a personal problem; it reflects a core element of how sexism works. Female fans, too, blame women who wear hyper-sexualized hip hop–inspired clothing and participate in hip hop videos and stripper and groupie culture. This was a common response to the Spelman College women's challenge to Nelly's "Tip Drill" video and the press their protest produced. As one student said: "I feel as though the women in the videos need to take responsibility for their actions, and start respecting themselves. Nelly is not the one to blame."[3] Even more dramatic were the attacks on Karrine Stefan, author of *Confessions of a Video Vixen*, who was subjected to "rancor, contempt, and

abuse . . . from blogs to interviews with Tyra Banks, the Queen of Dice, and Slice and Mix-It Up, Wendy Williams, Miss Jones @ Hot 97, and Star and Buc Wild at 105.1."[4]

There is no doubt that those fans who seek affirmation by emulating the women simultaneously glamorized and demeaned by hip hop images and stories should be educated about how they are being manipulated. What appears to be expression of sexual freedom is, in fact, participation in an industry that reinforces male sexual fantasy and power. But the extraordinary double standard on which women's sexual participation is judged by men (and women) reflects the same patriarchal system at work. It's bad enough when people exploit themselves, but far worse when others use them to gain success and fame, and then deny that their status depends on the exploitation of others.

The constant public labeling of black women in hip hop as "bitches and hoes" has forced young women to stake out a position. Some embrace "bitch" as a term of empowerment and also try to reverse the sexual-power exchange, calling men "hoes." Women who use "bitch" in this subversive way are trying to challenge the language of sexism; men who use "bitch" are ultimately supporting such language. Many women and girls say that since they are not "bitches and hoes," these rappers are "not talking about me" because I don't "behave that way." So, "it doesn't impact me." In some cases, this kind of distorted self-defense is a valiant but tragic effort to pretend that such labeling is not hurtful to all women no matter how one acts. It's often a matter of survival to craft this defense, as the distinction is mostly a fiction. In the film *Hip Hop: Beyond Beats and Rhymes*, Byron Hurt makes the following point to a young woman who tries to use this defense: "It's funny when I hear women say, 'when these rappers are calling women bitches and ho's, they're not talking about me.' It's like, yo, they *are* talking about you. If George Bush was to get on national TV and make a speech, and he started calling black people niggers, would you be like, 'I don't know who George Bush is talking about, but he ain't talking about me'?"

The line between women who "deserve" to be called these names and those who do not does not exist. Winding up on one side or another of this imaginary divide is at the discretion of the males (and sometimes females) around you; it's not a choice you get to make. Remember the "classy" women at BET's Spring Fling whom J-hood confidently identified as "bitches"?

"Nappy-Headed Hoes"

Imus: That's some rough girls from Rutgers. Man, they got tattoos and—

McGuirk: Some hard-core hoes.

Imus: That's some nappy-headed hoes there. I'm gonna tell you that now, man, that's some—woo. And the girls from Tennessee, they all look cute, you know, so, like—kinda like—I don't know.

—Transcript of *Imus in the Morning,*
www.MediaMatters.com

It's a completely different scenario. Rappers are not talking about no collegiate basketball girls who have made it to the next level in education and sports. We're talking about hoes that in the 'hood that ain't doin' sh—, that's trying to get a n—a for his money. These are two separate things. First of all, we ain't no old-ass white men that sit up on MSNBC going hard on black girls. We are rappers that have these songs coming from our minds and souls that are relevant to what we feel. I will not let these mutha—as say we in the same league as him.

—Snoop Dogg, responding to Imus calling the Rutgers
women's basketball team "nappy-headed hoes,"
www.MTV.com, April 1, 2007

IN APRIL 2007, radio disc jockey Don Imus used what he claimed was regular slang in hip hop to "jokingly" refer to the nearly all-black Rutgers women's basketball team as "nappy-headed hoes" during their bid for the women's national championship. Before anyone

could detail what actually made these comments so problematic, the immediate media aftermath was marked by an extraordinarily swift move from discussion about Imus's responsibility for his *own* comments to discussion about hip hop artists and *their* responsibility (not Sony's, Time Warner's, or some other corporatation's responsibility) for making these comments commonplace. So, even Imus, who has shown no general familiarity with or investment in hip hop parlance, was able to turn his own comments into a hyperbolic referendum on hip hop. Imus said that although he admits he had no right to use the now-infamous phrase, he knows "that that phrase didn't originate in the white community. That phrase originated in the black community" (www.Oprah.com).

This assertion, of course, is not true, except in the most narrow, literal sense. The ideas and negative terms in that phrase did not originate in the black community. The idea of very curly textured hair as "nappy" hair, and its use as an insult, is one of many dehumanizing strategies devised during the Western enslavement of African people. The idea that black people are sexually immoral and excessively promiscuous (the "ho" part of the phrase) originated in the same place. Disparaging black people's skin color, hair, lips, noses, and other distinctive characteristics as well as suggesting that they are immoral—especially sexually—helped justify the violence and domination of black people, including the rape of black women. It also falsely and deliberately elevated the value of whiteness, including the straight hair and other facial and physical characteristics associated with Europeans. White women were sexually valued because of their supposed chastity and thus they automatically attained a far higher status than black women, who were deemed not only ugly but unfeminine and, thus, acceptable targets for violence and unworthy of protection.

In the case of hair assessment, black people internalized this insulting multicentury attack on self-worth and value but also turned it into a source of pride; thus, the term "nappy" can be used as an insult from nonblacks, an internalized insult hurled among blacks, and a means used by black people—women especially—to embrace

what has been so systematically and openly despised. The use of black slang—"ho"—to reiterate the Western idea of black women as whores does not make black culture a point of origin for Imus's hostile-comedic use of this phrase, either. Black women were presumed to be sexually excessive and often labeled whores by white society throughout U.S. history. So it shouldn't be surprising that blacks invented a slang word or phrase for the term. But developing black slang for it doesn't make the idea black. (If that were the case, it'd be like saying that, since some black people call money "cream" or "duckets," blacks invented U.S. currency.) The use of "ho" in black slang and in hip hop is a function of how people under siege reflect, internalize, and resist the language and ideas of the intertwined strands of Western patriarchy and racism. That's a curl that we have to straighten out.

The claim that Imus's insult was actually "a black thing" went unchallenged, and the mainstream media then began analyzing Imus's comments in terms of their so-called origins in hip hop. Angry conservatives and Imus fans wrote endless blogs calling the whole thing a racist double standard. Al Roker, the lighthearted, apolitical NBC weather man and *Today Show* entertainment host, whose MSNBC column took a stand against Imus's language and defended his firing, received an overwhelming number of responses, many in defense of Imus and nearly all of these claiming a double standard. Many were angry that Imus should be held accountable for calling women names since others get away with it. In other words, if rappers can call women names, why can't Imus (as in, why can't we)? On another website, the author of a conservative column titled "Racial Double Standards to the Nth Degree" claimed that "Imus's firing is thus a pure example of the anti-white double standard that governs our world."[5] The otherwise familiar polarization between those who are for and those who are against hip hop now included highly visible black leadership on the anti–hip hop side, including political/business/media representatives such as Al Sharpton and the former editor of *Essence* magazine, Diane Weathers. Al Sharpton has long challenged much of what takes place on commercial hip hop/hot

urban radio. But others were perhaps emboldened by Bill Cosby's recent generalized attacks on what he considers the bad behaviors of poor black people. (These are discussed at length in Chapter 3.)

The *Oprah Winfrey Show* held two town forums on hip hop in April 2007—both generated by Imus's use of racialized sexist comments. Neither forum featured a speaker who could talk in an informed manner about the history of sexism against black women. No black feminists—women who study, understand, and can explain the larger issues in plain English—were there, much as the forums needed a black feminist equivalent to Dr. Oz or Dr. Phil. And although Al Sharpton, Diane Weathers, journalist Jason Whitlock, talented singer/songwriter India Arie, and writer Stanley Crouch were called "experts" by Oprah on her website, none of them specialize in the study of hip hop or the history of sexism against black women. Only male critics and activists and high-profile media women who were "fed up" and reacting from personal points of view were included. In addition, the speakers were separated into groups comprising those who "represent" the critics of hip hop and those who "represent" its corporate, "professional" supporters, thus sustaining the polarized terms that have marginalized black feminist women of the hip hop generation in this conversation.

During these shows, Snoop Dogg took a good deal of the heat generated by this conversation—mostly, I imagine, in reaction to his highly inflammatory defense of rappers' use of terms like "bitch" and "ho." At the heart of Snoop's challenge to Imus is the idea that because these are the terms of the "street" and Snoop comes from the street, he knows what he is talking about. But does this legitimate his sexist name-calling?

Although the roots of the common portrayal of black women as ugly, aggressive, and hypersexual were formed long ago, there is a more recent term that bears importance here. The term "welfare queen," coined by Ronald Reagan in the 1980s, typecast poor black women on welfare as sexually irresponsible, money-hungry, and lazy. To drum up support for drastic reductions in public welfare assistance, those who used this term accused economically limited black

women of manipulating and cheating the welfare system by having babies to increase their welfare assistance payments. The label "welfare queen" relied on the already sedimented idea that black women are sexually deviant and untrustworthy. Now, as the term implied, they were whoring themselves for state assistance.

This kind of racist and sexist name-calling is pretty similar to what Snoop claims about the "bitches and hoes" in his 'hood: "that ain't doin' shit, that's trying to get a nigga for his money." It's just that he says he has a right to do it because he knows them from personal experience. Snoop's attitude about poor black women isn't any better than that of many of the conservatives who attack him.

Snoop's "I know them from personal experience" defense also uses a racial authenticity argument to justify his sexism. Snoop and many other multi-platinum rappers from tough, poor black and brown neighborhoods continue to *choose to represent a sexist perspective about reality they no longer have*. There are many men and women in the 'hood who don't hold his sexist views, and he can't legitimately rely on his so-called reality to justify his own perpetuation of this image of black women. After several years of hits and celebrity living and socializing out of the 'hood, traveling the world, and having access to nearly any and all manner of ideas, knowledge, and new forms of socialization, to act as if they have no meaningful relationship to women beyond the ones they call "bitches and hoes" is ridiculous. Like they still live in a rented apartment in the 'hood and a brigade of money hungry black women are figuring out ways to take their riches?

Rappers are not under assault by black women whose behavior they don't like. The gangsta rapper image *needs* "bitches and hoes," and so they continually invent them. Women, so labeled, add lots of status and value to gangsta and pimp images. If you can't have lots of women serving and servicing you, then how can you be a real player, a real pimp? So, the process of locating, labeling, partying with, and then discarding black women is part of the performance that enhances gangsta- and pimp-style rappers' status and, thus, their income. If, as Jay-Z raps in "99 Problems," "I got 99 problems but a

bitch ain't one," then why bother telling us about her inability to give him problems—unless controlling bitches is part of his power? Similarly, Snoop and other rappers at his level don't have any reason to fraternize with women whom they feel are out to "take their money." So, if they're "just keeping it real," then they need to stop pretending that they are victims of black women out to take their money. That's nonsense. If they're so good at identifying women they insist should be called bitches and hoes, then it shouldn't be too hard to stay away from them. And, if they're able and want to stay away from them, then there's no reason to rap about them constantly.

I'm not saying that all women are above criticism. But if people want to challenge someone's behavior because they don't like it, they should talk about the behavior and say why it's problematic rather than using generalized, sexist, or racist language and labeling. The culture of women's sexual behavior promoted by hip hop videos shapes the actions of young black women in ways that will bring them attention and status. So, in a sense, hip hop is becoming a "bitches and hoes" factory, encouraging girls and young women to play the limited roles assigned to them.

Conservative responses to hyper-sexual popular culture usually involve an anti-sex agenda, one that functions to contain women's sexuality while failing to fight sexism or to work toward women's overall freedom. Rappers and corporate industry representatives highlight the sexually repressive tone and agenda of conservative attacks on hip hop in order to encourage women's complicity with their own exploitation. Indeed, the two positions—sexual exploitation and sexual repression—are birds of a feather. I am not interested in a less sexually open society or in sexual censorship, and I am not against sex workers or a gender-equal sex industry that protects women's rights and work conditions. Rather, I am concerned about black women's overall freedom and equality. This involves genuine sexual freedom of expression—not freedom of expression tied to sexist male fantasies or to male-dominated sex trades in which women are demeaned and degraded in order to appear to be sexually free. Nor does it involve women's sexual repression—a returning to sexual domination of

women through sexual repression in the interests of patriarchal male control. Sexual explicitness does not have to be sexually exploitative. If we don't make this distinction when we fight against the constant barrage of "there are bitches and hoes," then we wind up with a sexually repressive call for less sexuality.

The problem in commercial hip hop as it has evolved over the past fifteen years is that terms of sexual exchange are now so exploitative and overarching that nearly everyone is cast as either a player (the one in control) or the one getting played (the one being dominated). Women are nearly always on the latter end of this exchange and their only way out is to either confine their sexuality or try to become players. Those who reverse the terms and do try to become players are often relabeled "bitches and hoes" who are "trying to take a nigga's money." So, either way, they lose. This blending of sexual explicitness with sexual exploitation is hurtful and destructive for black women and for black male/female relationships and the black community generally.

So, although hip hop isn't primarily responsible for America's sexism, it is the most visible and extreme engine for it in black popular culture, which means that it has a special impact on black women and men who, because of the racist and sexist world in which they live, rely on black culture as a source of reflection, support, and affirmation. This is one key reason why it's important to make sure that black popular culture is not overrun by the worst forms of domination and inequality. Making sexism sexy only makes life harder for everyone, especially black women and others in the black community who already have too many unfair hurdles to overcome.

Instead, let's demand that empowered women be in charge of their own sexual imagery and give them the freedom to express themselves as they see fit. There is no evidence that most young women want to replace the more sexually explicit brand of sexism they currently manage with a repressed version of sexism. This less-repressed one gives them more day-to-day freedom, even though it is often highly exploitative. The anti-sex agenda of many conservatives is unappeal-

ing, disempowering, and uninterested in promoting women's rights or fighting sexism.

We have to work hard against what destroys who we are, what prevents us from reaching our best selves and stalls our efforts to create a truly just society. Many of the artists and executives who deflect legitimate criticism with the kinds of excuses presented here defend their constant use of highly insulting racist and sexist ideas about black women while profiting from it. We need to understand the roots of sexist images and work to reduce their impact, visibility, and perpetuation everywhere, not only in hip hop. We also have to confront the reason why these images are so successful as products sold to millions of people from all racial backgrounds. If the mainstream media were to cast a serious light on this crisis, it would be far more powerful to do so in a way unrelated to Imus's self-serving efforts to save his career. Doing so on the heels of Imus's sneaky misdirection only reinforces society's lack of concern for such images and perceptions of black women.

When asked about their lyrics, many rappers respond to the terms set out by conservatives who attack them, not to the many black women who have generally supported hip hop but find this escalation of highly destructive imagery a problematic betrayal. The fact that conservatives attack male rappers doesn't mean that these rappers' lyrics and their too-easy defense of their portrayals of black women are worthy of progressive defense. Save the defense for the young men and women who are willing to stand up for what is right, not for those who pander to what is clearly wrong and unjust because "it's the way it is," "other people do it," "I get unfairly attacked for it," and "conservatives don't understand or like it." We can attack the conservatives about plenty of issues, but we shouldn't marshal black people's solidarity in the service of defending sexist attacks on black women. Not in hip hop, and not anywhere else.

9

We're Not Role Models

Well, I think the people that listen to the radio station—one, I play edited versions of everything, so you don't hear that on the radio. So the people that have a concern, voice a concern, they also have the option, too. If you don't want to hear it and we're playing it, . . . you can turn it off. At the same time, people that do have strong opinions aren't fans of the music.

—Helen Little, program director for Power 105.1, *Fox News*, March 2, 2007

Coming from nobody wanting to lend you nothing to nothing, I never had a nine-to-five [job]. Either you gonna go get a job, you gonna beg or you gonna steal. Coming from that, my only responsibility is taking care of my kids and paying my bills. Mothers that wanna come talk about, "you make my kids do this. . . . " That's your responsibility. All my responsibility is, like I just told you, to pay these bills and get this money.

—Webbie, rapper, www.allhiphop.com, June 5, 2007

I see myself as a role model because I've been taking advantage of all the options and opportunities that have been created for me. They may not consider me as a role model because I write about harsh realities—the things that actually go on in the environment that I came up in—and I ain't going to change that. But what I say to the kids is, "Watch what I do, not what I say."

—50 Cent, www.MTV.com, March 21, 2005

A POPULAR RESPONSE TO CHARGES that hip hop has a nega-
tive influence on young people is not actually a defense of hip
hop's penchant for graphic violence, misogyny, and frequent celebra-
tion of drugs, alcohol, and street crime. Instead, it is an attempt to de-
flect responsibility for hip hop's potential impact away from the artists
and onto parents and fans themselves. This deflection takes place
through three oft-repeated phrases: (1) "We're not role models"; (2)
"parents are responsible for their own kids"; and (3) "if you don't like
what you see, turn it off." Many rappers and industry representatives,
as well as some fans, say that rappers don't intend to serve as models
for young people and thus their behavior, images, and stories should
not be criticized for lacking role-model qualities. They argue that par-
ents are responsible for their children's behavior and should monitor
their children's access to media. In particular, they should screen their
children's access to television, movies, video games, radio, CDs, and
other hip hop products. Finally, they insist that the power is really in
the hands of the consumer. Just turn it off, they say, if it bothers you.

It is true that hip hop gets overly blamed for being a uniformly
negative force while other forms of media entertainment seem to es-
cape scrutiny. Entertainment standards, despite all the blame leveled
at rappers, rest in the hands of global mass-media companies, all of
which have successfully hidden behind the rappers they profit from
and promote. So, rappers shouldn't be the only targets of blame for
what gets promoted by the record industry and global media. But the
defenses rappers frequently give are problematic in their own right
and deserve some challenge.

"We're Not Role Models"

The idea that media celebrities and popular artists should not be
judged on the role-model standard makes some sense. The term
"role model," coined by distinguished sociologist Robert K. Merton,
refers to a process in which individuals compare themselves to refer-
ence groups (i.e., people we see as closely reflecting our social and
cultural environments) who occupy the social role to which they as-

pire. This term has entered common usage to refer to positive behavior modeling, which has a much more limited definition, but its original use speaks more to a local form of looking up to those who have made it (positively or not). Creative people need more room than the positive-image use of the role-model standard allows. Many artists were considered rebels in their time and then subsequently elevated to exalted places in society's historical memory. On the other hand, the mere fact that someone generates media attention does not make him a candidate for emulation. Furthermore, there are many different standards for "positive" role modeling, so it would be difficult to please everyone, even if an artist were to try. But the "we're not role models" argument too often represents a blanket refusal to address two key issues: first, that people are responsible for what they project in the world And, second, that what gets projected in hip hop has a particular impact on young people who already face heavy burdens, have little public support, and need as much help as they can possibly get.

Because hip hop relies on the "reality" of life "in the 'hood" as its primary product, many hip hop artists project a certain image in order to be successful in the popular market. As we have seen, rappers' own credibility rests on convincing their fans that they are telling truths in their rhymes about having come from the toughest urban poor environments and thus knowing personally what it's like to experience drug dealing, street crime, jail, and so on. Rappers such as T.I., Snoop Dogg, and Lil' Kim who have been arrested for drug or gun possession or for violent acts get *more* credibility and value as artists; they are perceived as more authentic representations of life in urban ghettos and thus more "true" to hip hop's roots. The need to appear hard so as to prove one's street credibility certainly encourages rappers to project these images.

Despite claims to the contrary, this dynamic peculiar to hip hop closely mirrors the idea of a role model. The hip hop industry has become an accessible and potentially lucrative career aspiration, especially for young people who feel that other forms of upward mobility are closed to them. Artists regularly speak of their role as members of

the same social group as their black urban poor fans and identify themselves as having made lots of money, thus creating stories of success that seem worthy of emulation. Fan interest is exactly what drives rappers' popularity and success.

Hip hop artists more than other artists are actually serving as role models in the original definition of the term; they want fans to see them as their reference group, as people who occupy the social role to which fans aspire. This dynamic fuels their success and connection with fans. The "we're not role models" argument denies this relationship; it hides the direct connection between rappers' popularity and young people's identification with and emulation of their attitudes and personas that result precisely from the autobiographical and "reality-based" terms of their performances. And given the brand of "up from the streets" story being told, the fans who can most identify with these life experiences are the ones who most need a richly creative and productively inspirational model, not a celebration of predatory street culture. Whether rappers who present this image want to admit it or not, the constant celebratory glorifying of destructive behaviors and the penchant for "[making] cocaine cool," as rapper Lupe Fiasco points out in his brilliant song "Daydreamin'," contribute to the idea that hip hop's tragic trinity is inevitable, sexy, and potentially profitable.

It is important to acknowledge the power behind this ill-disguised role-modeling. We can't primarily celebrate dog-eat-dog street-level capitalists who are ready to exploit others for their own survival and then expect that the embrace of this philosophy won't undermine the quality of how we treat each other. Nor can we normalize the celebration of behaviors, language, and attitudes that reflect an ongoing disregard for one another (male, female, gay, straight, poor, rich) and expect that this version of "authenticity" will nurture a politics of inclusion, equal opportunity, and anti-discrimination. Our public speech and behavior matter, especially in our media-saturated and market-driven environment.

For those who garner public attention and adoration, it matters even more. It is absurd when 50 Cent says to watch what he does

rather than what he says, since the vast majority of his image and branding value comes precisely from what he says. Even if what he does is sometimes worthy of emulation, what he says cannot be ignored. People who represent products or who are a brand themselves are part of a larger machinery designed to make them more desirable, valuable, and worthy of our attention and participation. Advertising is designed to turn brands into our "reference groups," into people whom we emulate.

During a 2007 press conference for the BET Awards, 50 Cent was questioned by a reporter about the content of his lyrics and asked if he would make any changes in his music given the public outcry against the kind of content for which he is known. The reporter mentioned New Orleans rapper Master P as an example of a well-established artist who has decided to sign only positive rappers to his new Take a Stand Records label and to avoid using offensive language. This is especially noteworthy since Master P made his reputation on many of the images in question. 50 Cent's reply was this: "Well, Master P doesn't sell records anymore. You can tell him I said it. Cameras is rollin', right? . . . 'Curtis,' June 26." Reporters laughed at this response and didn't challenge him any further.[1]

Master P responded with his own public statement. In it, he said that it's time for a change. He reminded readers (and 50 Cent) that "he paid for Curtis's first rap tour through the South" and that 50 Cent "was such a humble guy at the time." He also challenged the fundamental dishonesty behind the "I'm from the streets and it was all good" celebration that several popular rappers promote. Master P said: "People in jail are not writing letters proclaiming to come out and do the same thing that landed them there in the first place. People in the 'hood don't want to stay poor for the rest of their lives. They want to change." He went on to expand the circle of responsibility to include the corporate executives at BET:

> It's simply disappointing to see people that are in a position to help make a change just sit back and entertain the negativity. It's sad to see Stephen Hill set all of these programming standards at BET, just to

contradict himself for the sake of marketing dollars or artist perform-
ances in order to create the appearance of a successful awards show.
The record company with the biggest marketing check controls the
music video stations so we need to go after the people who actually
control these programming networks if we want real CHANGE.[2]

Stephen Hill, at the top of *Source* magazine's 2004 list of most in-
fluential executives in the music industry, is executive vice-president
of Entertainment and Music programming at BET. The above ex-
change between Master P and 50 Cent merits attention because it re-
veals just how intertwined profit, "marketing checks" (another way of
describing the pay-for-play corruption outlined in the Introduction to
this book), corporate responsibility, media journalism, audience
power, and individual responsibility really are in terms of perpetuat-
ing the worst of hip hop and black popular cultural spaces today. In
his BET press conference, 50 Cent relied on the idea that Master P
"didn't matter" because he didn't have high levels of current market
power and record sales. This raises several questions, which the jour-
nalists should have asked him: So (since record sales are all that mat-
ter), if *not* using words like "bitch," "ho," and "nigger" would help
you sell more records, would you stop using those words? Or, do you
respect any particular artists for their talent and creativity, no matter
their sales position in the record industry? 50 Cent's claim that he
does not need to address the sexist language he uses, as well as the
fact that other rappers have agreed to stop using such language, de-
pends on the correlation of market success with legitimate power and
our complicity as part of the buying public. Although 50 Cent seems
to reject any responsibility for being a role model, he is already serv-
ing as one—just not one worthy of emulation. He is modeling the in-
terests of sales and profit over people—even people who have
extended a crucial helping hand, as did Master P.

Master P's focus on the fragility and suffering of poor black com-
munities as the ground on which the gangsta-pimp-ho trinity is
founded was a powerful reversal of the boastful tone that usually ac-
companies talk about black ghettos in hip hop. It was a more honest

take on what incarcerated people think about prison and the criminal life, about what poor people, especially parents, actually wish for in their own lives and the lives of their loved ones. In addition to challenging rappers themselves, his response pointed out the central role of black industry executives' culpability in perpetuating and adding glamour to street culture. These corporate leaders are a crucial link in generating much public space for what Master P calls "entertain(ing) the negativity." They are role models, too—models of corporate leadership who also elevate profits over people by using the exploitation of poor black people as raw material for corporate gain.

"Parents Are Responsible for Their Own Kids"

The thing that is going to make your child do or feel negative things is a lack of good parenting. Now, if you try to let BET or MTV raise your child, then you are going to have a problem.

—LL Cool J, *Jet magazine*, December 4, 2000

SOME CRITICISMS OF HIP HOP come from people who draw few distinctions between artists, see no merit whatsoever in the music and culture, and use the mass-mediated, commercially sponsored excess as an excuse to indiscriminately bash all things hip hop. But these are not the only critics who worry about the influence that hip hop's popular images, lyrics, and icons have on young people. Parents of younger fans (many of whom were teenagers when hip hop began) and younger fans themselves have also grown concerned over the narrow and increasingly destructive images in hip hop's commercial trinity.

Many rappers claim to know a great deal about the perils of poverty, the unconscionable conditions in which poor young black people live, and the fact that so many kids have been left to fend for themselves because their parents have been taken out of their role as parents. The combination of unjust and racially motivated high levels of incarceration, the impact of the drug plague, and the long hours working-poor parents spend on the job while leaving their kids un- or poorly attended (often because affordable, regulated childcare

is lacking) adds terrible burdens to parents of limited means. Many of these parents are asking hip hop celebrities to help them, or at least not to undermine their efforts by creating highly visible, constantly accessible, alluring images that encourage their children to make self-destructive choices.

Countless rappers have rhymed about not having fathers around to help them, about having been raised by the streets, about the sacrifices their mothers made to help them, and about schools that didn't seem invested in their success. These powerful rhymes reveal that many rappers understand the reality of how all kids are raised: They are raised by parents, schools, and communities—and environment, society, and images shape them. Jay-Z's brilliant song "Blueprint (Momma Loves Me)" depicts this context with exceptional insight. He describes his momma loving him, his grandmother feeding him banana pudding, his father leaving him—these are his primary influences. But he goes on to detail the importance of friends, other relatives, and the Marcy projects that he says raised him.

Parents alone couldn't possibly be responsible for all of the social influences and pressures that communities must weather. Yes, parents need to do their best, and they surely bear primary responsibility for raising their children. But to assume they have total responsibility—to deny the impact of larger social forces that profoundly limit some parents' ability, including what highly marketed celebrities say and do in our celebrity-driven culture—is to deny the powerful communal responsibility we all have for one another. It is a snub to the parents who raise their children under deep financial and social distress.

During his appearance on *The Tavis Smiley Show*, Nelly says that he's on the road nearly all the time, but he can stop his young daughter from watching his videos:

> I have an eleven-year-old daughter, and she loves her daddy. And she's never seen the video that a lot of these people were saying [referring to his video for the song "Tip Drill"]. Now, how is it that I'm on the road the majority of the time and I can stop my kids from seeing a video when you can't, and you're at home all the time?[3]

So when he asks why parents who are home all the time can't do the same, it seems like a reasonable question. But are working-class parents really "home" as much as Nelly suggests? There are vast differences between Nelly (and many other wealthy artists and media celebrities) and working-class parents who must raise their children under far different circumstances. Yes, he's on the road and away from his daughter, but he has vast resources at his disposal to help him parent by proxy. These resources allow him to give his family the time, energy, and even the staff to guide and direct the actions of his daughter while he is on the road. By contrast, regular, everyday working mothers or fathers work overtime, take extra shifts just to make ends meet (not unlike being on the road all the time), and have to leave their children home or with friends, neighbors, or relatives during these long hours. The television, although not an ideal substitute, is a relatively safe one under the circumstances; and thus what passes for black youth culture in highly visible hip hop on BET, MTV, and other youth-oriented media outlets has the potential to make a bigger impact on kids who spend less time with adults.

Many rappers are no doubt familiar with the trying circumstances that low-income parents face. The rapper Webbie, quoted at the outset of this chapter, has grounds for saying he works as hard as possible to make ends meet for his family, and he is rightfully outraged about how little others helped him throughout his leanest and most painful times. But his refusal to share responsibility with the rest of us for what hip hop culture has become, to say that his contribution to hip hop and its impact aren't his business, passes on the very injury he describes. He is, in effect, telling parents that they are on their own, just like he felt he was before. Why pay forward this experience of mistreatment? And why should the rest of us accept and embrace this attitude?

How we treat each other matters. If we accept and internalize an "every person for themselves" worldview, we undermine the progressive spirit required to create the communities we want and deserve. Rappers' lyrics and own real-life stories make plain the powerful impact of environment, circumstance, local figures, and larger societal

images on young people, especially poor kids. They deny these con-nections when it is profitable for them to do so, and they betray the poorest black children in the process.

"Just Turn It Off"

If people don't like it, and they think that it's—you can always turn it off. You know what I mean? So, people act like they can't turn it off. And you—you don't got to watch the booty videos. But the people that talk about it, they're so intrigued, they want to see it.

—Jermaine Dupri, rapper-producer, on CNN's *Paula Zahn, Now*, February 21, 2007

Again at the end of the day those that tune in to our network . . . are doing so by choice. If there is something that you see that you don't want to see, simply don't watch. I am not a gar-dener, but I am not leading a crusade myself against Home and Garden *simply because I am not a gardener. Simply, I just don't garden.[4]*

—Michael Lewellen, BET vice-president of communications

HIP HOP HAS BECOME the signature cultural language for a large majority of black youth. It isn't merely *one* alluring form of popular black music among many equally "cool" genres for black teens and young adults; it is *the* music for this generation. Thus, too, it isn't just a matter of one style among many, where young people can easily make alternative but equally socially viable choices in black popular culture. This is why the violence and sexism and the street-hustling worldview in highly successful and corporate-sponsored rap music matter so much to people who want to nourish a progressive, community-affirming cultural space for black youth.

What should be turned off? How can you turn off one video by, say, the Ying Yang Twins but turn it back on in time for one by Talib

Kweli or Common? You'd have to be a psychic to know when the videos that take the art of hip hop and the importance of community seriously are going to be aired. Given the level of commercial saturation of the hip hop trinity, "just turning it off" could easily mean that progressive and powerful music would be starved in the process.

Furthermore, even if someone had psychic powers, the "just turn it off" strategy requires immense capacity to reject one's own generational icons who have been made the most visible and desirable. What kind of advice is this? How can we possibly expect young black people to remain socially credible while rejecting so much of what has become the signature culture of their generation? Expecting individuals to "just turn it off" is tantamount to asking them to turn their backs on countless social spaces where musically nourishing but lyrically destructive songs prevail. Asking young people to "just turn it off" pretends that little would be at stake in their refusal to participate in hip hop culture.

Were parents and concerned fans to do what some rappers and media managers claim they ought to—stop their kids from watching and listening to offensive rap music—most highly successful rappers would not have much of a career any longer and corporate profits would decline. Why, then, do parents and fans make such a suggestion? First, because it parallels the ethically bankrupt and politically empty version of "free speech" too many artists and their representatives espouse. Anyone who doesn't want to listen can "just turn it off," so we can all get to hear and see what we want. But of course we do not get an endless array of options, and some are promoted and pushed much harder than others, creating desires and markets for them. Second, the suggestion to "just turn it off" would shift responsibility for what is being represented from the artists and the industry to the viewers entirely. Third, this suggestion would make it seem normal for the mass media industry to retain the power to decide what gets presented, and our only power is to turn it off. Yes, we should turn it off when we want to. But that's simply not enough. What gets presented creates audience desire as much as it reflects it.

So, if I turn off what I don't like, while millions of other fans are courted by destructive images of black people, the situation still isn't exactly ideal.

The airwaves are public and we have more than the right to "just turn it off"; we have a responsibility to challenge the images and stories carried over them. This is a public discussion that we should continually mount in public spaces rather than limiting ourselves to the private decision to watch one channel or another. In this context, consider the words of Phillipe Dauman, president and CEO of Viacom, who professes interest in educating and empowering viewers:

> That brings me to an equally important responsibility: the responsibility to engage, educate and empower our viewers, particularly young people. We continue to strive to make a positive difference in their lives and our world. This commitment is part of our DNA. . . . And, I am proud to say, we do it very well.[5]

If massive global media outlets such as Viacom, for whom "just turn it off" advocate Michael Lewellen of BET works, were as public-service-oriented as they claim, they would air far less sexist, troubling, and destructive material. But the lack of community access to these public spaces in the mass media makes this challenge very difficult to mount. It is as if corporate media executives know that young people and parents stand very little chance of countering the power of the mass-media advertising, product placement, and celebrity worship that have become central to our media culture. So, they say, "just turn it off—don't watch if you don't like it," knowing that this is virtually impossible given the saturation of hip hop in the marketplace. "Just turning it off" wouldn't be limited to a music video here or there, given the astonishing diversity of hip hop branding. It is in nearly every youth and young-adult consumer market—from music, television shows, footwear, clothing, jewelry, and soft drinks to alcohol, video games, movies, and magazines. And this market presence is used to extract maximum profits, via consistent promotion, from the destructive hip hop trinity of the gangsta, pimp, and ho.

The current state of hip hop is the product of many people and institutions: the executives in the media industry who promote the elevation of politically and culturally destructive culture, especially those who work with hip hop artists; the multiracial fans of hip hop who support these images of young black men and women above all others; and the adults who participate in and support these visions of black music and success at both the artistic and corporate levels.

Personal responsibility is too often overemphasized as the primary source of responsibility in our society, despite the importance of our past and present social institutions and the collective actions that underwrite them. This overattention to personal responsibility makes it hard to see how many groups and individual actions must come together to create what we have, both good and bad. In the case of hip hop, the problem isn't that rappers are solely responsible for the present state of affairs; rather, it's that they and their corporate ringleaders refuse to take any responsibility for what they cultivate and perpetuate. Perhaps the reason is that, once they acknowledge an ounce of personal responsibility, their investment in profits over people is laid bare. Instead, too many rappers stand in as representatives for the music industry and shift total responsibility to parents and fans.

The popular application of the term "role model" is too often used to suggest that anyone in the public eye should behave in excessively proper, stifling, uninspired ways that always follow the rules and norms of mainstream society. It pretends that all mainstream rules are worthy of support and denies that many need breaking and revising. From this perspective, it is not surprising that even conscientious and community-minded artists and fans reject this narrow sense of responsibility to be "positive" when society is itself so very "negative."

But this is not the only way to envision the spirit behind role modeling. There is a larger and more valuable purpose for being a role model, far beyond fitting into rigid social roles. Role models can be powerful agents for change, not just models for the status quo. If we are going to create a just, community-nurturing society where we constantly strive for respectful inclusion for all, where genuine concern and equal opportunity are serious commitments, then what we

project and what we emulate must match these values. There is extensive room for being wildly creative and honest while at the same time exhibiting affirmative good will for our community. Indeed, the bulk of black musical history reflects this tradition. This is not a sanitizing memory; the history of black music contains rough, rugged, and vulgar elements when some such stories require this, but it has generally avoided an internalization and celebration of the worst of American capitalism at the expense of community.

Hip hop has an important place in this black musical legacy, and the signature tales about the pains, pleasures, and struggles of segregated ghetto life in late-twentieth-century urban America that were central to hip hop's earliest commitments most often expressed an underlying affirmative community spirit. Its move toward an anti-community-based kind of glorification and promotion of street-life figures for profit was not inevitable and can be reversed. But redirecting this trend will require us to ask some pointed questions—ones that consider not just the subject of a story but what community values it proposes. Questions like: How much energy and space are devoted to personas, whether the artists' or their characters', that undermine healthy black communities? What kinds of social relationships are valorized in stories about "the 'hood"? Who "wins" in these stories? Who "loses"? How and why? What values do they embody? If the answers to these questions reveal a form of cultural self-exploitation, if the images too often undermine just and loving, politically enabled communities, then we have to become the role models we need and stand against them.

10

Nobody Talks About
the Positive in Hip Hop

It's not about the bling. It's just about doin' good for the hood. I think that's the most important part of the whole situation.

—Jermaine Dupri, *Worth* magazine, April 1, 2006

I believe that every black person has a responsibility. When you do well, everyone is looking at you—every black person. So, you're the same person as Rosa Parks, Martin Luther King, and Malcolm X. I'm not just representing the hood and Roc-A-Fella Records, I'm representing for the whole culture.

—Jay-Z, from the Shawn Carter Scholarship Fund website

If you look at every rapper, every rapper has a not-for-profit organization. Does anybody channel in on that? Does anybody look behind the scenes . . . and say "hey yo, what are you doing in your community?"

—Nelly, during BET's *Hip Hop vs. America* forum in October 2007

People consider me a philanthropist. I give away close to a quarter of my yearly earnings to send children from impoverished neighborhoods to different cities . . . to Disneyland. This gives them another vision. Rap music has changed my life, and the lives of those around me. It has given us the opportunity to eat. I remember sending 88 kids from the inner city on a trip. I went to the local newspaper and TV station, only to be told that the trip wasn't "newsworthy." But if I had shot somebody, it

*would have been all over the news. I threw the largest urban re-
lief concert in history. That never made the front cover of a
magazine.*

—David Banner, rapper, during "From Imus to Industry,"
congressional hearing of September 25, 2007

F ANS OF HIP HOP often grumble that very little attention goes to
 all the good things done by artists and others who participate in
hip hop and the industries that surround it. They often claim—and
they are right—that this contributes to a one-sided and already nega-
tive portrait of artists, fans, and others associated with hip hop. They
see this deemphasis on the positive works done by hip hop celebrities
as part of a larger bias against the music and the youth who feel an af-
filiation with it. It's as if nothing they do is considered valuable in the
eyes of mainstream America.

On the other hand, the negative images associated with these
high-profile artists are partly their own doing; many of hip hop's most
celebrated icons profitably trade on the very images that contribute
to their bad reputation. While many celebrities well beyond hip hop
would like to have their philanthropic efforts emphasized to enhance
their personae, many rappers have the added need to overcome nega-
tive publicity. Food drives, social programs, scholarships, and inner-
city voting initiatives can help do the trick.

Frustrated defenders of hip hop want more attention paid to the
positives in hip hop. Positive hip hop can refer to many different
types of programs, institutions, or images. Some refer to the more
progressive artists (sometimes called "conscious rappers"), who,
while remaining focused on urban black life, do so with more liberal
political consciousness and often avoid using curse words and sexual
insults and limit the use of violent metaphors. These artists—the
more visible ones are Common, Lupe Fiasco, Mos Def, KRS-One,
Tribe Called Quest, OutKast, Dead Prez, and Talib Kweli—are often
mentioned as notable examples of what is good about hip hop but
also often overlooked in the frenzy to condemn all that is associated
with hip hop.

Others refer to activists who do good work through hip hop style, music, dance, poetry, and art to help young people express themselves and to keep them interested in school by using hip hop to teach literature, poetry, and history. Yet these activists, teachers, and grassroots leaders, too, often find that they cannot generate attention or support for their sacrificial efforts despite their successes in helping students. The absence of public pride and affirmation is especially disheartening when we realize that their work is often low-paying, exhausting, and unstable; many grassroots groups survive on patched-together and partial grants.

Finally, there are the philanthropic and charity-based works of the most popular and financially successful rappers. These efforts, what Jermaine Dupri refers to as activities that do "good for the hood," are another part of the positive in hip hop that goes underreported. Chapter 12 will focus on progressive artists and activists, so the present chapter concentrates on the good works done by some of rap's most visible stars. What kind of work are they doing? What role does philanthropy or charity play in the larger careers of these artists? And what role does charity play in the advancement of social justice?

The philanthropic work of many black celebrities is either ignored or mentioned only in passing by mainstream media, more as a bulletin than a story worthy of attention. While this underreporting is part of a general trend in popular media (negative and sensational attention is more popular), it also reflects the way racial imagery works. What makes a black person newsworthy? The overemphasis on representing black people in negative terms (focusing on crimes, violence, and other trouble), along with the disproportionate silence about their good works and actions, has long been understood as a driving force behind the establishment of black newspapers, magazines, and other media outlets.

Of course, celebrities who have their own highly popular outlets and can stir up sustained interest in their good deeds—as Oprah's project in South Africa has done—fare far better than others. But other black celebrities who are doing similarly inspired work struggle to sustain mainstream media attention. Basketball player

Dkembe Mutumbo's heroic efforts to raise money for the building of a much-needed hospital outside of Kinshasa in his native country, the Democratic Republic of Congo (formerly Zaire), have received humanitarian awards but little media attention. It seems back-page news, an afterthought, really, even in a sports journalism field that is otherwise very interested in "off the court" stories about athletes' activities. The gap in coverage is especially noticeable when we consider how much ink is spilled over the misdeeds and excesses of black celebrities. For example, Michael Vick's dog torture scandal remained front-page sports news for quite a while. This is not to say that others' misdeeds go unnoticed; there is a high premium on celebrity crimes, gaffs, drug problems, divorce, and other problems across the racial board. Rather, my point is that the shortage of affirmative coverage for already wildly popular black celebrities contributes to an overemphasis on negative black actions, conflicts, and misdeeds.

Other factors play a role here. Some are skeptical of the good works of high-profile rappers who may otherwise represent a negative force. For example, *New York Times* reporter Lola Ogunnaike has written that rappers are sweetening their image and "cultivating their philanthropy" as a way to secure mainstream sales and successfully manage their brand. The charity, scholarships, and other philanthropic works by artists such as Jay Z, Ludacris, and Nelly may be perceived as effective public relations efforts, not just as efforts reflecting a genuine concern and interest in making a serious, positive difference. This perception may be true; as Buffy Beaudoin-Swartz reports, "research has shown that the vast majority of Americans have a positive image of companies that support the causes they care about, and many consumers say they would switch to a brand associated with a good cause." In short, philanthropy can be and has been a powerful tool in crafting a successful public relations and marketing strategy. This is especially true for companies and "brands" that need to overcome negative images, such as hip hop.[1]

At the same time, it seems overly skeptical to perceive all of this charity work as mere strategy. Many high-profile artists have well-

developed philanthropic and charity programs to which they seem quite dedicated. Probably both characterizations are true: At the same time that these artists are shrewdly "giving back"—a well-known and successful public relations and marketing strategy—they have heartfelt ties to the young people in the poor and fragile communities to which they contribute.

Giving B(l)ack

The spirit of giving back is a powerful one and has a long tradition in African-American communities, beginning in the 1700s in black churches where members, especially women, raised funds to found trade schools and improve living conditions in their communities. This history is quite noble as it reflects the efforts of people who, despite having very little to give, helped others in need, spoke out about injustices, founded trade schools, established scholarship funds, and channeled funds to promote better living conditions. These weren't just casual individual decisions to give; "giving back" was part of a powerful ethos born out of black communities throughout U.S. history. These communities have long had to rely heavily, if not entirely, on a variety of self-help, community-based strategies since equal access to mainstream organizations, jobs, civil servant positions, and municipal aid organizations has been denied or only insufficiently provided.

According to a recent study conducted by the Chronicle of Philanthropy, African-Americans give 25 percent more of their discretionary income to charity than do others of similar income. This is quite remarkable given the images perpetuated in some mainstream conservative circles of African-Americans as takers rather than givers, as people disproportionately dependent on government aid.[2]

In light of this tradition, it makes sense that many African-American rappers would be keen on giving back. Of course, their particular lives and histories also inspire them. As Diddy says on his website: "Bad Boy's rising success allowed Mr. Combs to follow through on his private vow to give back to the community that had supported

him in his youth and career." Jay-Z, on his Shawn Carter Scholarship Fund website, also notes: "I'm blessed with all of the successes that I've had, I know that. But I think anybody that came from the projects can look at my story and say: 'I can do that, too.' I want kids coming up to see I'm doing my own thing and I'm successful at it." This giving is especially important now that black charities, which had a very small share of grants from traditional foundations, are shrinking. According to the Foundation Center, allocations dropped from 3.8 percent in 1998 to 1.6 percent in 2003.

Highly visible hip hop artists, producers, and moguls have developed many avenues for aiding underserved, underprivileged communities that are often overlooked in the scope of philanthropic giving. Several of these multimillionaires in hip hop focus their philanthropy on local education, grassroots organizations, and the arts—crucial and highly underfunded organizations and institutions in lower-income urban communities that have been de-funded by federal and local leaders.

Russell Simmons, considered the leader of hip hop philanthropy, encourages others with fame and fortune gained through hip hop to follow his lead. Simmons is the founder of the Hip Hop Summit Action Network (which has awarded artists for their charity) as well as the head of the Rush Philanthropic Arts Foundation, which gave away about $523,000 in 2004 and raised more than $2 million in 2005. He also gives in smaller, more targeted ways, taking time out to "personally investigate potential beneficiaries." In an interview on *The O'Reilly Factor*, Simmons referred to a program in Chicago called Anota, which he said is an ongoing dialogue between police and the community. "[B]ecause of this dialogue," he pointed out, "they have a much greater cooperation and appreciation with the police from the community. And the police have learned different levels of respect."[3]

In 1995, Sean "Diddy" Combs created several educational initiatives for inner-city youth collectively called Daddy's House Social Programs. These initiatives include the Daddy's House Weekend Boys and Girls Club, which provides academic tutoring and the

teaching of life skills to hundreds of kids every weekend during the school year; a three-week course that teaches the basics of the stock market and financial skills, called Daddy's House on Wall Street; and travel and summer camp programs and internships at Bad Boy. His highly promoted run of the New York City Marathon in 2003 raised more than $2 million for children's charities. And he has been active in his organization Citizen Change, which sponsored the "Vote or Die" campaign in 2004, promoting voting among young people and minorities. Combs also works with other charities such as VH-1's "Save the Music" and a pediatric AIDS charity, among others.

Shawn "Jay-Z" Carter founded the Shawn Carter Scholarship Fund, which identifies underserved students who have fallen through the cracks of traditional scholarship programs:

> Historically, scholarships are offered to youth who have demonstrated high levels of academic achievement and extra-curricular involvement; the emphasis being community involvement and self-awareness. As a result, average students (i.e., C students with grade point averages of 2.0) are virtually ignored by all scholarship foundations. Youth that progress at a steady or satisfactory pace in their educational and social endeavors fall off the radar. The Fund provides disadvantaged youth, non-traditional High School graduates, GED recipients, and those who have been formerly incarcerated, an opportunity to fulfill their desire to attend college.[4]

The company goals are also a powerful statement of commitment. They include challenging economic disparities by providing higher educational opportunities to inner-city youth and encouraging "average student[s] to challenge themselves to movement beyond complacency and peer conformity" as well as to "bridge the gap between consumers to becoming entrepreneurs through mentorship."

In addition, Carter teamed up with the United Nations and MTV to produce the documentary *The Diary of Jay-Z: Water for Life*, a compelling film about the world water crisis that brought attention to the fact that 1.1 billion people have no access to safe

water. Using "Water for Life" as the name of his world tour, Jay-Z sustained attention on the issue far beyond that of the viewers of the MTV documentary.

Chris "Ludacris" Bridges has been active in helping Katrina victims, and through his foundation, the Ludacris Foundation, he works to "inspire youth to live their dreams, uplift families and foster economic development." Founded in 2001, his foundation revolves around what he calls the "Principles of Success," including "self-esteem, spirituality, communication, education, leadership, goal setting, physical activity and community service." Since 2003, in the wake of the cancellation of his contract as a Pepsi sponsor, Bridges and Pepsi have had a $3 million partnership "to support community groups." Bridges also works to support the National Runaway Switchboard; according to NRS, their collaboration to help runaway youth has resulted in a 17 percent increase in calls to the switchboard.

Other Hip Hop Philanthropists

Numerous other hip hop philanthropists have also made a name for themselves, including the following:

50 Cent has a G-Unity Foundation that has donated funds to the Boys Choir of Harlem, the Compton Unified School District, Queensborough Community College, the Jam Master Jay Foundation, the National Alliance for Public Education, and Teach for America.

Chingy, a rapper from St. Louis, founded "Chingy for Change," which is primarily a college scholarship program. He holds fundraising concerts and visits local schools to encourage kids, "telling them that there is a way out of poverty."

Queen Latifah has generously supported Acting for Women as well as the Cambodian activist Somaly Mam, whose group rescues girls from prostitution in Southeast Asia.

Jermaine Dupri helped launch Hip-Hop for Humanity, a "relief effort which is unifying the hip hop community to provide financial support for the victims of the September 11th tragedy."

Dr. Dre gave $1 million to the World Trade Center Relief Fund.

As for rapper Nelly, in keeping with the tradition of negativity getting more attention than charity he received far more attention for the drama associated with his visit to Spelman College on behalf of his bone marrow transplant charity than he did for the same work before the ill-fated trip to Spelman. Founded on behalf of his sister, the Jes 4 Us Jackie Foundation works to educate African-Americans about the importance of signing up to be bone marrow donors in order to create more possible African-American matches. When Nelly planned to visit Spelman for a bone marrow drive, a group of Spelman students who were upset with Nelly's now-infamous "Tip Drill" video felt that if Nelly wanted to come to campus and use Spelman's name and community to promote this good cause, he should be willing to talk with concerned feminist students about the sexist images that now dominated rap videos and his song "Tip Drill" in particular, meant to be aired on the late-night, TA-mature-rated BET video show "Uncut." "Tip Drill" is a sexually explicit song and video about Nelly and his friends looking for women to have sex with. There seem to be multiple definitions for "tip drill": slang for a girl who is considered ugly but who has a nice ass, a man who is considered ugly but has money, or a woman with a large enough behind to bury a man's penis between the buttocks and simulate sex. The term can also be used as a sexual revision of the basketball warm-up exercise ("drill") in which many players take turns touching the backboard ("tip"), which is intended to suggest group sex with one woman. The constant close-up footage of black women's naked, gyrating behinds, Nelly's credit card swipe between the buttocks of one woman, and the lyrics "It must be your ass cuz it ain't yo face" and "It ain't no fun 'less we all get some" suggest that all of the above definitions are potentially applicable.

Contrary to much public media, the members of the Feminist Majority Leadership Alliance at Spelman did not want to prevent Nelly from coming or to protest his visit. Rather, they wanted to use his visit as an opportunity to hold a conversation with Nelly about his video and, more generally, the troubling power of sexism in hip hop. Nelly refused to meet with these women and chose to cancel the trip rather than speak with them about their concerns. As Spelman student and protest organizer Moya Bailey reported:

> Our intention was to do exactly what Nelly stated on the program. We planned to have him come to campus and meet with a small group of concerned students, something he was unwilling to do. Not only that, we still had a bone marrow drive and all the students initially involved registered to donate bone marrow! The foundation was apparently so upset about this issue that THEY went to the press, saying that Spelman canceled the drive because of the video "Tip Drill."[5]

Nelly's incident with Spelman captures a fundamental tension at the heart of hip hop philanthropy. If black artists in hip hop make millions of dollars pandering images that degrade black people and then give that money back to the community in the form of charity to uplift them, aren't they fundamentally undermining the spirit of "giving back"? Doesn't this behavior mimic the manipulative pattern of an abusive lover (or pimp) who insults and injures and then showers his victim with gifts? *Forbes* magazines' Richest Rappers list ranks Jay-Z as the number-one richest rapper, grossing $34 million; 50 Cent comes in second, grossing $32 million; and Diddy is third with $28 million—and these are their incomes in 2006 *alone*.[6] Isn't it hypocritical for artists to glamorize their history of drug dealing— deriving their earnings from endless tales about being gangstas who, for the most part, die young or spend most of their lives incarcerated, and pimps who revel in and exploit the objectified bodies of black women strippers and prostitutes—and then to use the monies generated from perpetuating these images to support stay-in-school efforts and bone marrow drives? Isn't it ultimately destructive, since

the celebrated path of such compelling icons continues to get more press than a handful of scholarships? This is the contradiction in which Nelly got caught. He wanted the Spelman community's support even though some members of that community felt that his celebrity was fueled by harmful images and attitudes about black women. Why didn't he elect to talk with them in private, and to face the possibility that his public images were harmful enough to undermine his service?

In short, big money comes from the successful fashioning of alluring and rhetorically powerful stories that normalize and often even celebrate images of black people as thuggish, promiscuous, sexist, and violent. And if these long-standing images of black people, which are perpetuated most visibly by highly profitable rappers, have served as ammunition and justification for policies that help destroy black communities, then what good is this philanthropy? Isn't it—no matter the good intentions—taking from black people with one hand and giving back with the other?

Popular media journalists and pundits are given ample public space for reinforcing the notion that blacks are violent, deviant, and sexually irresponsible. The context for receiving these images is the continuation of mainstream beliefs that black people, especially poor ones, are culturally dysfunctional and fully responsible for their unequal condition. Robert Entman and Andrew Rojecki, media scholars whose work centers on racial imagery, have noted that "whites we interviewed spontaneously referred to media images of sexuality and violence that supported their negative views. These images substituted for the absence of sustained contact between whites and blacks."[7] Thus, it matters how black people are represented and what images, ideas, and icons are endorsed and perpetuated. Philanthropy cannot undo what constant repetition in mass media reinforces.

Beyond the issue of how others see black people lies the matter of how black people see themselves within these commercially dominant images. What gets celebrated there cultivates as much as, if not more than, it reflects. Hip hop certainly did not create the larger conditions that are apolitically overemphasized in the music, but its

commercial take on the hip hop trinity of ghetto life—the pimp, ho, and hustler—gives it prestige and allure. The expansion of the hustler's philosophy as a model for black masculinity and a template for personal success corrodes already brittle communities from inside. The monies "given back" cannot begin to compensate for the damage to spirit, social relations, and self-image that most of commercial hip hop has wrought.

This kind of trade-off is what defines the idea of "blood money," a term that refers to payment made to the family of a murdered person. The money is provided as compensation for a devastating loss, one that cannot bring back the dead but that is intended to soothe the wound resulting from the loss. In a sense, the portion of hip hop's profits generated from constant celebration of black suffering, despair, and violent and sexist street economies returned in the form of charity is a kind of blood money, a "compensation" for what amounts to a devastating loss of self-worth. Instead of celebrating black life in a way that sustains community, instead of reversing the legacies of socially fostered self-destruction by nourishing resistance, love, and community health, commercial hip hop has become the home for images and icons of black death. It contributes to the spiritual death of the next generation and nurtures an exploitative model of profit at high social cost to the community. No matter how much rappers who perpetuate these destructive images "give back," they won't reverse the deaths in heart and mind to which these images contribute. Blood money never brings back the dead.

Charity, absent a powerful social justice agenda, fosters the status quo even as it temporarily abates the symptoms of inequality. It can be disempowering, turning citizens into grateful recipients and democratic participants into spectators. Celebrities who bristle at being held accountable and expect their charity to override their negative contributions to black community building are not connecting with or giving back to serious community empowerment. Giving back is most empowering when it enables democratic participation toward greater social justice. Joining charity to justice changes the entire formula; it minimizes, for example, the contradictions inherent in

Nelly's response to the Spelman women who wanted community representation and inclusion in exchange for their participation in his bone marrow drive. Charity wedded to justice emphasizes group empowerment over individual survival and personal achievement, especially that which undermines community health. It demands accountability and has the potential to create lasting social change.

PART TWO

Progressive Futures

11

Mutual Denials in the Hip Hop Wars

DESPITE THE DEPTHS OF CONFLICT and ostensible lack of common ground in the polarized war over hip hop, if we look carefully at this public stand-off, we'll find something rather startling. The seemingly absolute opposition isn't so very absolute. The anti–hip hop camp and its archrivals represent divergent political positions and generate very different images and points of emphasis, but they actually share six important underlying beliefs. Neither side admits to sharing these beliefs or to maintaining silence about their contents—and, indeed, such denial helps perpetuate the very problems that have taken root in commercial hip hop. Thus, these six beliefs have become foundational assumptions on which the battle over hip hop takes place. What is taken for granted? What contradictions suit the positions of both the hyper-critics and the super-defenders? What effects does silence have on our understanding of the war over hip hop?

Revealing the mutual denials and silences in the hip hop wars is important because it helps us envision the anchorage points for a progressive and pro–hip hop politics. Further, disclosing the underlying terms of agreement between the two sides of the debate can help consumers make informed and politically progressive decisions in a confusing environment. It can also guide young people who want to shape the direction of hip hop along lines that do not hurt black or any other communities. Sometimes what isn't said, what people don't mention, is as important as what is constantly shouted from the rooftops.

217

Creative Disregard

Both sides in this public battle disrespect the power of challenging and expanding the creative ceiling of hip hop and apply low defining standards to the art form. Some severe critics think it is barely music or even compelling rhyme or storytelling, describing it instead as simple-minded rhymed rantings. Social critic Stanley Crouch, who appeared on both Oprah's *Town Hall* and BET's *Hip Hop vs. America* forums has said that rap is "dick and jane with dirty words. It is not a very complex art form or much of anything."[1] The blanket rejection of the creativity in hip hop is categorical for some critics; hip hop is not music, the rhymes are not poetic, and everything about it is simple and requires no special talent. Among hip hop's supporters, there are hyper-pro hip hop fans and activists who are so busy defending hip hop (and sometimes supporting what sells, because it sells) that even the most banal, repetitive, lyrically uncreative music like "The Whisper Song" by the Ying Yang Twins, and D4L's "Laffy Taffy," tends to get a pass.

Not nearly enough commercial public conversation addresses the nature of creativity in hip hop, what innovations have taken place, or how musical production techniques and rhyme styles have been elaborated and refined. The marginality of serious engagement over the creative value of hip hop has reduced the literacy about hip hop even among its most ardent fans and has thus lowered the standards for creative embrace of the music.

Cultural knowledge about music and other expressive forms is developed, learned, and shared by fans, artists, and critics. Black musical forms have long suffered from profound levels of underappreciation by various public writers and institutions, especially during the early years of these forms. Jazz, now considered one of America's greatest art forms, was for many decades considered a sign of the decline of American music. The lack of literacy about such musical expressions impacts not only the quality of listening among fans but also the depths of society's investment in the music. The response of the record industry to hip hop (e.g., keeping music and video production budgets lower

than for other genres, discouraging costly live instrumentation, etc.) is part of this long-term underinvestment in black musical creativity. Rappers' own empire-building model of success also contributes to the lack of emphasis on developing and expanding the music in the genre. As comedian Chris Rock humorously noted in *Rolling Stone*:

> Nobody's into being a musician. Everybody's getting their mogul on. You've been so infiltrated by this corporate mentality that all the time you'd spend getting great songs together, you're busy doing nine other things that have nothing to do with art. You know how shitty Stevie Wonder's songs would have been if he had to run a fuckin' clothing company and a cologne line? Plenty of rappers say, "I'm not a rapper, I'm a businessman." That's why rap sucks, for the most part. Not all rap, but as an art form it's just not at its best moment. Sammy The Bull would have made a shitty album. And I don't really have a desire to hear [billionaire] Warren Buffett's album—or the new CD by Paul Allen. That's what everybody's aspiring to be.[2]

Not surprisingly, then, a great number of listeners with unnecessarily limited aesthetic literacy are growing attached to the current musical and lyrical standards in hip hop. Too many lack the language of appreciating the more complexly rendered rhymes or musical composition, while rap's biggest stars expand their product lines and dedicate lyrics to promoting them. As journalist Gil Kaufman has noted: "With the success of the Roc-A-Wear clothing line and the recent purchase of the Armadale vodka brand, Jay has products of his own to hype (check the lyrics to 'All I Need'). Same goes for Puffy name checking Sean Jean, or the Ruff Ryders giving shout-outs to Dirty Denim, because why give others free advertising when you can help yourself out?"[3] Because of this multifaceted divestment from the music, a great many fans are being encouraged to unwittingly contribute to the "dumbing down" of the genre. Then, the presumed need to keep it simple—to please the audience who supported the last basic rhyme and beat that did well financially—generates ever more basic rhymes, and so it goes.

This "dumbing down" has an especially profound effect on lyrics, within which complexity can be challenging for listeners. Many of hip hop's most talented lyricists have been told that they must make their rhymes more simplistic, less metaphorically sophisticated, if they expect to sell records. Lupe Fiasco explores this issue with exceptionally complex lyrics and a catchy hook in his satirical song "Dumb it Down." Others have admitted that dumbing lyrics enhances sales. Jay-Z, for example, in his song "Moment of Clarity" raps: "I dumbed down for my audience to double my dollars" and says that if skills sold, he'd be "lyrically Talib Kweli." Our ability to hear and appreciate the most in-depth and layered storytelling music is a developed skill, nurtured by regular listening, participation, vigorous public conversation, and critical engagement. Without this skill, our ability to appreciate those with the most talent is undermined.

There is far too much comfort with the underdevelopment of aesthetic appreciation for hip hop; too many rappers with enormous talent and plenty of money (so paying the bills is no longer an excuse) capitulate to this market substandard and thus contribute to the reduction of market value of more complex rhymes, creative risks, and unexpected collaborations. Record executives and the companies for which they work are driven primarily by the celebrity value and the bottom line. Creativity is governed by sales and profits. So, although many executives will talk a good deal about artistic freedom and their role in protecting the truth-telling core of rappers' stories, for the most part this is true only when rappers generate profit and remain successful in market terms. Once a style or technique or rapper is seen as "hot" or highly profitable, then the goal is to find a way to reproduce it. And although record, radio, and television industry executives claim that they are simply following existing trends, their "follow the money and work the land until it is barren" attitude contributes to a narrowing of creative options for artists and fans.

Although the two sides appear to have entirely different stakes in the music, those who find no creative value in hip hop whatsoever and those who most profit from its creativity (mass media corporations and rappers' biggest sellers) wind up collectively denying the

importance of investing in the creative expansion and diversification of the genre.

Unadulterated Products

Each side of the hip hop debate often pretends that the record industry and the media-marketing apparatus that fuels and shapes it are just conduits that bring "pure" black cultural expression and experience to "a store near you" without any interference, without shaping the image, lyrics, or sound. Of course, the opposite is true now more than ever. As described in the Introduction to this book, once hip hop began evolving into a fixture in mainstream youth music and culture, the big music corporations took a direct and heavy-handed interest in determining which artists were signed, promoted, and marketed throughout the media. Much earlier in hip hop's development, the record industry relied heavily on smaller labels and local promoters (who were far more dependent on local fan input) to serve as informants and kept a more hands-off approach to content. By the middle to late 1990s, the financial successes of gangsta and then pimp-oriented hip hop produced much greater direct and hands-on attention from large record company managers. This dramatically increased their influence on what music was available and whose music played endlessly on powerful outlets such as "urban contemporary" radio stations, BET, and MTV.

For those who publicly denounce hip hop, the depth of corporate influence on its content is nearly always twisted in such a way as to suggest that the record companies are responsible only for serving as a neutral outlet—a conduit, really—for black culture and, thus, black fan desire. Their role as industrial plants for sound and rhyme that turn creative raw materials into industrial products is rarely acknowledged. The power they can exert to make sure they get their artists played repeatedly on corporate-controlled radio stations shapes listeners' sense of "what is" and "what is hot" in hip hop. Surely, many artists benefit from grooming, education about musical production techniques, and other aspects of being part of the music

industry. But the industry has a powerful impact on determining what and who is at the center of the music and culture, and what is therefore considered profitable.

Some heavy-handed anti–hip hop critics reinforce the illusion that what we get in mass-marketed hip hop is a reflection of "pure, un-tainted" black sounds, ideas, and values. They talk to and about rap-pers almost entirely in a vacuum, avoiding the mention of both extensive corporate influence and the fact that fans of all back-grounds, but especially whites, enjoy hip hop. It is as if corporate de-cisions, influence, and guidance have nothing to do with the careers of major, highly visible artists. This scenario helps convince the pub-lic that the unwanted elements in hip hop are the product of young black people's imagination alone and that the most we can do is ask corporations to stop playing or promoting hip hop in the interests of "decency." Illuminating the deeper role of the industry in the manip-ulation and manufacture of black images would reveal the depths of the larger society's cultural complicity in what we think black culture is and what, therefore, will "sell" as black culture. In other words, the black ghetto gangsta, pimp, and ho are as much about ghetto life as they are about racial imagination and desires about black people.

Corporate representatives and those artists who defend all things hip hop also deny the depths of corporate influence on hip hop. In-dustry executives want to maintain their appearance as open-minded cultural outlets. In Byron Hurt's film *Hip Hop: Beyond Beats and Rhymes*, Hurt asks BET executive Stephen Hill about reinforcing stereotypes. Hill replies: "Probably what should happen is you should look at people who are actually making the videos. We play the videos that are—that are given to us." Hill wants to claim that the record la-bels and producers who make the music videos to promote records are to blame, whereas BET just plays them. Russell Simmons has re-sponded to similar concerns about hip hop content by referring to the rappers as poets who speak their truths and to the lyrics as "a product of their experiences." Surely there's a valuable grain of truth in this; many rappers (but surely not all!) are talented poets, and some speak out about the oppressive conditions that shape hip hop content. But

commercial rappers' lyrical content is not a pure reflection of lived experience. Record label executives exercise censorship and manipulate content in hip hop away from things they think will get them into political trouble (which, in turn, might reduce sales) and toward that which they think will sell mightily without too much protest.

Corporate-sponsored hip hop artists, too, feel compelled to support this fiction, because their status as "authentic" troubadours of ghetto life (uninfluenced by corporate pressures) is crucial to their identity as renegades who speak as artists and draw directly from personal experience, or at least appear to. There is an incredibly powerful scene in Hurt's *Beyond Beats and Rhymes* in which he invites some young men to showcase their rhymes and they enthusiastically break into stereotypically gangsta-style raps about raping bitches and shooting people. Hurt tells them that this is what young aspiring hip hop artists offer to rhyme about wherever he goes: killing and bitches. In reply, one young man breaks into a well-composed and reflective rhyme about alternative futures he has imagined for himself and the consequences of choices. Upon finishing he says, "That's nice, but nobody wants to hear that right now. The industry usually don't give us deals when we speak righteously. . . . [T]hey think *we* don't want to hear that." Another man jumps in: "How many MC's you see in the industry right now talking something positive? None. They're doing it because they said, 'I wanna get there.' They're gonna do whatever we can do to get there. That's what it is."

Although it's well known that mainstream commercial hip hop's obsession with black gangstas and ghetto street culture is a product line, the illusion that it is unadulterated remains. So, everyone "agrees" that rap music, despite its extraordinary expansion as a brand, is the truth from the streets of the black ghetto, uninfluenced by corporate agendas for profit, by white desire to consume black violence and sexual excess, and by rappers' own desire to feed such desire for their own financial gain. This collusion of denial supports the belief that "authentic" black people are criminals, that being poor is a "black thing," and that corporate-sponsored rap has had no impact on hip hop content or in any way shapes our access to hip hop artists.

Profiting from Black Suffering

Both sides in the hip hop wars implicitly accept the realities of black suffering and inequality, identifying them as justification for what hip hop has become when it suits them, but generally standing by with little outrage as the conditions of poor black communities worsen. Neither side expends much energy developing a sense of urgency about the devastated life in poor black communities today. And anti–hip hop critics, in particular, rarely mention the structural context for what are decidedly problematic behaviors, preferring instead to call the whole thing "dysfunctional black culture," and thus wash their hands of the entire affair.

The regular reference to black culture, images of black crime, and sexual excess overshadows the structural factors that have produced social decline; this emphasis generates support for a conservative focus on behavior. Uncritical hip hop promoters and artists enjoy the success and visibility that "performing" fantasies of ghetto life brings them. They know that reminding mainstream America about black suffering and its direct relationship to hundreds of years of racialized oppression—not least in its present-day form—is a buzz kill, especially for many white fans. Images of black suffering that implicate society don't sell records to those who want a ghetto version of Disneyland. They also don't support naive consumption across the color line. Keeping our eye on black suffering and why ghettos are what they are and how they came into existence would challenge record executives, artists, and fans of all backgrounds to think about exactly what they are packaging, normalizing, and celebrating.

Illuminating this urgent context for hip hop would be like promoting tourism with a colonial critique built in. Avoidance of the reality of gross inequality is the reason tourist resorts in desperately poor warm-weather countries are so walled off from the lives and spaces of local residents. Such compound-style vacationing gives tourists a manufactured connection to an island or a people but keeps them buffered from the suffering, inequality, and oppression that define the exchange. This is not unlike the kind of ghetto tourism that too

much commercial rap music provides. A white female fan interviewed in *Beyond Beats and Rhymes* describes the racial tourism that frames her consumption of hip hop:

> I've never been to "the hood." I've never been to a ghetto. I grew up in, you know, upper middle class, basically white suburbia—we had a very small minority in our town, and that was it. And to listen to stuff like that is a way [for] us to see almost a different cul—well a—a completely different culture. It's something that most of us have never had the opportunity to experience. I've never had to worry about drive-by shootings and the stuff in the music. It appeals to our sense of, um, of learning about other cultures and wanting to know more about something that we'll never probably experience.

Where's the fun in actually living in the kind of environment in which street-level drug dealers, street prostitutes, and pimps ply their trade? Instead of this grim reality, hip hop gives far-flung fans—many of whom populate relatively comfortable and nonblack environments— the black pimp, criminal, ho, trick, drug dealer, bitch, hustler, gangsta, and parolee without the actual suffering, without any reference to the larger social policies that have disproportionately produced these figures and the conditions in which they flourish. This tourism is fed by the pleasures of black music and style (which carry an allure all their own), constant "advertising" through corporate venues, and the continued legacy of cross-racial fascination with black street life.

Many hip hop supporters who defend the exaggerated expansion of thuggery and hyper-aggressive machismo say that it's society's fault since thugging and drug dealing are direct outgrowths of racial and economic discrimination. However real these connections may be, there is little challenge to such images as forces of destruction in the same black communities. The thug both represents a product of discriminatory conditions and embodies behaviors that injure the very communities from which it comes.

Two examples of this dynamic are the distorted culture of "no-snitching" and the veneration of the hustler. Once limited to criminal

subcultures, the idea that giving police any information on a crime is itself a crime has expanded into everyday speech and standards for action. Some of the suspicion and hostility directed at the police is completely reasonable. Despite the heroic and community-supporting efforts of some officers, police forces as a whole have systematically mistreated and discriminated against black communities, especially poor ones. A lack of trust and a deep sense of fear are born of communities being terrorized by a culture of racism that has permeated police forces around the country in all the time that we've had had such forces. The expansion of the culture of no-snitching into everyday life is animated by this negative experience with the police, but it ends up empowering criminal subculture, not the community as a whole. Many poor black communities are trapped between violent and unscrupulous police and criminals. Following the criminal code of no-snitching deprives these communities of ways to protect themselves from criminals and to legitimately seek justice for crimes against law-abiding citizens.

Hip hop's embrace of criminal subculture has helped expand this no-snitching ideal and further legitimates criminals' exploitation of black people's reasonable doubt about the trustworthiness of the police. Lil' Kim, Busta Rhymes, and others have refused to share information with police because doing so would seriously damage their credibility. Lil' Kim went to jail for lying rather than be considered a snitch. Jay-Z's "Justify My Thug" song contains the line "I will never tell even if it means sitting in a cell." And Busta Rhymes, as detailed in Chapter 3, has refused to speak with the police about the murder of his bodyguard, Israel Ramirez, despite the fact that he claims to have been present during the shooting. Refusing to share information adds to Busta Rhymes's street and, thus, hip hop credibility. But while this may make for a great hip hop media story, the reality is that refusing to give information about serious crimes only empowers criminal activity and vigilante justice; it does not reduce police brutality or racism.

The fact that criminal subcultures manipulate black people's justifiable suspicion and fear of the police by equating the reporting of

a crime with "snitching" is itself a powerful example of a hustle. A hustler is a person who uses his or her exceptional enterprising talent to dishonestly sell something. Hustling (in the sense of "working hard") can go on in any industry, but being a hustler usually involves illicit economies: sex, gambling, drugs, and general criminal activity. The fact that poor black people have been economically excluded and marginalized and disproportionately kept at entry-level positions has aided the expansion of various illicit economies — especially since the 1970s, when entry-level industrial jobs rapidly began drying up.

The glamour associated with hustling as a form of economic success increased during this period and has become a nearly completely legitimated standard in hip hop. Being a hustler is *the* central model of success. Hip hop rhetoric presumes that the "normal" mode of success (schooling, hard work, and talent provide opportunity and upward mobility), as a model for "getting out of the ghetto," is completely cut off for black youth. Independent, most likely illegal, entrepreneurial activity is the only way. Being a hustler isn't just a model of hard work outside legitimate avenues. It is also a model of profitable dishonesty. A hustler takes advantage of his "buyer" and profits from doing so. A hustler represents a dog-eat-dog model of capitalism for the excluded.

But when the ghetto street-hustler is venerated, who is it we are happy to see getting hustled? Sure, it is exhilarating to imagine that with the right level of energy and skill, even those who have been given the shortest end of the economic stick can make it. But this model of success doesn't challenge systemic discrimination and unjust treatment; it winds up revering and mimicking it. It most hurts other poor people. Why internalize and celebrate an exploitative model of dishonest profiteering?

Both the glorification of the hustler and the expansion of criminal subcultural standards like "no-snitching" are twisted appropriations of responses to structural discrimination. They are difficult for some to reject because they seem to represent models of community survival under duress (and they are sometimes conveyed with inimitable

style!), but in fact, they contribute to the decline of trust and mutuality. Both are necessary ingredients for community survival.

Conservatives use the specter of the "black ghetto thug and ho" to generate solidarity and power, rappers perform these roles for profit and prestige, and the record industry promotes them for profit and market share. As Chuck D has said many times, black death is very profitable.

Invisible White Consumption

Both supporters and detractors underplay the role of unexamined desires among many white fans to consume destructive stereotypes of black people, especially if and when they are perceived as "authentically" black. Some supporters also deemphasize white fans' maintenance of their own racial privilege as integral to their appreciation of hip hop. In fact, many hip hop advocates argue that hip hop is a project of racial unity. Russell Simmons described hip hop as not seeing color and only seeing culture (referring to hip hop culture): "Hip hop is the most unifying cultural source this country has ever seen. It forms a relationship between people in trailer parks and people in the projects. They are not only seeing their common thread of poverty, but also their oneness."[4]

Surely there are many factors that give people born in the post–civil rights era a new and sometimes refreshingly open perspective on cross-racial exchange and community. And the wide range of underground scenes around the country carries more possibility for developing a potent progressive cross-racial politics. But the racially stereotypical content of commercial hip hop consumed by many young white fans is omnipresent. This consumption is compounded by a general lack of knowledge of the history of black culture or racial oppression, the workings of white privilege and power, and few lived experiences with black people. This context for racial exchange in hip hop undermines the possibilities for racial unity and equality. There is a long and complicated history of how and why white youth use black culture that they can consume and imitate (music, fashion,

slang, etc.) without having any meaningful grasp of black culture and the history of racism, especially the ways that black expressions and images have been produced, channeled, and repressed. However, the post–civil rights era has also brought a new twist on the love/hate dynamic that has shaped the compound history of white racism and white fascination with black people and culture: color-blindness.

Commercial hip hop, as it has evolved since the mid-1990s, represents a new fascination with old and firmly rooted racial fantasies about sexual deviance (pimps and hoes) and crime and violence (gangstas, thugs, and hustlers). These images drive the racial subtext of white consumption of commercial hip hop, but now, this distorted form of cultural exchange is framed/masked by a post–civil rights rhetoric of color-blindness. The idea that hip hop is for everyone — that it represents a new moment of multicultural exchange where white consumption is no longer about racial consumption (no more white negroes, hip hop is the new multiculturalism) — denies the fact that mainstream commercial hip hop consumption has been propelled by the same images and terms of appropriation that have consistently shaped mainstream consumption of black style and music and that they take place under vast and entrenched forms of racial inequality. Spike Lee's 2000 film *Bamboozled* is a brilliant satire on this dimension of black media hyper-popularity past and present — including hip hop — and reveals the complicated collusions of white desire for black "authenticity" and for stereotypes that are based in white supremacist ideas. Lee holds black managers and artists accountable for promoting and performing the images, and still keeps his eye on the larger white-dominated corporate interests in profiting from the entire project.

A hallmark of post–civil rights racism is the public renouncing of racial prejudice and claiming either not to see color or the absence of its significance. But color-blindness is not what its name suggests. Post–civil rights color-blindness, says scholar Charles Gallagher, "does not ignore race; it acknowledges race while disregarding racial hierarchies by taking racially coded styles and products and reducing these symbols to commodities or experiences that whites and

racial minorities can purchase and share." Researchers have also shown that white fans of hip hop take up a color-blind approach to the consumption of hip hop's black coded images, stories, and style as a means by which to retain the associations with progressive coolness afforded by black culture through hip hop and simultaneously avoid direct confrontation with their own racial privilege. Jason Rodriquez, who conducted ethnographic research in local hip hop scenes in Massachusetts and Providence, Rhode Island, concluded that white fans use "use color-blind ideology to justify their participation in a local scene." They admit the "importance of racial inequality for others, and a denial of the salience of race in their own lives" at the same time.[5]

However, the absence of racial prejudice or the claim to not see color at all does not equal the absence of structural forms of racial discrimination against black people that are also structural forms of privilege for whites. These structural advantages continue despite the supposed divestment from racial prejudice. Majorities of whites can and do support policies that maintain white institutional privilege and advantage while remaining color-blind and while consuming black cultural expressions and images of black people. And images and stereotypes about black people, such as those constantly reinforced by commercial hip hop, fuel this dynamic. As Andrew Rojecki, coauthor of *The Black Image in the White Mind*, argues:

> Majorities of whites now believe that the lesser position of African Americans is due to individual moral failing or flaws in black culture itself. In our own research on the black image in the white mind, whites we interviewed spontaneously referred to media images of sexuality and violence that supported their negative views. These images substituted for the absence of sustained contact between whites and blacks, inevitable in a society that remains segregated by race. This is especially true among those persons whom we call the ambivalent majority, those whites who are sympathetic to aspirations of black Americans but who are influenced by images that highlight irresponsibility and violence.[6]

In my own experience speaking to thousands of white students and fans of hip hop over the past fifteen years, I have found that hip hop, and only hip hop, is the way most of these young people come to black culture—and to black people, for that matter. Yes, there is a highly informed core of young white fans who have a larger appreciation and understanding of black culture and history, who critically engage with white privilege in their own lives and in society at large. However, for the most part, white hip hop fans (often through no direct fault of their own) know virtually nothing about black people or the cultural traditions out of which much of hip hop comes. They lack knowledge of broader issues such as black people's history in America, how ghettos came into existence, and why and how aspects of whiteness—that is, their own racialized identities and privileges—are yoked to black exploitation and the expressive cultures this history has produced. In my own classes on hip hop and black popular culture, I am consistently struck by white students' genuine appreciation of hip hop and their simultaneous ignorance of the racial issues that swirl around the music, that govern their investment. In one class, a white male student fan of hip hop exasperatedly asked, "Are you saying that white males as a group actually have more power and privilege than others in society?" I replied "Yes," but said that this fact was not a personal indictment of him or others; it was the result of ideas and policies that support racial and gender inequality we can work together to change. I also wondered aloud how his own consumption of hip hop didn't seem to suggest the existence of racial inequality. No one in the class seemed to have an answer. At the end of the semester, another white male student explained that he has "loved hip hop his whole life" but came into the class being strongly against affirmative action or any other non-color-blind policies, even if they intend to help disadvantaged people.

Because I also lecture around the country, I hear from young white hip hop fans well beyond my own classrooms. I could regale readers with tales of incredibly earnest white liberal college students raised in and attending college in places where black communities are more of an idea than a reality, who admit to having had virtually

no experience with more than a smattering of individual black people over their lives or any background in black history. But they also admit to feeling confident when reminding me that "Jay-Z is telling it like it is in the ghetto. He's really black and knows what he is talking about." Jay-Z's actual veracity about ghetto life notwithstanding, how do these students come to this distorted and limited understanding of life for poor black people with such confidence? Why are they so very convinced, given their limited knowledge? What role is Jay-Z playing for them?

Without this knowledge and context, white consumers of hip hop, although perhaps partly driven by their connections with others who feel alienated from American society, wind up reinforcing problematic ideas about race, sexuality, class, and the state of urban America. So, rather than becoming a hopeful sign of shared lived experiences and community connection, white consumption of hip hop—in this moment, at least—has a strong likelihood of reproducing the long and ugly history of racial tourism that requires black people to perform whites' desires in order to become successful in a predominantly white-pleasure-driven marketplace.

It was not always this way. Early in hip hop's evolution it was not easy for whites who either didn't live around any black people or had no existing investment in black cultural expressions to listen to hip hop. To become a white fan of hip hop often meant leaving one's predominantly white social spaces and comfort zones. As recently as the early to mid-1990s, little hip hop was played on MTV (and BET wasn't an automatic part of nonurban cable packages), so suburban whites, if they wanted to be "down" with hip hop, had to seek it out and, in many instances, share physical space where they themselves were a minority. The stories and images of black youth in hip hop were far more diverse and complex, undermining the legacy of one-dimensional stereotypes on which most Americans are raised. The terms of their participation often required, if not cultural knowledge, certainly familiarity with aspects of black life and a willingness to express a shared appreciation for actual black people.

This kind of forced risk taking or facing of a larger, predominantly black social reality is completely unnecessary now. Hip hop is popular enough among whites to generate larger-venue concerts in mostly white suburbs, augmented by the emergence of the Internet and the constant, but also unconfined, rotation of hip hop on MTV. It is firmly at the epicenter of youth culture. It is conceivable now to be a white fan of hip hop who knows a great deal about black hip hop artists and tales of ghetto life but who has little or no contact with black people and knows very little about black life and history. A startlingly rare and honest article by Justin D. Ross hits this dynamic head-on when he writes:

> Across the country, white kids in comfortable suburban neighborhoods (mine was the Greenbelt) sit in their cars or bedrooms or studio apartments, listening to the latest rap music that glorifies violence, peddles racist stereotypes and portrays women as little more than animals. We look through the keyhole into a violent, sexy world of "money, ho's and clothes." We're excited to be transported to a place where people brag about gunplay, use racial epithets continually and talk freely about dealing drugs. And then we turn off whatever we're listening to and return to our comfy world in time for dinner.[7]

The public conversation about hip hop over the past ten years has generally avoided the issue of how the acceleration of white fan consumption of hip hop dovetailed with the commercial rise of gangsta-pimp-ho figures in the genre. White interest and consumption drive the mainstream commercial success of black thugs, gangstas, hustlers, pimps, and hoes. Little conversation about this link takes place despite the public outcry. Many critics need hip hop to be all black and only black in origin and end product so that full blame can be squarely placed on black people. Thinking about how white desires and projections onto black people and the post–civil rights brand of color-blind white privilege might play an important role in determining what becomes popular in the mainstream could generate a real

examination of how racist ideas and histories influence our cultural landscape.

The power and influence of mainstream commercial hip hop undermines the formation of a progressive, racially informed hip hop community. In response, hip hop progressives, disturbed by the direction of commercial hip hop, understandably emphasize the more marginal cross-racial, multicultural scenes ripe with political potential. Bakari Kitwana's *Why White Kids Love Hip Hop* is a laudable move to shed light on the underexamined progressive facets of white hip hop consumption. But given the largely unchallenged realities of color-blind racism and sexism among many white hip hop fans, this political potential has been too easily perceived as proof of the "we are one" hip hop rhetoric espoused by corporate hip hop spokespeople who assume white hip hop fans to be racially self-critical and progressive.

At the same time, the artists themselves avoid considering the kinds of racial desires that likely drive white consumption of black entertainers (and therefore shape which types of images go mainstream). How would they look, admitting that they are pandering to white fantasies of the black gangsta, thug, and pimp, instead of just keeping it real? And if you insult your largest audience group by suggesting that their investment in you might be problematic, what might this do to your future sales? Clearly, the industry doesn't want too much mention of this. They promote the "hip hop includes everyone" rhetoric while it works to exploit the very racial dynamic and perpetuate the very stereotypes of black people for the white consumption from which it profits. Hip hop matters to the record industry because it makes money, and it makes the level of money it makes primarily from white consumers. Record executives thus pretend that the industry is a neutral conduit of real black culture so they can keep the ghetto fantasies rollin' off the product line.

Sexism Isn't Really a Problem

Neither polarized camp in the hip hop war seems truly interested in dismantling male privilege, encouraging black women's sexual

power and agency, or revealing the workings of male-dominated culture. While few will argue against the importance of gender equity in the abstract, the actual social and cultural workings of gender inequality and exploitation of the sexuality of women (especially black women) are not the concern of either side in this public battle.

As we've seen, each side has several angles from which to approach this issue. Supporters of hip hop will tell you that "there are bitches and hoes," that "men are hoes, too," that women in hip hop have sexual freedom, and that "we have women fans." The pro–hip hop side often digs up the range of pro–black women songs that several high-profile artists have written and performed, such as Tupac's classic rhymes on "Dear Momma" and "Keep Ya Head Up," Jay-Z's 2001 "Blueprint (Momma Loves Me)," and Ludacris's 2006 "Runaway Love." This side tries to claim that artists like Lil' Kim are expressing their sexual freedom and that hip hop supports women's self expression — as long as it dovetails with male sexual fantasy. Of course, the very pressures that developed over the past decade for black men to perform ghetto thug life are also a mandate for black women to be "bitches and hoes." Parallel to the elevation of the thug/gangsta figure is black women's sexual self-exploitation for male viewing pleasure as a near requirement for female visibility in the male-dominated world of hip hop. Sexism that seems "authentically" black also serves as a cover for white male consumption of sexist culture. Through hip hop, young white fans can get a good dose of male domination of women, in the familiar package of black women's titillating performance of sexual excess, without owning up to their primary investment in it or taking any responsibility for it.

Those on the anti–hip hop side strategically pretend as if hip hop damn near invented sexism, and that it's the only really sexist place in American society. They suggest that America needs protecting from this outside (black) threat via hip hop. Sometimes these anti–hip hop critics actually try to claim a pro-women stance by criticizing the exploitation of black women in hip hop through a male-dominant language of "respect." Of course, most mainstream media show little interest in any other aspect of black women's or women's

rights. It is startling just how few feminists have been visible in this public conversation and how many men, few of whom could safely be called advocates for women's rights and freedoms, have remained center stage, even when the issues are so patently about black women. The rhetoric of "respect" without equal time for a discussion about the structures of gender inequality gives male public figures an opportunity to "protect" women while retaining male privilege. So, the problem isn't really sexism; it's sexually explicit culture, in which women are not "respected" while under male authority.

Furthermore, even this "interest" in sexism fits into the umbrella category of "regaining our moral compass," which is far too often a shorthand for the sexual repression and containment of women rather than the support of nonexploitative sexual freedom and agency for women. Even more insidious, this apparent interest in bringing attention to sexual exploitation is part of a larger attack on black culture as dysfunctional and sexually deviant. Some conservatives have gone so far as to blame the entire status of poor urban black America on the welfare state by yoking the small amounts of economic support given to unmarried mothers—about whom the sexual dysfunctional claim is made—with all of the socially created conditions that poor black people face.

Homophobia Is Okay

Homophobia is tacitly accepted on both sides of this battle over hip hop. Most public critics of hip hop—progressive as well as conservative pundits, ministers, and journalists—simply remain silent about or only occasionally mention hip hop's homophobia, letting the emphasis on sexism or the "disrespect" of black women stand in for other kinds of hatred and discrimination perpetuated by hip hop. This is another example of how the influence of a conservative, sexual morality–based argument that might otherwise seem an ally against women's sexual exploitation could be a real problem for progressive mobilization. For many on the religious right and even some progressive groups and individuals focused on sexual morality, mas-

culinity is equated with patriarchy and homosexuality is itself considered a sin, a sign of sexual deviance. Although members of the religious right have been openly disparaging of hip hop, their criticism has not been based on hip hop's homophobia—thus increasing the likelihood that critics across the political spectrum will denounce homosexuality itself rather than homophobia. Since most public hyper-defenders of hip hop are on the strongest ground when they limit their responses to the most conservative attacks leveled at them, conservative homophobia works in synergy with rappers' homophobia, leaving the whole subject relatively unexamined.

Another reason homophobia in hip hop garners less critical attention than its sexism is that its pro-gangsta-pimp-ho profile is driven explicitly by its sexism and amplified by gangsta-style, sexist music videos. Few music videos depict gay men or women at all (although women rubbing on each other as an aspect of male heterosexual fantasy does take place), while a large number of songs by male rappers talk about sexy women and music videos depict an endless barrage of women as sexual objects. While homophobic lyrical content laces many rappers' rhymes, the music videos that get produced and aired do not consistently accentuate homophobia or feature gay characters.

The general public silence about homophobia helps obscure the fundamental connections among patriarchal masculinity, femininity, and homophobia. Hip hop reflects the important role that homophobia plays in defining masculinity. Women who are considered too independent, tough, or powerful are negatively labeled as lesbians. Men insulted for being too weak are often called "faggots." In this version of heterosexual masculinity, the parameters of manhood are being protected when homosexuality is equated with "femininity," and both are designated as weak and subordinate. This general culture of homophobia is compounded by black males' long-denied access to the full powers of patriarchal masculinity, which in turn may have encouraged a particular brand of black homophobia. Writing for Alternet.org, Earl Ofari Hutchinson argues: "In a vain attempt to recapture their denied masculinity, many black men mirror America's

traditional fear and hatred of homosexuality. They swallow whole the phony and perverse John Wayne definition of manhood, that real men act tough, shed no tears and never show their emotions." Hutchinson also comments on the important role of black conservative religious leaders in reinforcing a religious justification for homophobia.[8]

Ja Rule, whose music often features strong references to Christianity, couched his 2007 homophobic outburst in traditionally conservative rhetoric about needing to protect his children from negative, gay influences that were being aired on television: "[S]tep to MTV and Viacom, and let's talk about all these fucking shows that they have on MTV that is promoting homosexuality, that my kids can't watch this shit. Dating shows that's showing two guys or two girls in mid-afternoon. Let's talk about shit like that! If that's not fucking up America, I don't know what is." Two weeks later, in response to criticism, Ja Rule said his comments were taken out of context and that he's "a very avid speaker for all people's rights and people having their own preferences." He went on to say that people should be focused on other things like the war (a familiar defense used in response to challenges to sexism). Eminem, too, has homophobic lyrics laced with violent metaphors about words being like jagged-edged daggers "that'll stab you in the head whether you're a fag or lez." And in 2004, 50 Cent told a *Playboy* reporter that he's not "into faggots" and doesn't "like gays around" him, because he's not "comfortable with what their thoughts are." In 2005, 50 Cent reiterated his homophobic beliefs and attached them to hip hop more broadly, saying that "hip hop isn't for gays" because the genre is too aggressive for homosexuals. Reinforcing the homophobic idea that gay men are weak and that real masculinity is heterosexual and aggressive, he continued: "Being gay isn't cool—it's not what the music is based on. There's always been conflict at the center of hip hop, because it's all about which guy has the competitive edge, and you can't be that aggressive if you are gay."[9]

This is a reflection of the myth about hip hop's hyper-heterosexuality and machismo, not of reality. Indeed, there are many openly gay rap-

pers, such as San Francisco's Rainbow Flava, Tim'm, Midwestern transplants God-des and She, and Tori Fixx from Chicago. Moreover, a former MTV executive, Terrance Dean, penned his memoir about his life in the hip hop industry as a gay man, saying that the hyper-heterosexuality and homophobia in the industry do not mean that gay people are not central to hip hop culture. In his book *Hiding in Hip Hop: On the Down Low in the Entertainment Industry—From Music to Hollywood,* Dean describes a world where some industry executives and even some of the typically gansta-style artists lead quasi-secret gay lives. "Everyone knows," he says, "It's not a secret in that sense. It is just that people do not talk about what goes on in private and who is sleeping with who. Now I hope a mainstream artist will have the courage to soon come out."[10]

Even conscious rap, which is known for being politically progressive on issues of class, race, and women's equality, is sometimes part of this problem. On the one hand, for example, Common's song "The Light" has been described by Cynthia Fuchs on Popmatters.com as a "charming, tender, and undeniably soulful declaration of affection and respect," and Mos Def and Talib Kweli's "Brown Skinned Lady" pays a detailed and powerful homage to black women. But on the other hand, it is not entirely uncommon for otherwise thoughtful and progressive artists such as Immortal Technique and Saigon to have deployed, at one point or another, hateful slurs against gay people or homophobic name-calling to insult others' masculinity. In Common's 2000 braggadocio-style rap "Dooinit," he says: "[I]n a circle of faggots, your name is mentioned." In 2005, Kanye West spoke openly and definitively against homophobia in hip hop and in America generally, admitting that he himself had behaved in a homophobic way in order to shore up his masculinity among his peers. Unfortunately, in 2006 the rhymes he featured on DJ Khaled's *Grammy Family* (perhaps recorded years earlier) nonetheless include the line "used to hit the radio them faggots ain't let me on." Finally, in *Beyond Beats and Rhymes,* when Hurt asked rappers Busta Rhymes and Mos Def to talk about homophobia in hip hop, they both became quite uncomfortable and closed down the conversation. Busta Rhymes said that he

can't "partake in that conversation . . . that homo shit? . . . I ain't trying to offend nobody. It's my cultural, what I represent culturally, doesn't condone it whatsoever." And Mos Def looked decidedly distressed about the subject. Of course, the dead silence from record industry executives on this issue does not reduce their complicity in allowing hip hop to become so openly and extensively homophobic. Their silence is a central reason for its public and visible perpetuation.

These six collusions in hip hop—where seemingly opposing sides in the debate over the value and role of hip hop actually share positions—are very powerful in terms of shaping the conversation about hip hop. The overlapping beliefs among so many stakeholders make it exceptionally difficult to get these issues on the table. Together, these points of agreement (silently held or loudly spoken) thus contribute to the gridlock in which hip hop finds itself. For the vast majority of critics and supporters, homophobia is not worthy of our attention, sexism (in all its structural forms and manifestations) isn't really an issue, and lowest-common-denominator creativity is okay. Hallmarks of black suffering are acceptable sources of entertainment; white consumption of black stereotypes is fine (as long as it looks like "authentic" black culture), and so is the illusion of "purely" black hip hop products, as long as they both generate profits. This is what the loudest members of the combatants in the hip hop wars are saying, intentionally or not.

In the absence of serious attention to these issues, the creative future of hip hop is in jeopardy, and a progressive musical community where justice matters, where trading in violence, insult, and domination are rejected, is stymied. The powerful possibility of meaningful, gender-equal, and collaborative cross-racial exchanges through music and culture is squandered, and progressive values are pushed to the margins, while the myths of black dysfunctionality remain profitable and perilous for black people and for America as a whole.

12

Progressive Voices, Energies, and Visions

Why did one straw break the camel's back? Here's the secret: the million other straws underneath it.

—Mos Def, rapper, "Mathematics"

Listen to your spirit, nothin' weaker than the flesh, so while you try to keep it fresh you gettin' deeper into debt.

—Talib Kweli, rapper, "Listen!"

Don't think I haven't been in the same predicament, let it sit inside your head like a million women in Philly, Penn., it's silly when girls sell their souls cause it's in.

—Lauryn Hill, rapper and R&B singer, "Doo Wop (That Thing)"

I N THE BATTLE OVER THE POLITICS OF HIP HOP, convention separates the commercial realm from conscious rap, with the latter largely considered part of "the underground." The distinctions made between the two tend to revolve loosely around whether or not a given artist has politically progressive content. Many conscious rappers are on commercially powerful record labels (or have distribution deals with them), but what generally distinguishes their music from commercial rap is that it avoids pandering to the worst images of young black people, favors more socially conscious content, and is not nearly as heavily promoted as that of artists who rely on the gangsta-pimp-ho trinity. Those considered "underground" are generally progressively

minded artists, some of whom have not been signed to a major record label and tend to operate in local DIY (do it yourself) networks, online, or through local, marginally commercial distribution networks.

Throughout *The Hip Hop Wars*, I have deliberately labeled much of what I have criticized about hip hop's ascent into mainstream stardom as "commercial," even though many progressive artists have commercial contracts or distribution deals with major labels. Artists such as Mos Def, Common, Talib Kweli, Lupe Fiasco, Nas, and The Roots are visible in the commercial realm of hip hop, and most if not all have record contracts or some kind of distribution deal with major labels. The term "commercial" as it is used here, and by others who are similarly concerned about representations of black people in hip hop, is meant to illuminate the significant role of corporate and mainstream American cultural imperatives in shaping the direction and content of what is most visible and most highly promoted in hip hop for profit. This problem is far too often laid solely at the feet of young black people generally and of rappers in particular.

My pejorative use of the term "commercial" is meant to draw sharp attention to the power of Viacom, Universal, Sony, and other massive media conglomerates in elevating one thin slice of what constitutes hip hop over all other genres, because doing so panders to and helps reinforce America's veiled but powerful interest in voyeuristic consumption of black stereotypes. But I have not intended to suggest that nothing creative and community-enabling can or does take place through commercial outlets. Although it is tempting to tell everyone to "just turn it off," to stop paying attention to mainstream outlets such as BET, MTV, Vibe, *The Source* magazine, and other places where hip hop youth culture lives, this is not practical given the intense investment in these outlets and the role that corporate culture plays in creating community. Furthermore, unless nearly all viewers follow this strategy (which is hard to imagine), the content is not likely to change sufficiently. For better or worse, commercial culture is central to "the mainstream"; it shapes our collective conversation. As a space we all share, it must be taken seriously and challenged.

Many of rap's most visible commercial ambassadors are highly talented. Talent isn't the central issue in urging a transformation among hip hop's biggest stars, but using that talent in service of the common good is. Furthermore, the most-fun music has not always been challenging and complex, so calls for increased complexity isn't the main goal either. The issue is best framed as a question: Toward what end is black popular creativity being expressed and promoted? The crux of the problem is the profits-over-people mandate that too often dominates in the marketplace and has been internalized in hip hop cultural attitudes and lyrics. Hip hop has been a casualty of this mandate, all under the guise of "authenticity." As Andre C. Willis wrote in 1991, long before hip hop's destructive commercial fate was sealed, we must work to push "these artists to understand the tradition whose shoulders they stand on, and encourage them to comprehend struggle, sacrifice, vision and dedication—the cornerstones for the Black musical tradition."[1]

The conventional split between commercial and politically conscious rap creates a narrow "alternative" to the commercial options that saturate hip hop. One of the ways that hip hop's progressive spirit has been driven to the margins is through the fashioning of an overtly "political" identity (i.e., conscious rap) as the only alternative to gangstas, pimps, and hoes. It's as if the only answer to a stylishly conceived "thug life" is to grimly "fight the power." But this is a rigid and one-dimensional set of options that significantly disadvantages establishing a progressive vision as the basis for a wide variety of hip hop styles, approaches, and levels of explicitly political content. Because of the restricted vision used to label progressive artists, being called "socially conscious" is almost a commercial death sentence for artist visibility and everyday casual fan appreciation. From this sober perspective on consciousness, gangstas appear to be the only ones having fun. Generally speaking, "socially conscious" artists, no matter how brilliant their rhymes or how funky their beats, have been kept on the margins of commercial radio and industry promotional agendas. This seriously shapes fan perception of value in the musical market economy. In our advertising-driven society, we tend to gravitate

toward what is most accessible, most highly promoted. Marginality, then, is related in part to the power of the fiction that black gangstas are "keeping it real" when they venerate street life. The suffocating grip of the perception of street culture as the key to what makes black people "really black" contributes as well. This perception is a fundamental lie that has to be exposed in order to move progressive artists and progressive visions center stage in hip hop.

Popular music must be dynamic, playful, exciting, and cutting edge. Sometimes this involves politically conscious content, but it surely cannot nor should not always do so. A crucial aspect of a progressive reclaiming of the soul of hip hop is the refusal to limit the scope of progressive art to the narrow application of "social-consciousness"-oriented topics, as has sometimes been the case. A story with a progressive foundation can and should be about any subject, any facet of the human experience. And socially conscious artists should be able to talk about anything, including ghetto street culture. Progressive, community-centric music can sometimes be vulgar, explicit, and violent. Rappers with a progressive social consciousness can't be expected to pretend that street violence, exploitative sex, and self-destructive behaviors don't exist, or claim that nothing being said about them is worthy of artistic examination, just because of the current state of mainstream commercial hip hop. The distinction, then, between "gangsta rap" and progressive or "socially conscious" rap is not solely about the subject of the story being told but also about how and how often that story is told. What kind of community is being hoped for, what standard for treating others in one's community is being elevated and emulated? Progressive artists have resisted various dividing lines, refusing to succumb to a kind of elitism that suggests that gangsta rappers aren't sophisticated or intelligent and that dance-oriented hip hop is automatically less valuable than politically explicit hip hop. Many have shown solidarity with the realities of black street life from which commercially peddled "authenticity" is crafted. Lupe Fiasco, who is properly considered one of the most talented and progressive recent artists to emerge in hip hop, has rejected these terms of

criticism—both the idea that street life equals "authentic" blackness and the elitism sometimes expressed by politically sophisticated fans—while still openly criticizing what he thinks has become of mainstream hip hop. Originally signed as a gangsta rapper on Epic Records, Fiasco eventually made a decision to stop using his talent to promote that life, despite his own connections to it:

> I felt like, man, I can't keep putting all this negativity into the world, cause it's gonna come back and get you. . . . I don't wanna go plat-inum because I'm dead. So, I'm not gonna put that out there. . . . Don't get me confused: I come from the hood, the west side of Chicago—don't let that fool you just 'cause I was riding skateboards—all my friends are gang-bangers, hustlers, convicts, killers, the whole situation. I just—I just don't want to put that face out there into the world because it's not necessary. It ain't gonna do nothing but glorify it and add to the saturation that's in the game right now. . . . So I'm like, you know what, I'mma go out there and stand up for it [hip hop]. I'mma stand up for that little sixteen year old kid who either has the option to make a bunch of bang bang shoot 'em up kill 'em records because he thinks that's what he need to get played on the radio or I'mma show him that he can be successful with a record talking about skateboarding and robots.[2]

Given what artists who are committed to progressive values are up against in the current commercial terrain, we should work hard to support them. Politically thoughtful consumption, while not the only means of contributing to positive change, is an important strat-egy in a market where sales often determine visibility and power. Artists who visibly pander to the hip hop trinity should not be re-warded for doing so, even if they have the occasional progressive rhyme in their repertoire.

Categorically rejecting songs about sex or violence or material-ism is not the answer, although reducing their overall space cer-tainly is. We must also keep our eye on how often and in what way

such stories are told: What are the implicit politics of community being expressed in them? Will these politics enable and support progressive change, mutual respect, and empowerment? Is an artist bragging about having stylish gear, or is the entire rhyme driven by a celebration of symbols of luxury excess and brand-label name dropping? Is the song's tale of sexual exchange supporting mutual desire or at least regarding women with basic human dignity, or is it treating them as nameless, dehumanized sexual objects? During a recent Hip Hop Honors program on VH-1, where A Tribe Called Quest was honored, group member Ali Shaheed Muhammad put it this way: "We noticed that the world was kind of negative and a lot of people in hip hop talked about their love of jewelry and money and love of cars. We wanted to discuss the love of humanity, loving yourself, loving the real emotion that's relevant to life." Some progressive hip hop artists have sensual and sexual lyrics about women but they are not in the spirit of degrading, insulting, and dominating them. When A Tribe Called Quest said "I like to kiss ya where other brothers won't" in their 1990 hit "Bonita Applebaum," they weren't referring to kissing her hand. What would the musical world be without sexual and sensual content? What would happen to the next Marvin Gaye, Al Green, Prince, Teddy Pendergrass, Donna Summer, and Jill Scott if this challenge to exploitation were conflated with a rejection of sensuality?

Artists are not alone in the effort to expand the vision, critical language, and use of hip hop. Journalists, bloggers, activists, teachers, students, filmmakers, social workers, and novelists are all working to broaden the creative and intellectual grounds for progressive hip hop. Their work suggests that there is a diverse, invested, and significant group of people who are part of hip hop but willing to challenge and re-envision it. Their films, essays, curriculums, youth festivals, and other activities not only generate literacy about hip hop, black culture, the power of progressive cross-cultural exchange, and social justice but also make incisive challenges to corporate agendas.

The remainder of this chapter is devoted to identifying some of these warriors in the hope that doing so will help spread the word about their activities and perhaps encourage readers to seek them out. Two important caveats: First, the artists, people, and organizations listed are not "perfect"; there is no such thing. (The standard for progressive belonging cannot be so restrictive that only a few can make the cut.) And, second, the lists below are not intended to be exhaustive, nor should they be taken to imply that only the most important people or organizations are named. Rather, the aim is to give readers a way of discovering what is missing from the mainstream conversation on hip hop, to show that there are many people who are against both extremes in the hip hop wars, to help consolidate progressive spaces, and, ultimately, to help build community. Too many of the people and organizations listed below have been marginalized in the public conversation on hip hop. Their marginalization helps keep the conversation trapped.

If you know of other current and active hip hop–related progressive organizations, groups, artists, activists, writers, or teachers who should be included in the following lists, please visit www.triciarose.com/bpc and let me know about them.

Progressive Artists

This category includes the following active artists, among others: *Afu Ra, Akrobatik, Alternate Reality, Bahamadia, Black Star, Brand Nubian, Brenda Gray, Common, The Coup, De La Soul, Dead Prez, Deep Dickollective, Derrick "D-Nice" Jones, El-P, Faqts One, Gangstarr, God-des and She, Immortal Technique, Jean Grae, Jurassic 5, Kam, Kanye West, Kev Brown, KRS-One, Lauryn Hill, Little Brother, The Living Legends, Liza Jessie Peterson, Lupe Fiasco, MC Lyte, Mos Def, Mr. Lif, Nas, Outkast, Paris, Perceptionists, Rainbow Flava, The Roots, Sage Francis, Saul Williams, Sarah Jones, Spearhead, Strange Fruit Project, Tori Fixx, Staceyann Chin, Talib Kweli, Tim'm, Wyclef Jean, Zimbabwe Legit, and Zion-I.*

Progressive Organizations

Bling: A Planet Rock
Director: Raquel Cepeda
Executive Producer: Irena Mihova
Released: September 2007 (United States)

Directed by Raquel Cepeda, *Bling: A Planet Rock* critically examines the overlooked relationship between the violent, illicit diamond trade in Sierra Leone and hip hop culture in the United States. Cepeda follows Pall Wall, Raekwon, and Tego Calderon to Sierra Leone, where these hip hop artists are exposed to the realities of the illicit diamond industry from the perspectives of miners, war survivors, government officials, local hip hop artists, UN groups, and NGOs. *Bling* digs deep into both the history and significance of diamonds in hip hop and the significance of hip hop in diamond trading regions. Finally, the film explores the way in which the hip hop community can be a source for responsible consumerism and positive change.

Byron Hurt
Website: www.bhurt.com

Byron Hurt is an anti-sexism advocate and filmmaker concerned with gendered and sexualized violence. His 1998 film *I Am a Man: Black Masculinity in America* examines black masculinity in the contexts of racism, sexism, homophobia, and violence, and his 2007 film, the acclaimed *Hip Hop: Beyond Beats and Rhymes*, examines representations and performances of race and gender in hip hop music and culture. The latter, a groundbreaking documentary, features interviews with fans, industry executives, artists, and scholars and is especially concerned with questions of violence, masculinity, sexism, and homophobia. Hurt's forthcoming film *The Masculinity Project: Black Community in Focus* will take a multigenerational look at black masculinity in the United States.

Davey D
Website: www.daveyd.com

Davey D's Hip Hop Corner is one of the largest and oldest hip hop hubs on the Internet, run by "hip hop historian, journalist, deejay, and community activist" Davey D. The site features Davey D's "Hip Hop Daily News" as well as interviews; articles on hip hop history, politics, culture, and industry; music reviews; discussion boards; and venues where artists can share their work.

Enough Is Enough: The Campaign for Corporate Responsibility in Entertainment
Founder/Convener: Reverend Delman L. Coates
Location: New York City
Website: www.enoughisenoughcampaign.com

Reverend Coates founded Enough Is Enough to respond to corporations that proliferate and profit from degrading depictions of black men and women in popular culture. The campaign stages weekly protests at local media outlets and corporations that sponsor such images. In so doing, Enough Is Enough challenges both the commercialization and the marketing of degrading depictions of black men and women.

Global Artists Coalition
Location: New York City
Website: www.globalartistscoalition.org

The Global Artists Coalition is a nonprofit group that helps youth from underserved communities to attain success in the arts, communication, and entertainment fields by developing mentoring relationships with industry professionals. These professionals serve as career mentors and provide the resources and funding for the workshops so that the youth can participate free of cost. The Global Artists Coalition is also affiliated with the Hip Hop Culture Center in Harlem and with a traveling hip hop culture and history exhibition.

H.E.L.P.: *Hip Hop Educational Literacy Program*
Founded: 2005
Cocreators: Gabriel Benn and Rick Henning
Location: Washington, D.C.
Website: www.edlyrics.com

H.E.L.P. uses hip hop to promote literacy and critical-thinking skills in ways designed to meet the needs of a diverse community of learners. Its curriculums use hip hop's popularity to engage students in reading and to increase vocabulary, comprehension, and writing skills. Each month, new workbooks use the work of hip hop artists with "socially conscious content and rich vocabulary" to promote comprehension and critical thinking at individual, small-group, and classroom levels. H.E.L.P. is currently seeking corporate partners to provide H.E.L.P. materials and trainings to schools free of cost.

Hip Hop 4 Humanity
Founders: Michael Mauldin and Jermaine Dupri
Founded: 2001
Website: www.hh4h.com

Originally founded to provide support to those intimately affected by the attacks on September 11th, 2001, Hip Hop 4 Humanity now works in concert with Georgia State University on a series of summer camps that provide alternative education opportunities to Georgia youth. These camps engage youth by teaching them about the business side of the entertainment industry.

Hip Hop Archive
Director: Marcyliena Morgan, Harvard University
Website: www.hiphoparchive.org

The Hip Hop Archive was established in 2002 to enable the development of knowledge, art, culture, and leadership through hip hop. It acquires, organizes, and develops collections relating to hip hop in the U.S. and internationally and its collections include audio recordings, videos, websites, films, original papers, and interviews that are orga-

nized around themes and initiatives. In this way, the Hip Hop Archive facilitates research and scholarship concerning the knowledges, movements, cultures, and arts that have developed around hip hop.

H2A: *Hip Hop Association*
Founder and President: Martha Diaz
Founded: March 2002
Location: Harlem, NY
Website: www.hiphopassociation.org/about.php

The Hip Hop Association, a "Global, Multicultural, Multilingual" organization with over twenty annual events, was founded in Harlem in 2002 by Martha Diaz in response to the commercial appropriation of hip hop culture that "exploits and perpetuates negative stereotypes." H2A concerns itself with supporting a hip hop culture that is engaged in social change and community building: "facilitating, fostering, and preserving hip hop's original vision." H2A has two central initiatives through which it works toward this objective: "Hip Hop Odyssey" and "H2Ed." "Hip Hop Odyssey," H2A's media initiative, creates its own apparatus for the dissemination and appreciation of cultural forms. Its programs include the Hip Hop Odyssey International Film Festival, the Freshest Youth Program, and the Odyssey Awards. And "H2Ed," H2A's education initiative, uses hip hop—"the most influential cultural force today"—as a tool for youth education and empowerment. Its programs include the Summer Teacher Institute, the H2Ed Summit, the Hip-Hop Education Wiki, and the Hip-Hop Education Guidebook.

Hip Hop Project
Website: www.hiphopproject.com

Founded in 1999 by Chris "Kharma Kazi" Rolle, the Hip Hop Project helps at-risk teens to express themselves using hip hop. The project brings the teens together with music industry professionals who work with them to create albums and marketing materials, the proceeds of which go toward scholarships for the students.

Hip Hop Speaks
President: Donyale Hooper-Reavis
Location: Philadelphia
Website: www.hiphopspeaks.org

Hip Hop Speaks responds to a contemporary situation in which young people are increasingly less connected to traditional community structures such as school and church and increasingly more influenced by the media and entertainment industries. Hip Hop Speaks's school-year kaPow! programs use an arts- and media-based approach to help students achieve state academic standards. Its after-school programs and summer camp encourage media literacy; youth critically examine hip hop music, film, television, and advertising, challenging representations and creating space for marginalized perspectives. Thus engaged, youth participating in Hip Hop Speaks are also given the tools and mentorship to "create new and exciting media of their own."

Hip Hop Summit Action Network
Founders: Russell Simmons and Dr. Ben Chavis
Founded: 2001
Website: www.hsan.org

The Hip Hop Summit Action Network is a coalition of hip hop artists, industry executives, education advocates, civil rights proponents, and youth leaders that was formed after the first National Hip Hop Summit in 2001. In accordance with that summit's theme, "Taking Back Responsibility," HSAN has focused on directing the cultural and economic capital of hip hop toward initiatives for community development and youth empowerment. Since its inception, HSAN projects have included more than forty hip hop summits, voter registration initiatives, youth leadership development programs, and public awareness campaigns. See especially the "what we want" page of their website.

Hip Hop Theatre Festival
Founder: Danny Hoch
Founded: 2000
Website: www.hiphoptheaterfest.com/node/3

Based in four festival cities—New York, Chicago, San Francisco, and Washington, D.C.—HHTF events feature live performances by artists who are breaking new creative and aesthetic ground in the areas of theatre, dance, spoken word, and live music sampling. Through soliciting and supporting the development of new work and building networks and coalitions, HHTF works to promote the integrity and visibility of Hip Hop Theatre as a genre. HHTF engages social and political issues and is committed to keeping live theatre vital and accessible to audiences across race, class, age, and gender lines. Education and outreach initiatives such as the Arts Cultivation and Education program reflect the organization's dedication to serving urban youth.

Hip-Hop Therapy Project
Founder: Nakeyshaey M. Tillie-Allen
Websites: www.thehiphoptherapist.com,
www.hiphoptherapyproject.com

Founder Nakeyshaey M. Tillie-Allen launched the 'Hip-Hop Therapy Project' in 1994. 'Hip-Hop Therapy' synthesizes various therapeutic methods into a hip hop–centric therapeutic technique applicable to both individuals and groups. 'Hip-Hop Therapy introduces and analyzes Hip-Hop music, its lyrics, and culture as it relates to the person in therapy or community development.' Hip-Hop Therapy uses a 'person in environment' to serve 'high risk persons and/or persons of color' whose social and cultural realities are often [left out of] mainstream therapeutic techniques. Hip-Hop Therapy seeks to empower youth and communities through its critical deployment of hip hop music and cultures.

HOTGIRLS: Helping Our Teen Girls, Inc.
President, CEO, and Founder: Carla E. Stokes, Ph.D., M.P.H.
Founded: 2001
Location: Atlanta
Website: www.helpingourteengirls.org

HOTGIRLS is a small nonprofit that uses hip hop and youth culture as foundations and inspirations for "culturally relevant and age-appropriate, girl centered information and programming" aimed at improving the health and well-being of black girls and young women. Through HOTGIRLS, girls and young women challenge dominant conceptions of black girlhood and womanhood not only through media literacy but also through technology and media production. HOTGIRLS also invests in the leadership potential of black girls and young women in its Young Women's Leadership Council, Girls' Leadership Council, and annual girls' summits. In 2008, HOTGIRLS relaunched FIREGRL.COM, a safe space online for advice, support, and discussion. It is also working with the Young Women's Leadership Council to develop a website—www.get yourgameright.com—that will raise awareness about gendered violence and advocate for black women and girls.

Industry Ears
Co-Founders: Lisa Fager Bediako and Paul Porter
Website: www.industryears.org

Industry Ears is made up of professionals from the entertainment and broadcast industries who are "dedicated to revealing truth and promoting justice in media." The group addresses disparities in media that have ill effects on individuals and communities, such as the disparity between consumer expectations and the FCC standards. It also works to empower both individuals and communities to advocate for themselves within media structures by providing educational and research materials and by promoting media literacy and dialogue between consumers and industry professionals.

J.U.I.C.E.: *Justice by Uniting in Creative Energy*
President: Erik Qvale
Founder: Dawn Smith
Founded: 2001
Website: www.rampartjuice.com

Justice by Uniting in Creative Energy is a nonprofit hip hop collective in Los Angeles's Rampart District that uses artistic elements of hip hop culture as tools for education, social change, and youth empowerment. These tools are provided to at-risk youth through its programs in breakdancing, graffiti murals, emceeing, spoken word, and music production.

Kevin Powell
Website: www.kevinpowellforcongress.org

Kevin Powell wears many hats: activist, journalist, anti-sexism activist, social critic, hip hop historian, public speaker, and aspiring politician. A high-profile figure in hip hop and popular culture, Powell has hosted and produced shows on BET, HBO, and MTV and is dedicated to using hip hop as a tool for social change. In 2008, he turned his talents to politics, running as a democratic candidate for U.S. Congress.

PeaceOUT World Homo-Hop Festival
Founded: 2001
Website: www.peaceoutfestival.com

PeaceOUT is an annual international festival that celebrates the "worst of the best" queer hip hop artists engaged in DJing, emceeing, spoken word, filmmaking, art, and dance. The first PeaceOUT was held in Oakland in 2001; the festival has continued to be held there on an annual basis and will be held biannually beginning in 2009. This original PeaceOUT festival inspired Peace Out East, Peace Out South, PeaceOut Northwest, and Peace Out UK.

pH Music, LLC
Director of Operations: Dumi Right
Website: www.phmusic.ouofam.com

Dumi Right's long-term goal is to revolutionize the operating paradigms of the commercial music industry. On a more immediate level, pH Music enables the recording, publishing, and distribution of underground hip hop music. The "pH" part of the name represents the type of hip hop that the company supports—pure and progressive. The name also plays on the acid-base scale of the periodic table, as pH Music intends to provide a positive balance to the "negative images and subject matter" that predominate in commercial hip hop.

Project HIP-HOP
President: Eric Esteves
Executive Director: Mariama White-Hammond
Founded: 1993
Location: Boston
Website: www.projecthiphop.org

Project HIP-HOP (Highways Into the Past—History, Organizing and Power) began its "Summer Leadership Institute" in 1993. Through 2007, SLI-participating high school students traveled to important sites of the civil rights movement and met with both civil rights movement leaders and leaders of contemporary social change efforts. Upon returning to Boston, the youth then traveled to area classrooms to teach what they learned. Beyond the SLI, Project HIP-HOP has grown into a larger organization. Its youth-led programs focus on cultivating organizational and resistance skills among low-income youth of color, drawing on hip hop culture and histories of resistance to oppression. Project HIP-HOP initiatives include such areas as political education, critical thinking, hip hop arts and media work, leadership development, and community activism.

Rap Sessions

Founder: Bakari Kitwana
Founded: 2005
Location: Westlake, OH
Website: www.rapsessions.org

Founded by Bakari Kitwana in 2005, Rap Sessions encourages dialogue around the most pressing issues concerning the hip hop community and social change. Rap Sessions' panelists bring town-hall-style meetings to cities across the nation. The organization engages issues within the broad categories of "Politics and Hip-Hop," "Race and Hip-Hop," and "Gender and Hip-Hop." Past themes have included "Does Hip-Hop Hate Women?" and "Hip-Hop and the Presidential Election of 2008." Rapsession.org's video center makes these dialogues available to the broader, web-based audience.

The Rhode Show

Website: www.therhodeshow.com

The Rhode Show is a group of young performing artists from Providence, Rhode Island, who "use their music and creative process as a tool to empower, engage, and educate youth." They perform hip hop, R&B, and spoken-word pieces based in the communities and lived experiences of its members, affirming the importance of young voices both in musical innovation and in social change.

Rosa Clemente

Website: www.hiphopliveshere.com

Rosa Clemente is a hip hop journalist, scholar-activist, and community organizer. Long involved with media justice issues, she formed Know Thy Self Media Messengers in 1995 and conducted workshops at colleges, universities, high schools, and prisons. She helped to form the National Hip-Hop Political Convention in 2003 and co-founded R.E.A.C.Hip Hop, a media justice group. She also cohosts the weekly radio program *Where We Live*.

Take a Stand Records

Founder: Master P and Romeo
Founded: May 2007
Website: www.takeastandrecords.com

A "Record Label for Responsible Hip Hop Artists," Take a Stand Records promotes hip hop artists whose music empowers communities and refrains from employing offensive lyrics and negative imagery. Take a Stand Records is currently recruiting artists through a nationwide talent search, "America's Next Hip Hop Star." Proceeds from record sales go toward scholarships for high school students.

Take Back the Music Campaign

Website: www.essence.com/essence/takebackthemusic/about.html

Take Back the Music is a campaign that developed out of ESSENCE in response to negative representations of black women in the media generally and in hip hop music specifically. TBTM creates space in which to discuss these derogatory images of black women and encourages self-reflection. It also works toward more balanced representations of black women and men in popular culture and promotes artists who engage in more positive representational practices.

Team Rescue

Founder: Master P
Website: www.teamrescueone.com/about.html

Team Rescue is an initiative begun by Master P in response to high rates of crime, gang involvement, drug abuse, teen pregnancy, and truancy among youth. Libraries and Gymnasiums in P. Miller Youth Centers in New Orleans, Chicago, and Los Angeles help youth to build alternative pathways using literacy and athleticism. Team Rescue has also concerned itself with helping communities in Louisiana, Alabama, and Mississippi to recover from Hurricane Katrina.

Womanhood Learning Project

Team: Martha Diaz, Mona Ibrahim, Nakia Alston, Beth Sachnoff, Kompalya Thunderbird, Deanne Ziadie-Nemitz, Amanda Cumbow, Renee Moore, and Ebonie Smith

Website: www.netvibes.com/hiphopassociation

The Womanhood Learning Project, a two-year program launched in March 2008, was developed by the Hip Hop Association with the aim of cultivating "unity among women in Hip-Hop to create a space to learn, build, and bring about concrete change." The WLP seeks to create awareness of and give voice to the contributions of women in leadership positions in the music and entertainment industries who have "maneuvered the sexist system." At the same time, the project hopes to acknowledge and illuminate aspects of the media that not only limit these women's opportunities and awareness but also adversely impact young girls.

Women in Entertainment Empowerment Network

Founder: Valeshia Butterfield

Founded: September 2007

Website: www.weenonline.org

In the wake of the increased outcry in 2007 over sexism and racism in the entertainment industry, Valeisha Butterfield, executive director of the "Hip Hop Summit Action Network," founded WEEN to organize entertainment executives around the goal of promoting a more positive and balanced portrayal of women of color in entertainment and society. WEEN aims to use its members' "impact and visibility" to push for change in three broad areas: corporate social responsibility, media and artist responsibility, and community programs and outreach. One of WEEN's earliest initiatives was "the Pink List," a list of films, books, movies, music, publication, and other media programming whose portrayal of women meets WEEN's standards.

Youth Speaks
Founder: James Kass
Website: www.youthspeaks.org

Founded in 1996 in San Francisco, Youth Speaks embraces the creative and liberatory capacity of oral and written literacy to empower youth to be agents of social change. It offers literary arts education and youth development programs, publishes the work of young artists through "First Word Press," and hosts several poetry slams, theatre productions, festivals, and reading series throughout the year. Currently, Youth Speaks works with 45,000 teens annually in the Bay Area, and has partner programs in thirty-six U.S. cities.

13

Six Guiding Principles for Progressive Creativity, Consumption, and Community in Hip Hop and Beyond

ENJOYING BLACK POPULAR CULTURE, especially hip hop, in a way that reflects progressive principles isn't easy these days. If rejecting it all isn't an option, then how do we make meaningful distinctions? How can we determine where to invest our energies? It would be far easier if this problem could be solved merely by boycotting a given artist. But the situation is far more messy than this. The cross-marketing of ghetto-gangsta-cool saturates so many aspects of hip hop that doing a strict artist-by-artist evaluation and cutting those who are complicit with this trend could leave us with a mighty short playlist. This strategy could even mean rejecting pop-friendly artists such as Justin Timberlake and other pop stars who collaborate with rappers like T.I., Snoop, Jay-Z, and 50 Cent who trade primarily in the gangsta-pimp-ho trinity. Instead, it seems more effective to let some guiding principles shape our responses to songs, artists, trends, and images. The point is to disable the trade in destructive images and visions of black people, to make them undesirable and unprofitable no matter where they take place. This means tackling the power of such images and rejecting them, not letting one particular artist become the focus of our ire. Zeroing in on the underlying politics of the images and words helps us to keep our eye on what we specifically do not want, not just what we'll settle for. It keeps us actively engaged in setting the terms for what we'll support in hip hop and everywhere else.

Toward this end, I am proposing six principles that I hope will provide a starting place for encouraging all who love black music to create a progressive community around it: (1) *Beware the manipulation of the funk.* (2) *Remember what is amazing about chitterlings and what isn't.* (3) *We live in a market economy; don't let the market economy live in us.* (4) *"Represent" what you want, not just what is.* (5) *Your enemies might be wrong but that doesn't make you right.* (6) *Don't settle for affirmative love alone; demand and give transformational love.* These principles are especially meant to support young artists in their efforts to energize and innovate in the spirit of good will, in the presence of justice.

Beware the Manipulation of the Funk

On countless occasions over the past decade or so, I have found myself listening, driving, or dancing to a song, yet only later really heard the lyrics. One such song was Dr. Dre and Snoop Dogg's 1992 classic and unbelievably funky "Gin and Juice"; another was 50 Cent's 2003 hit, "In da Club." In some cases I was unaware of the words because I couldn't actually make out the lyrics or translate the slang; but then there were the times I heard the "clean version" and then got depressed when I learned what the artist really wanted to say. At still other times, I was mostly listening to the music or merely letting the music, the style, and the swagger move me so completely that only the most oft-repeated phrases really sunk in. Once I really listened to the words and thought about the story being told, it was hard to know what to do: Respond to the funk and ignore the words, or reject the story and give up the funk that goes with it. The moment I realized that I was being asked to give myself over to the power of the funk—which in turn was being used as a soundtrack for a story that was really against me—was very sad for me. I thought my feelings must be very much like those of *Washington Post* writer Lonnae O'Neal Parker when she reached a turning point with this music, saying that she could no longer sacrifice her self-esteem or that of her two daughters on the "altar of dope beats and rhymes."[1]

Some people swear that they can "ignore" the words and just enjoy the music. No matter what gets said, they are not affected; the words don't matter. I've asked my students if there was any limit at all for them — any lyric that would upset or anger them enough to make them reject the song outright. The hip hop fans among my students would bravely say "No, the words don't matter" to show that they would always be down with hip hop. So, then I'd ask them if a pro–Ku Klux Klan performer came up with an incredible, infectious, undeniable beat and rhyme, but the words celebrated the domination of black people, would they just "block out the words" and still claim that "the words don't matter"? Of course, few would still say "yes." My point in drawing this volatile analogy is not to imply that hip hop lyrics are in any way comparable to white supremacist rhetoric. But I want to point out that we all have a line to draw. It's not a "free for all," "anything goes as long as its funky" situation but, rather, a matter of recognizing that before we reach our limit, we are saying "yes" to what we shake our hips to. My analogy also reveals that once we have pledged allegiance to something, we will submit to excesses and a negative influence that, if expressed by others, would be grounds for self-defense.

Were this about one bitty song that uses the word "bitch," or only one or two rhymes that use violence, metaphorically or otherwise, to settle "beef"; or if only an occasional song relied on insults such as calling neighborhood enemies "bitch ass niggas," well, maybe we wouldn't need to raise our defenses so high. But unfortunately, this kind of spirit has become too common in commercial hip hop. Yes, we can ignore some lyrics on occasion; but when the music that gets played over and over at the clubs and on hip hop–oriented commercial radio, BET, and MTV is saturated with hustlers, gangstas, bitches, hoes, tricks, pimps, playas, and stories that glamorize domination, exploitation, violence, and hustlers — when this becomes the primary vocabulary for hip hop itself — then the power of the funk has been manipulated. The life force of the funk has been wedded to a death imperative.

Black music has played an extraordinary role in the history of black people and in the world. It has helped black people to protect, nourish,

and empower themselves, and to resist forces operating against their freedoms. This music has not always been explicitly political or dubbed as "protest music." Indeed, its political significance has gone far beyond the confines of a direct protest standard, registering in the positive spirit of sounds tied to stories that exhibit a fundamental love of black people.

There is no doubt that this tradition lives today. But it *is* under duress, and we need to pay attention, to be aware of the manipulation of the funk. It is being pressed into a spirit-crushing repetition of un-reflective, instant gratification. As Cornel West said during BET's October 2007 *Hip Hop vs. America* forum: "Dominant forms of hip hop are about what? A repetition of the present; over and over again—the next orgasm, the next pleasure; no history, no future. No different future can emerge in a present that's just repeating itself over and over again without a difference." It is not just about saying "no" to manipulative uses of the funk; it is about saying "yes" to music that doesn't force us to block out the words as a form of self-protection. For those who don't melt at the power of an amazing rhythm, drum, or bass line, this may be hard to understand. The funk is the Achilles' heel for lovers of black music. The love of a great funky beat is like kryptonite for Superman. Our places of weakness make us vulnerable but also open us up to our greatest places of con-nection. This is why the music must be revered, not discarded. But, like any other powerful and compelling force, beats can be distorted, used as a baseline for stories that undermine the spirit. Music comes from but also makes community, so the question becomes: What kind of community do we want to make?

Remember What Is Amazing
About Chitterlings and What Isn't

The genius of black creativity has often involved making something good out of the scraps—creating a delicacy out of undesirable, dis-carded parts. Sometimes, though, we get so excited about the re-silience and transformative power of black people's creativity that we

confuse the creative energy and talent with the creative output. In hip hop this has meant reveling over the ingenuity of hip hop's creative genius for using scraps from the urban landscape to make music—presenting exhilarating dances on cardboard in the street, reusing obsolete technical-trades equipment to rebuild stereos, telling stories on street corners in ways that made people in corporate offices listen—while at the same time ignoring the toxic conditions under which such creativity occurs.

This confusion between the genius of remaking and the final product reminds me of chitterlings. There is a crucial distinction between the genius behind turning pig guts into a grassroots delicacy and the actual chitterlings themselves. Poor people around the world have made delicacies out of nearly every part of an animal. In Europe, brain chitterlings, andouilles (pigs' large intestines), trotters (feet), snouts, and tripe (stomach) have been common menu items. Traditional Scottish haggis consists of sheep's stomach stuffed with rolled oats, boiled liver, lungs, and other animal parts. And the West African tradition of using all edible parts of plants and animals in cooking has meant that eating hooves, intestines, and the like was already part of a larger pre-enslavement tradition for African-Americans.

What makes the case of chitterlings as an African-American soul-food tradition unique is the fact that slaves were given *only* what were considered scraps—food that slave owners and their families would not eat. So, no matter how well they were prepared, no matter how much creative efficiency surrounded previous decisions to eat intestines, ears, hooves, and other animal parts, the context for African-Americans' use of chitterlings—or chitlins as they are affectionately called—symbolizes not just black people's resilience, tradition, and creativity but also their mistreatment. Chitterlings were not part of a diet filled with other, more nutritious animal parts. They were just one "part" provided, while whites were given access to all available food sources. Pig guts were considered inedible trash and were given to enslaved black people as such. Enslaved people were given bare-minimum nutrition—just enough to keep them alive so they could work endlessly for the profits of others.

Making decent chitterlings out of pig guts took deft culinary skill. It required expert cleaning, preparation, and seasoning—especially given African-Americans' limited access to a wide range of cooking materials at the time. Making them edible was truly an art. But the artistry of making chitterlings out of pig guts under stress and mistreatment is only really appreciated when we understand the context. Having pig intestines to serve as the basis for a meal was a clear symbol of the deep disregard and dehumanization that black people experienced under slavery. African-Americans' ability to make a delicacy out of discarded trash, to make nourishment out of the nearly indigestible—all the while knowing that it was part of a larger system of dehumanization— should be lauded and honored. But this should be a somber honoring because it also represents the duress under which such creative culinary genius evolved.

Hip hop was born and grew up under extreme social and economic pressure; its powerful tales of fun, affirmation, and suffering should be honored but also recognized as reflections of the stress under which it was brought into creation. It relied on various black musical traditions and approaches to sound, language, and rhythm but also continued the long tradition of making something out of nothing. Too much celebration of hip hop's creativity deemphasizes the fact that it reflects the genius of black people's ability to make delicacies out of scraps.

This is a warning not to forget the mistreatment and the debilitating context in which so much black creativity must operate. It's a call to remember what is amazing about chitterlings and what isn't. It is a call to strive for optimum circumstances, to reject limiting conditions, and to avoid getting so caught up in celebrating the ability to create under limiting and destructive conditions that this context becomes an acceptable norm, a black badge of honor. Challenges to destructive energies in hip hop that are countered with claims that at least the rapper is not robbing people reflect the worst of this embrace of toxicity. What would the genius of black creativity produce with normal levels of social resources, with less social starvation, and without high levels of violence and incarceration? Shouldn't we

demand more than the intestines of society, no matter how creative we have been with them?

We Live in a Market Economy;
Don't Let the Market Economy Live in Us

Today, it would be unreasonable to ask people to permanently turn their backs on the mass media or on our society's consumer-based focus. Not everything that goes on in consumer culture is negative. The problem is the way that the very logic of the market—the designation of things as valuable only when they can be exchanged for profit—has become the governing logic not just for market trading but for human exchanges and cultural value as well. The emphasis on valuing the wealthy and all the trappings of luxury and excess is constantly marketed to us all. The rich, the famous, and the financially powerful are considered more important than the rest of us; they take up enormous media space simply because they have power through wealth; they can dazzle us with their fancy cars, jewels, multiple homes, and glamorous lifestyles. This larger U.S. drive to value those who can consume the most drives the "bling-bling" aesthetic in hip hop. Exactly what have wealthy celebrities like Donald Trump done in service of expanding democracy? Why was Paris Hilton's forty-five-day jail sentence covered in news reports with such empathy and concern while stories about the thousands of poor and ill-educated black and brown men and women in jail for multiple years for nonviolent crimes are rarely addressed? Our consumption-based culture perpetuates the coveting of the bling-bling lifestyle as it encourages us to spend in the hopes of emulating celebrities' lives, looks, and fashions. This pursuit keeps us from constantly asking why it is that so few have so much, why even the legal system seems to reinforce higher and higher levels of wealth accumulation and concentration, why such excess is okay when so many starve, suffer, and live on the streets. It's not surprising that dog-eat-dog capitalistic logic has become a visible fact of commercial hip hop: It reflects larger trends in our society. But these trends, internalized among those who have

the least, intensifies suffering. It feels exhilarating to see someone from the 'hood make it, but we must not forget to ask how that success was made and on what ideas about black people it might have traded. To avoid these questions is to let the market's overemphasis on exchange value take hold of our spirit. While we live in this market economy, let's try not to let market value and personal profit rule over love, collective well-being, and sacrifice for the larger good.

"Represent" What You Want, Not Just What Is

Far too much of the "representing" energy in hip hop deals with the reflection of what "is" (whether true or not). No matter the level of creativity applied to this realist model, it does not open up enough space for imagining things beyond where we are now. The emphasis on representing reality doesn't encourage us to seriously consider what we actually want (which we must imagine) but, rather, trains our eye on reflecting where we are (what we see all around us). To redirect the destructive energies in hip hop toward building humanizing communities that will challenge injustice means focusing as much as possible on the cultivation of ideas and visions about what we want to build. Representing what "is" (especially if that is a perpetual snapshot of the worst aspects of living in the ghetto) but without constantly taking that next step to ask "What do I want my community to look like?" can turn into a vicious visionless cycle.

Serious reflection on the question of what we want is a risky venture because it means displaying a sense of hope and longing. If we want affordable housing and good schools and safe streets, then we have to work toward getting them. Even when anger drives some of this wanting, there is a vulnerability in it. It expresses a wish that can be denied, mocked, and rejected—especially by a get-mine-at-all-costs attitude. Hoping, such an attitude suggests, is for suckers. Given the multigenerational betrayal of African-Americans' many demands for equality and justice, it shouldn't be surprising that disengagement from hope sometimes becomes a necessary form of self-protection.

Cynicism takes root where hope has begun to wane. The hustler is a quintessential cynic.

We must keep thinking about what we want—not money, cars, and material things, but what kind of communities do we want? How do we want to be treated? What kinds of schools, homes, stores, jobs, parks, childcare, and police work would uplift and transform our communities? How can we create cultural spaces that nurture ideas about the communities we want, not just the ones we already have?

Your Enemies Might Be Wrong But That Doesn't Make You Right

The "blame versus explain" approach to conversations about the state of hip hop winds up encouraging the best artists, writers, and thinkers to expend too much energy responding angrily to mean-spirited and sometimes ignorant opponents, and, at the same time, discouraging the allocation of energies for developing and sharing an internal critique. A number of artists, such as Nas, The Roots, and Lupe Fiasco, have used their considerable musical and lyrical talents to address the state of affairs in hip hop eloquently and at length. Yet, in fact, internal critique of hip hop is highly underreported. Those working to do the necessary groundwork do not get nearly the airtime they deserve. Even worse, the lack of awareness that results perpetuates the distracted self-defense model of politics being cultivated among hip hop's youngest fans. The mainstream conversation about hip hop reinforces the oppositional model that drives media ratings and provokes a good deal of self-protective energy in response.

This seems clear, given the polarized debates over violence and sexism in hip hop. Too many conversations draw their energy from proving hip hop's "enemies" wrong as a source of bonding and hip hop allegiance. And, unfortunately, this allegiance doesn't make what goes on in a lot of mainstream hip hop right. Nor does it allocate adequate energy toward the creation of a hip hop–based position that serves as a guiding light for the young people who identify with it

so strongly. One aspect of this guiding light is the ability to develop serious internal critique and to be able to fully assess the value of others' perceptions as objectively as possible.

Misguided attacks on people we feel solidarity with (even though we may have our own quarrels with them, too) often encourage folks to close ranks. The constant barrage of hyperbole about rap's "cause-of-all-evil" role in U.S. society has siphoned off energies that could otherwise be augmenting internal critique and analysis. It also contributes to an inability to really think about what might be wrong. If our cultural energy is going to help create interactions that fuel and support growth, healthy challenges to injustice, community sacrifice, and collective good will, then we have to spend the majority of our energy on refining what we do and say, and learning how it can be improved to serve our larger goals. This means expanding the internal criticisms of hip hop in the interests of social justice. If our goal is to prove our enemies wrong rather than to figure out how to make what we love right, then we could be working against our own interests and not even know it.

Don't Settle for Affirmative Love Alone; Demand and Give Transformational Love

The history of African-Americans is marked by an ongoing, multifaceted experience of disaffirmation. Enslavement in the United States was rationalized by the idea that Africans were only three-fifths human. This fundamental disaffirmation, the denial of African humanity, is reflected in the U.S. Constitution itself. The idea that blacks were not fully human—that they were less intelligent than whites, lacked any valuable culture, threatened civilization, and were therefore not worthy of protection or full rights—was perpetuated across various, legal, scientific, social, and cultural spheres for hundreds of years. This disaffirmation in nearly every arena continued uninterrupted throughout most of our history leading up to the period of the civil rights movement. While civil rights laws attempt to redress this extensive history, the application and enforcement of them have

been met with sustained resistance. As George Lipsitz argues in his book *The Possessive Investment in Whiteness*: "At every stage over the past fifty years, whites have responded to civil rights laws with coordinated collective politics characterized by resistance, refusal and renegotiation." And Cornel West's Preface to *Race Matters*, published in 2001, reminds us that "[n]o other people have been taught systematically to hate themselves—psychic violence—reinforced by the powers of state and civic coercion—physical violence—for the primary purpose of controlling their minds and exploiting their labor for nearly four hundred years." "Loving Black people," then, as Patricia Hill-Collins rightly argues, "in a society that is so dependent on hating Blackness constitutes a highly rebellious act."[2]

There is ample and powerful rejection of the legacy of dehumanization in African-American communities, but also in those of many other racial groups, including whites. The heroic tradition of affirmation among African-Americans is a crucial part of the love ethic— what Cornel West, bell hooks, Toni Morrison, James Baldwin, and other great minds have identified as a vital form of survival. Toni Morrison's extraordinary body of work insists that we consider the power and importance of love. In *Salvation: Black People and Love*, bell hooks says that "the denigration of love in black experience, across classes, has become the breeding ground for nihilism, for despair, for ongoing terroristic violence and predatory opportunism. . . . [We thus must address] the meaning of love in black experience today, calling for a return to an ethic of love as the platform on which to renew a progressive anti-racist struggle, and offering a blueprint for black survival and self-determination." And in *The Fire Next Time*, James Baldwin tells his nephew about how much black survival depends on love: "We have not stopped trembling yet, but if we had not loved each other none of us would have survived."[3]

The love ethic needs as much support as it can get. But what should this love ethic look like? Is it enough to affirm the disaffirmed in this historical moment? Can this strategy bring about what Michael Eric Dyson has called "the rehab of the black psyche"?[4] It seems that multiple types of love might be more necessary now than

ever. In particular, I am interested in a strategy that emphasizes the ability to experience some kinds of critique as a central part of the love ethic. Theologian William F. May, in talking about parental love, presents us with a model for loving that seems especially useful in navigating the conversation about black youth, hip hop, and the future of black America. May says that parents give their children two types of love: accepting love and transforming love. Accepting love is a kind of *affirmational* love, one that attends to the unconditional support of the child. Transforming love seeks the child's well-being. May claims that each corrects the potential excesses of the other: Whereas affirmational love alone can stunt growth because it produces a calm acceptance of where things are, *transforming* love sets boundaries in the interests of change, growth, and health.[5]

The parent/child model is a special and limited one, but the larger idea that different types of love are vital to helping us reach our fullest potential is applicable far beyond the family context. All of us, adults included, need from our closest friends, community members, leaders, lovers, and supporters both accepting or affirmational love (a love that affirms us fundamentally) and transforming or transformational love (a love that pushes us past our comfort zone, that demands that we wrestle with standards and challenges growth in the interests of society's well-being). Given the larger history of denial about the powerful reach of racism and the continued attacks on black people, there is an understandably high investment in affirmative love just to break even. The universal need to have one's experience validated is exaggerated by such a history of refusal and denial. But transformational love is necessary and crucial. Giving and receiving transformational love are more challenging under hostile conditions, since the need for affirmation might be very strong and hearing critique might feel like adding salt to already raw wounds. But these circumstances—in which it is so easy to reflect the hostile world in which one must live—may only make transformational love all the more important. Affirmation for destructive responses to destructive conditions quickly fosters more of both.

In the battle over hip hop, many hip hop fans—especially the black youth among them—feel that there has been too much hostility directed toward them, too little affirmation of them, and far too much rejection of hip hop artists' music and creativity. And, I would add, too much denial of what they have been asked to shoulder. In many ways they are right. Supporters and too many visible and powerful rappers have responded to these attacks by defending hip hop unequivocally. But depending on what is being defended, explained, and generally allowed, this gesture of love and defense can be and has been crippling. Not all critics of hip hop are the proverbial "haters," and to label them this way stymies the powers of transformational love. The struggle, in this climate of "blame hip hop versus explain hip hop," is to be able to give transforming love and have it be received in that spirit. Defending the indefensible, even in the spirit of love, doesn't create well-being for the beloved. I have written this book in the spirit of both affirmational and transformational love, and I hope both spirits have arrived intact.

Appendix:
Radio Station Consolidation

This chart highlights the post-1996 consolidation of ownership of radio stations playing commercially significant black music in twenty-two major urban metropolitan areas. Nearly all of these radio stations are owned by two major corporations: Clear Channel and Radio One. Stations in italics are dedicated to hip hop music and contemporary R&B.:

NEW YORK CITY
Power 105.1: Hip Hop/R&B—Clear Ch
Hot 97: Hip Hop/R&B—Emmis
Kiss 98.7: R&B/Soul—Emmis

CHICAGO
107.5 WGCI: Hip Hop/R&B—Clear Ch
V 103: R&B/Old School —Clear Ch
Inspiration 1390: Gospel—Clear Ch

RICHMOND
106.5 The Beat: Hip Hop/R&B—Clear Ch
Power 92.1: Hip Hop/R&B—Radio One
Kiss 99.3/105.7: Soul/R&B—Radio One
Praise 104.7: Gospel—Radio One
Newstalk 1240: Newstalk/R&B—Radio One

PHILADELPHIA
WDAS FM 105.3: Soul/R&B—Clear Ch
Power 99: Hip Hop/R&B—Clear Ch
100.3 The Beat: Hip Hop/R&B—Radio One
Praise 103.9: Inspirational—Radio One
107.9 WRNB: R&B—Radio One

COLUMBUS
Power 107.5: Hip Hop/R&B—Radio One
Joy 106.3: Gospel –Radio One
Magic 98.9: R&B/Oldies—Radio One

NEW ORLEANS
Q93.3: Hip Hop/R&B—Clear Ch
98.5 WYLD: R&B/Oldies—Clear Ch
WYLD 940: Gospel—Clear Ch

OAKLAND/SAN FRANCISCO
98.1 Kiss FM: R&B—Clear Ch
106 KMEL: Hip Hop/R&B—Clear Ch

BOSTON
JAM'N 94.5: Hip Hop/R&B—Clear Ch

MEMPHIS
V101.1: R&B/Old School—Clear Ch
WDIA 1070: Soul/R&B—Clear Ch
Hallelujah 95.7: Gospel—Clear Ch
K97.1: Hip Hop/R&B—Clear Ch

NORFOLK/ VIRGINIA BEACH
103 JAMZ: Hip Hop/R&B—Clear Ch
105.3 Kiss FM: R&B/Oldies—Clear Ch

ATLANTA
Hot 107.9: Hip Hop—Radio One
Classic Soul 102.5: Soul—Radio One
Praise 97.5: Gospel—Radio One

HOUSTON
101.1 WIZF: Hip Hop/R&B—Radio One
Mojo 100.3: R&B/Old School—Radio One

CINCINATTI
101.1 WIZF: Hip Hop/R&B—Radio One
Mojo 100.3: R&B/Old School—Radio One

INDIANAPOLIS
Hot 96.3: Hip Hop/R&B—Radio One
AM 1310 The Light: Gospel—Radio One
106.7 WTLC: R&B—Radio One

WASHINGTON, D.C.
93.9 WKYS: Hip Hop/R&B—Radio One
Majic 102.3: R&B—Radio One
Praise 104.1: Inspiration—Radio One
SPIRIT 1340: Gospel—Radio One

DETROIT
98 WJLB: Hip Hop/R&B—Clear Ch
Mix 92.3: Soul/R&B—Clear Ch
Hot 102.7: Hip Hop—Radio One
105.9 Kiss FM: R&B—Radio One

LOS ANGELES
Hot 92.3: R&B/Old School—Clear Ch
Power 106: Hip Hop/R&B: Emmis

CLEVELAND
Z107.9: Hip Hop/R&B—Radio One
93.1 WZAK: R&B—Radio One
Praise 1300: Gospel—Radio One

DALLAS
97.9 The Beat: Hip Hop—Radio One
94.5 K Soul: R&B—Radio One

HOUSTON
97.9 The Box: Hip Hop/R&B—Radio One
Majic 102.1: R&B—Radio One
Praise 92.1: Inspiration—Radio One

RALEIGH-DURHAM
K97.5: Hip Hop/R&B—Radio One
193.9 The Light: Gospel—Radio One
Foxy 107.1/104.3: R&B/Soul—Radio One

ST. LOUIS
100.3 The Beat: Hip Hop/R&B—Clear Ch
Hot 104.1: Hip Hop—Radio One
Hallelujah 1600: Gospel—Clear Ch
Majic 104.9: R&B/Old School—Clear Ch
Foxy 95.5: R&B—Radio One

Acknowledgments

THE PUBLIC CONVERSATIONS THIS BOOK engages grew out of many small and sometimes private conversations. If the book has anything to offer it is largely due to the many brilliant insights offered by friends, colleagues, family members, students, and strangers. Clark and Coleman Craddock-Willis brought their vast knowledge of hip hop, special brands of intelligence, and soulful generosity to every dialogue and listening session. Special thanks go to Clark for reading early chapters and for sitting me down and playing several Lupe Fiasco tunes early in the project. Students at UCSC, Brown, and many other schools around the country were inspiring and always helpful. George Lipsitz, Felice Blake, Paula Ioanide, April Garrett, Rahiel Tesfamariam, and Allen Payne read portions of the manuscript and offered a level of critical engagement for which most writers can only hope. Katherine Belshae, Lisa Duggan, Liz Fitzsimmons, Yoshiko Harden, Mark Jefferson, Adam Mansbach, Chris, George, and Jeanne Rose, Billie Rose-Willis, Bob Taren, and Rini Van Every are some of the many friends and family members who offered intellectual community, necessary distraction, support, humor, and encouragement along the way. Thanks are also heartily extended to the students and my colleagues at Brown University, especially the Africana Studies Department. My agent, Geri Thoma, saw a place for this book immediately and supported it and me with her trademark élan. Research is an odd combination of thrill and tedium, but because of Hannah Pepper-Cunningham, the indomitable research assistant for this book, it was nearly all thrill for me. Hannah brought her commitment, excellent research talents, and good cheer to every assignment I concocted, and for this I am very grateful. Editorial care

makes all the difference and for this I also heartily thank Kaudie McLean, Lara Heimert, and the entire Basic Books team.

This book has been most enriched by the loving, challenging, and nourishing conversations I shared with Andre C. Willis. It rides on the foundation of his joyful, indefatigable support and sacrifice, and draws on his brilliant mind and abundant heart. So do I.

Notes

Introduction

1. This statistic was calculated on the basis of RIAA's consumer profile reports of 1998 and 2006.

2. Adrienne P. Samuels, "Russell Simmons: The Godfather Takes a Stand," *Ebony* magazine, July 2007, p. 79. In this article Simmons is quoted as saying: "Poverty created these conditions and these conditions create these words."

3. Neil Strauss, "Are Pop Charts Manipulated?" *New York Times*, January 25, 1996.

4. Stephen Holden, "Billboard's New Charts Roil the Record Industry," *New York Times*, June 22, 1991.

5. Glen Ford, "Hip Hop Profanity, Misogyny and Violence: Blame the Manufacturer," *Peninsula Peace and Justice Center*, May 7, 2007, available online at www.peaceandjustice.org/article.php/20070507114621137/print.

6. Quoted in Havlock Nelson, "Rapping Up '93," *Billboard*, November 27, 1993.

7. Ben H. Bagdikian, *The New Media Monopoly* (Beacon Press, 2004), p. 27.

8. Ibid. See also the transcript of the PBS documentary *Merchants of Cool* featuring charts of media consolidation, available online at www.pbs.org/wgbh/pages/frontline/shows/cool.

9. Mark Fratrik, "Radio Transactions 2001: Where Did All the Deals Go?" *BIA Financial Networks* (2002), p. 8; Eric Boehlert "One Big Happy Channel?" Salon.com, June 28, 2001.

10. Peter DiCola and Kristin Thomson, "Radio Deregulation: Has It Served Citizens and Musicians? A Report on the Effects of Radio Ownership Consolidation Following the 1996 Telecommunications Act," Future of Music Coalition, November 18, 2002, p. 3.

11. Bruce Dixon, "Making Real Change: Taking on Black Commercial Radio," *Black Agenda Report*, May 21, 2008.

12. Eric Boehlert, "Payola City," Salon.com, July 24, 2001.

13. Ibid.

14. Paul Porter, "Same Song," unpublished manuscript.

15. Author Interview with Paul Porter, May 24, 2008.

16. Ford, "Hip Hop Profanity, Misogyny and Violence."

17. Marcus Franklin, "Music Execs Silent as Rap Debate Rages," *USA Today*, May 11, 2007, available online at www.usatoday.com/life/music/2007–05–11–3355380428_x.htm.

Chapter 1

1. Dr. Craig Anderson and Karen E. Dill, "Video Games and Aggressive Thoughts, Feeling and Behaviors in the Laboratory and in Life," *Journal of Personality and Social Psychology* 78, no. 4 (April 2000): 772–290.

2. Andrew Rosenthal, "The 1992 Campaign: White House; Bush Denounces Rap Recording and Gives D'Amato a Hand," *New York Times*, June 30, 1992.

3. Carrie B. Fried, "Who's Afraid of Rap: Differential Reactions to Music Lyrics," *Journal of Applied Social Psychology* (July 2006), available online at www.blackwell -synergy.com/doi/abs/10.1111/j.15591816.1999.tb02020.x.

4. "Nobel-Winning Biologist Apologizes for Remarks about Blacks," CNN, October 19, 2007, available online at www.cnn.com. For further information on eugenics past and present, see Troy Duster, *Backdoor to Eugenics* (Routledge, 2003); Daniel J. Kevles, *In the Name of Eugenics: Genetics and the Uses of Human Heredity* (Harvard University Press, 1985); and Zack Z. Cernovsky, "On the Similarities of American Blacks and Whites: A Reply to J. P. Rushton," *Journal of Black Studies* 25, no. 6 (July 1995): 672–679.

5. Quoted in Lauren Lazin, *Tupac: Resurrection* (Paramount, 2003).

6. "MP Wants Rapper 50 Cent Banned from Canada," Canada Television, November 23, 2005, available online at www.ctv.ca.com; "Jay-Z Says Rap Music Overrates Violence and Crime," September 20, 2005, available online at www.news .softpedia.com.

7. Robin D. G. Kelley, *Yo' Mama's Disfunktional: Fighting the Culture Wars in Urban America* (Beacon Press, 1997), p. 46; Joint Center for Political and Economic Studies report, January 1990, available online at www.census.gov/hhes/www/ poverty/histpov/hstpov2.html.

8. Quoted in Mindy Fullilove, *Root Shock: How Tearing Up City Neighborhoods Hurts America and What We Can Do About It* (One World/Ballantine, 2004), p. 68.

9. Ibid., p. 20.

10. Neil Strauss, "The Confessions of Chris Rock," *Rolling Stone*, April 7, 2004; "Chapelle Show Memorable Quotes," available online at www.imdb.com/title/ tt0353049/quotes.

11. U.S. Sentencing Commission, Special Report to Congress: Cocaine and Federal Sentencing Policy (Washington, DC: U.S. Sentencing Commission, February 1995), pp. iii, v; Barbara S. Meierhoefer, *The General Effects of Mandatory Minimum Prison Terms: A Longitudinal Study of Federal Sentences Imposed* (Washington, DC: Federal Judicial Center, 1992), p. 20; U.S. Sentencing Commission, Special Report to Congress: Cocaine and Federal Sentencing Policy (Washington, DC: U.S. Sentencing Commission, April 1997); Manning Marable et al., eds., *Racializing Justice, Disenfranchising Lives: The Racism, Criminal Justice, and Law Reader* (Palgrave Macmillan, 2007). See also Bakari Kitwana, *The Hip Hop Generation* (Basic Books, 2003), for a detailed discussion of the war on drugs vis-à-vis hip hop during this period.

12. Statistics are available online at www.justicemappingcenter.org and www .sentencingproject.org. See also Jennifer Gonnerman, "Million Dollar Blocks: The Neighborhood Costs of America's Prison Boom," *The Village Voice*, November 9, 2004; Marc Maur and Meda Chesney-Lind, eds., *Invisible Punishment: The Collateral Consequences of Mass Imprisonment* (New Press, 2002); Natalie J. Sokoloff, "The Impact of the Prison Industrial Complex on African American Women," *Souls* 5, no. 4 (2004): 31–46; and Editorial Staff, "More Black Men Are in Jail than Are Enrolled in Higher Education," *Journal of Blacks in Higher Education 41* (Autumn, 2003): 62.

13. Todd I. Herrenkohl et al., "Developmental Risk Factors for Youth Violence," *Journal of Adolescent Health* 26, no. 3 (March 2000), available online at www.ncbi.nlm.nih.gov/sites/entrez?db=PubMed&cmd=Retrieve&list_uids=1070616 5&dopt=Citation).

14. Austin Scagg, "Jay-Z: The Rolling Stone Interview," *Rolling Stone*, November 29, 2007.

Chapter 2

1. Sidney W. Mintz and Richard Price, *The Birth of African-American Culture: An Anthropological Perspective*, rev. ed. (Beacon Press, 1992); Nathan Huggins et al., *Key Issues in the African-American Experience, vol.* 1 (Harcourt Brace Jovanovich, 1971); Robert Faris Thompson, *Flash of the Spirit: African and Afro-American Art and Philosophy* (Random House, 1983); Paul Gilroy, *The Black Atlantic: Modernity and Double Consciousness* (Harvard University Press, 1993); Walter Jackson, "Melville Herskovits and the Search for Afro-American Culture," in George Stocking, ed., *Malinowski, Rivers, Benedict, and Others: Essays on Culture and Personality, History of Anthropology*, vol. 4 (University of Wisconsin Press, 1986), pp. 95–126; Robin D. G. Kelley, *Yo' Mama's Disfunktional!: Fighting the Culture Wars in Urban America* (Beacon Press, 1997).

2. Kathy J. Ogren, *The Jazz Revolution: Twenties America and the Meaning of Jazz* (Oxford University Press, 1989), p. 156.

3. Cornel West, *Race Matters* (Beacon Press, 1993), p. 12.

Chapter 3

1. John H. McWhorter, "How Hip-Hop Holds Blacks Back," *City Journal 13, no.* 3 (Summer 2003): 75. See also Robert L. Smith, "Anti-Education Mind-Set Hurts Black Boys, Study Says," *Cleveland Plain Dealer*, May 15, 2007.

2. Devah Pager and Bruce Western, "Race at Work: Realities of Race and Criminal Record in the NYC Job Market," available online at www.princeton.edu/ ~pager/race_at_work.pdf.

3. S. Fordham and J. U. Ogbu, "Black Students' School Success: Coping with the Burden of 'Acting White,'" *The Urban Review* 18, no. 3 (1986): 176–206.

4. Jabari Asim, "Did Cosby Cross the Line?" *Washington Post*, May 24, 2004; Hamil R. Harris and Paul Farhi, "Debate Continues as Cosby Again Criticizes Black Youths," *Washington Post*, July 3, 2004; Ta-Nehisi Coates, "This Is How We Lost to the White Man," *Atlantic Monthly*, May 2008.

5. McWhorter, "How Hip-Hop Holds Blacks Back."

6. Quoted in Anderson Cooper, "360 Degrees: The Stop Snitching Crisis," April 24, 2007, available online at www.cnn.com/transcripts.

7. "Can Hip Hop Be More than Gangsta Rap?" *Hip Hop vs. America*, BET, September 25, 2007.

8. Interview with Paul Porter of *Industry Ears*, former radio and BET programmer.

9. Fox News, *"The O'Reilly Factor:* Is Gangsta Rap Hurting America's Children?" November 14, 2003, available online at www.foxnews.com/transcripts.

10. Consumption data from MediaMark, a demographic, product usage, and Internet research firm for magazines, TV, cable, radio, and other media, available online at www.Mediamark.com.

11. This segment of *Larry King Live* aired on Saturday November 3, 2007.

12. Quoted in Patricia Hill-Collins, *Black Sexual Politics: African-Americans, Gender and the New Racism* (Routledge, 2004), p. 24.

13. James Baldwin, *The Fire Next Time* (Vintage, 1963), pp. 7–8.

Chapter 4

1. David Nassau, *Going Out: The Rise and Fall of Public Amusements* (Harvard University Press, 1999); Kathy Peiss, *Cheap Amusements: Working Women and Leisure in Turn-of-the-Century New York* (Temple University Press, 1986); George Lipsitz, *Rainbow at Midnight: Labor and Culture in Post-War America* (University of Illinois Press, 1994); Steven Mintz, *Huck's Raft: A History of American Childhood* (Belknap Press, 2006).

2. Kathy J. Ogren, *The Jazz Revolution: Twenties America and the Meaning of Jazz* (Oxford University Press, 1989); Lewis Erenberg, *Steppin' Out: New York Nightlife and the Transformation of American Culture, 1890–1930* (University of Chicago Press, 1981).

3. Lorenzo Vidino, "Current Trends in Jihadi Networks in Europe," *Terrorism Monitor* 5 (2007), available online at www.jamestown.org/terrorism/news/article.

4. Candace de Russy, "Countercultural Higher Education Contribution to Jihadi Networks," *National Review*, November 2, 2007, available online at www.national review.com.

5. G. William Domhoff, "Wealth, Income, and Power," available online at www.sociology.ucsc.edu/whorulesamerica/power/wealth.html; U.S. Women's Bureau and the National Committee on Pay Equity, available online at www.pay-equity.org/info-time.html.

6. Marvin M. Ellison, *Erotic Justice: A Liberating Ethic of Sexuality* (Westminster John Knox Press, 2004), p. 18. See also John D'Emilio and Estelle Freedman, *Inti-*

mate Matters: A History of Sexuality in America (University of Chicago Press, 1997); and Anna Marie Smith, *Welfare Reform and Sexual Regulation* (Cambridge University Press, 2007).

7. Jeffery O. G. Ogbar, *Hip-Hop Revolution: The Culture and Politics of Rap* (University of Kansas Press, 2007), p. 30.

8. George Lakoff, *Don't Think of an Elephant! Know Your Values and Frame the Debate* (Chelsea Green Publishing, 2004), pp. 6–15. See also George Lakoff, *Moral Politics: How Liberals and Conservatives Think* (University of Chicago, 1996).

9. Lakoff, *Don't Think of an Elephant!*, p. 4.

10. Michael Eric Dyson, *Know What I Mean* (Beacon Press, 1997), p. 94.

11. Fox News, *"The O'Reilly Factor:* Is Gangsta Rap Hurting America's Children?" November 14, 2003, available online at www.foxnews.com/transcripts.

Chapter 5

1. Evelyn Brooks-Higginbotham, *Righteous Discontent: The Women's Movement in the Black Baptist Church 1880–1920* (Harvard University Press, 1993); E. Francis White, *Dark Continent of Our Bodies: Black Feminism and the Politics of Respectability* (Temple Press, 2001).

2. Myrna Blyth, "You, Go, Girlfriends," January 13, 2005, available online at www.nationalreview.com.

3. Michael Eric Dyson, during his appearance on *Talk of the Nation*, NPR, July 9, 2007.

4. Quoted in Jayson Rodriquez, "Al Sharpton Leads March Calling for More 'Decency' in Hip Hop Lyrics," May 3, 2007, available online at www.mtv.com/news/articles/1558786/20070503/id_0.jhtml.

5. "BET Honors Protest Gets Out of Hand," available online at www.youtube.com/watch?v=i5jDkMKi4m4.

6. Chisun Lee, "Counter 'Revolution,'" *Village Voice*, June 20–26, 2001.

7. Kristal Brent Zook, "The Mask of Lil' Kim: What Lies Behind the Hip-Hop Artist's Raunchy Image? A Businesswoman, a Feminist . . . an Enigma," *Washington Post*, September 3, 2000.

8. Joan Morgan, *When Chickenheads Come Home to Roost: My Life as a Hip Hop Feminist* (Simon and Schuster, 1999), p. 67.

9. Dream Hampton, "Free the Girls: Or Why I Really Don't Believe There's Much of a Future for Hip Hop, Let Alone Women in Hip Hop," in *Hip Hop Divas* (Vibe Books, 2001), p. 3.

10. bell hooks, "Misogyny, Gangsta Rap and the Piano," *Z Magazine*, February 1994, available online at www.allaboutbell.com.

11. Black Girls Rock!, December 5, 2007, available online at www.blackgirls rockinc.com.

12. Lonnae O'Neal Parker, "Why I Gave Up on Hip Hop," October 15, 2006, available online at www.washingtonpost.com.

Chapter 6

1. Robert J. Morgado, "We Don't Have to Like Rap Music, But We Need to Listen," Letter to the Editor, *New York Times*, November 4, 1990.

2. "Russell Simmons—The Godfather Takes a Stand," *Ebony*, July 2007, p. 79; Fox News, "*The O'Reilly Factor*: Is Gangsta Rap Hurting America's Children?," November 14, 2003, available online at www.foxnews.com/transcripts.

3. Quoted in Rebecca Carrol, ed., *Uncle Tom or New Negro* (Broadway Books, 2006), pp. 80–81.

Chapter 7

1. Quoted in Dana Williams, "Hip Hop's Bad Rap?" February 23, 2003, available online at www.tolerance.org.

2. Tricia Rose, *Longing to Tell: Black Women Talk About Sexuality and Intimacy* (Picador, 2003), pp. 390–391.

3. Quoted in Janell Ross, "It's Raw. It's Raunchy. Why Are Women Fed Up with Hip-Hop?" *The News and Observer*, January 1, 2006, available online at www.news observer.com.

4. Testimony of Lisa Fager Bediako of Industry Ears at congressional hearing titled "From Imus to Industry: The Business of Stereotyping and Degradation," September 25, 2007.

5. Nelly on *The Tavis Smiley Show*, May 26, 2005, available online at www.PBS.org.

6. "The Civil Rights vs. Hip Hop Generation," *Hip Hop vs. America*, BET, September 26, 2007.

7. Liz Funk, "Drop It Low: Sexist Rap Reconsidered," *The Nation*, May 22, 2007.

8. "Rap Music Mogul Russell Simmons," *The O'Reilly Factor*, April 26, 2007, transcript available online at www.foxnews.com.

9. Dana Williams, "Hip Hop's Bad Rap?," February 23, 2003, available online at www.Tolerance.org.

10. Quoted in Mike Sager, "What I've Learned: Cordozar Calvin Broadus Jr., aka Snoop Dogg, Rapper, 36, Los Angeles," *Esquire* magazine, July 2008, p. 104.

Chapter 8

1. T. Denean Sharpley-Whiting, *Pimps Up, Ho's Down: Hip Hop's Hold on Young Black Women* (New York University Press, 2007), p. xviii.

2. Glen Ford, "Hip Hop Profanity, Misogyny and Violence: Blame the Manufacturer," available online at www.peaceandjustice.org/article.php/2007050711462 1137/print.

3. Quoted in Marissa Jones, "Nelly Cancels Spelman Bone Marrow Drive," *Hill Top Newspaper*, April 13, 2004.

4. Sharpley-Whiting, *Pimps Up, Ho's Down*, p. 96.

5. "Racial Double Standards to the Nth Degree," available online at www.amnation.com/vfr/archives/007650.html.

Chapter 9

1. Present author's transcription from YouTube, available online at www.youtube.com/watch?v=CySrshUMwIw.

2. Open letter by Master P, posted on May 21, 2007, available online at www.hhnlive.com/news/more/1309.

3. Nelly, speaking as a guest on *The Tavis Smiley Show*, May 26, 2005.

4. Rose Arce, "Hip-Hop Portrayal of Women Protested," March 4, 2005, available online at www.CNN.com.

5. Testimony of Phillippe Dauman at congressional hearing titled "From Imus to Industry: The Business of Stereotyping and Degradation," September 25, 2007.

Chapter 10

1. Lola Ogunnaike, "Sweeten the Image, Hold the Bling-Bling; Eyeing Mainstream Success, Rappers Clean Up Their Act and Cultivate Their Philanthropy," *New York Times*, January 14, 2004; Buffy Beaudion-Schwartz, "Philanthropically Speaking—The Value of Philanthropy as a PR Tool, *SmartWoman*, July/August 2006.

2. Buffy Beaudoin-Schwartz, "Philanthropically Speaking . . . A Rich Tradition of African American Philanthropy," *SmartWoman*, February 2004, available online at www.abagmd.org.

3. "Rap Music Mogul Russell Simmons," *The O'Reilly Factor*, April 26, 2007, available online at www.Foxnews.com.

4. Shawn "Jay-Z" Carter, in a quote dated November 28, 2007, available online at www.scartersf.org.

5. Open letter to Debra Lee, October 2, 2007.

6. Lea Goldman with Jake Paine, "Hip Hop Cash Kings," *Forbes*, August 16, 2007, available online at www.forbes.com/2007/08/15/hip-hop-millionaires-biz-cx_lg_0816hiphop.html.

7. Robert Entman and Andrew Rojecki, statement at congressional hearing titled "From Imus to Industry: The Business of Stereotyping and Degradation," September 25, 2007.

Chapter 11

1. Quoted in Geoff Boucher, "A Politician Who Runs on Hip-Hop," *Los Angeles Times*, May 11, 2003, available online at www.articles.latimes.com/2003/may/11/nation/na-kwame11.

2. Brian Hiatt, "RS40 Anniversary: Chris Rock," *Rolling Stone* magazine, November 15, 2007.

3. Gil Kaufman, "Push the Courvoisier: Are Rappers Paid for Product Placement?" June 9, 2003, available online at www.MTV.com.

4. Quoted in Scott Mervis, "Diversity Training: The Gangsta Alternatives," *Pittsburgh Post-Gazette*, February 17, 2004.

5. Charles Gallagher, "Color-Blind Privilege: The Social and Political Functions of Erasing the Color Line in Post Race America," *Race, Gender and Class* 10, no. 4 (2003): 23–37; Jason Rodriquez, "Color-Blind Ideology and the Appropriation of Hip-Hop," *Journal of Contemporary Ethnography* 35 (2006): 646. See also George Lipsitz, *The Possessive Investment in Whiteness: How Whites Profit from Identity Politics* (Temple University Press, 1998).

6. Andrew Rojecki, statement at the congressional hearing titled "From Imus to Industry: The Business of Stereotyping and Degradation," September 25, 2007; R. M. Entman and A. Rojecki, *The Black Image in the White Mind: Media and Race in America* (University of Chicago Press, 2000).

7. Justin D. Ross, "Offended? The Rap's on Me," *Washington Post*, September 9, 2007.

8. "50 Cent's Gay Problem," March 18, 2004, available online at www.Alternet.org.

9. The quotes in this paragraph originally appeared at the following websites: www.blog.vh1.com/2007–09–12/ja-rule-dont-hate-hip-hop-hate-gays-instead/, www.blog.vh1.com/2007–09–26/ja-rule-backpedals-on-that-whole-homophobia-thing/, and http:www.boston.com/news/globe/living/articles/2004/03/16/50_cents_values_arent_worth_much.

10. Terrance Dean, *Hiding in Hip Hop: On the Down Low in the Entertainment Industry—From Music to Hollywood* (Atria Books, 2008); Rowan Walker, "Hidden Gay Life of Macho Hip Hop Stars," May 13, 2008, available online at www.buzzle.com/articles/195121.html.

Chapter 12

1. Andre C. Willis, "Rap Music and the Black Musical Tradition: A Critical Assessment." *Radical America* 23, no. 4 (1991): 29–39. Pg. 37.

2. Lupe Fiasco interview, Real Talk New York Radio Phone-In Interview, October 11, 2007, available online at www.soulbounce.com.

Chapter 13

1. Lonnae O'Neal Parker, "Why I Gave Up on Hip Hop," *Washington Post*, October 15, 2006.

2. George Lipsitz, *The Possessive Investment in Whiteness* (Temple University Press, 2006), p. 25; Cornel West, *Race Matters* (Beacon Press, 2001), p. vii; Patricia Hill-Collins, *Black Sexual Politics: African-Americans, Gender and the New Racism* (Routledge, 2004), p. 250.

3. bell hooks, *Salvation: Black People and Love* (Harper Perennial, 2001), pp. xxiii–xxiv; James Baldwin, *The Fire Next Time* (Vintage International, 1993), p. 7.

4. Dyson has used this phrase on several occasions during lectures attended by the present author.

5. Quoted in Michael Sandel, "The Case Against Perfection," *Atlantic Monthly*, April 2004.

Bibliography

Bagdikian, Ben H. *The New Media Monopoly*. Boston: Beacon Press, 2004.

Baldwin, James. *The Fire Next Time*. New York: Vintage International, 1993.

Bonilla-Silva, Eduardo. *Racism Without Racists: Color-Blind Racism and the Persistence of Racial Inequality in the United States*. Lanham: Rowman & Littlefield Publishers, 2003.

Cepeda, Raquel, ed. *And It Don't Stop: The Best American Hip-Hop Journalism of the Last Twenty-Five Years*. New York: Faber and Faber, 2004.

Chang, Jeff. *Can't Stop Won't Stop: A History of the Hip-Hop Generation*. New York: St. Martin's Press, 2005.

_____, ed. *Total Chaos: The Art and Aesthetics of Hip-Hop*. New York: Basic Civitas Books, 2006.

Cole, David. *No Equal Justice: Race and Class in the American Criminal Justice System*. New York: The New Press, 1999.

Collins, Patricia Hill. *Black Feminist Thought: Knowledge, Consciousness, and the Politics of Empowerment*. Boston: Unwin Hyman, 1990.

_____. *Black Sexual Politics: African Americans, Gender, and the New Racism*. New York: Routledge, 2004.

_____. *From Black Power to Hip Hop: Racism, Nationalism, and Feminism*. Philadelphia: Temple University Press, 2006.

Davis, Angela Y. *Abolition Democracy: Beyond Empire, Prisons and Torture*. New York: Seven Stories Press, 2005.

Duggan, Lisa. *The Twilight of Equality?: Neoliberalism, Cultural Politics, and the Attack on Democracy*. Boston: Beacon Press, 2004.

Dyson, Michael Eric. *Holler If You Hear Me*. New York: Basic Civitas Books, 2001.

Entman, Robert M., and Andrew Rojecki. *The Black Image in the White Mind: Media and Race in America*. Chicago: The University of Chicago Press, 2000.

Forman, Murray. *The 'Hood Comes First: Race, Space, and Place in Rap and Hip-Hop*. Middletown: Wesleyan University Press, 2002.

Forman, Murray, and Mark Anthony Neal, eds. *That's the Joint! The Hip-Hop Studies Reader*. New York: Routledge, 2004.

Fullilove, Mindy Thompson. *Root Shock: How Tearing Up City Neighborhoods Hurts America, and What We Can Do About It*. New York: One World/Ballantine, 2004.

Gaunt, Kyra D. *The Games Black Girls Play: Learning the Ropes from Double-Dutch to Hip-Hop*. New York: New York University Press, 2006.

George, Nelson. *Hip Hop America*. New York: Viking, 1998.

Guerrero, Ed. *Framing Blackness: The African American Image in Film*. Philadelphia: Temple University Press, 1993.

Hess, Mickey. *Is Hip Hop Dead? The Past, Present, and Future of America's Most Wanted Music*. Westport: Praeger Publishers, 2007.

hooks, bell. *Salvation: Black People and Love*. New York: Harper Perennial, 2001.

Hurtado, Aída. *The Color of Privilege: Three Blasphemies on Race and Feminism*. Ann Arbor: University of Michigan Press, 1996.

Kelley, Robin D. G. *Yo' Mama's Disfunktional! Fighting the Culture Wars in Urban America*. Boston: Beacon Press, 1997.

Kitwana, Bakari. *The Hip Hop Generation: Young Blacks and the Crisis in African-American Culture*. New York: Basic Civitas Books, 2002.

_____. *Why White Kids Love Hip Hop: Wankstas, Wiggers, Wannabes and the New Reality of Race in America*. New York: Basic Civitas Books, 2005.

Lakoff, George. *Don't Think of an Elephant: Know Your Values and Frame the Debate—the Essential Guide for Progressives*. White River Junction: Chelsea Green Publishing, 2004.

Lipsitz, George. *Time Passages: Collective Memory and American Popular Culture*. Minneapolis: University of Minnesota Press, 1990.

_____. *The Possessive Investment in Whiteness: How White People Profit from Identity Politics*. Philadelphia: Temple University Press, 2006.

_____. *Footsteps in the Dark: The Hidden Histories of Popular Music*. Minneapolis: University of Minnesota Press, 2007.

Macek, Steve. *Urban Nightmares: The Media, the Right, and the Moral Panic over the City*. Minneapolis: University of Minnesota Press, 2006.

Mansbach, Adam. *Angry Black White Boy or, the Miscegenation of Macon Detornay*. New York: Three Rivers Press, 2005.

Mitchell, Tony, ed. *Global Noise: Rap and Hip-Hop Outside the USA*. Middletown: Wesleyan University Press, 2001.

Morgan, Joan. *When Chickenheads Come Home to Roost: A Hip-Hop Feminist Breaks It Down*. New York: Simon & Schuster, 1999.

Neal, Mark Anthony. *New Black Man*. New York: Routledge, 2006.

Ogbar, Jeffery O. G. *Hip-Hop Revolution: The Culture and Politics of Rap*. Lawrence: University Press of Kansas, 2007.

Oliver, Melvin L., and Thomas M. Shapiro. *Black Wealth/White Wealth*. New York: Routledge, 1995.

Osayande, Ewuare X. *Misogyny & the Emcee: Sex, Race & Hip Hop*. Philadelphia: Machete Media, 2008.

Perry, Imani. *Prophets of the Hood: Politics and Poetics in Hip Hop*. Durham: Duke University Press, 2004.

Pough, Gwendolyn D. *Check It While I Wreck It*. Boston: Northeastern University Press, 2004.

Rose, Tricia. *Black Noise: Black Music and Black Culture in Contemporary America.* Middletown: Wesleyan University Press, 1994.

_____. *Longing to Tell: Black Women Talk About Sexuality and Intimacy.* New York: Picador, 2003.

Ross, Andrew, and Tricia Rose, eds. *Microphone Fiends: Youth Music & Youth Culture.* New York: Routledge, 1994.

Schloss, Joseph G. *Making Beats: The Art of Sample-Based Hip-Hop.* Middletown: Wesleyan University Press, 2004.

Shapiro, Thomas M. *The Hidden Cost of Being African American: How Wealth Perpetuates Inequality.* New York: Oxford University Press, 2004.

Sharpley-Whiting, T. Denean. *Pimps Up, Ho's Down: Hip Hop's Hold on Young Black Women.* New York: New York University Press, 2007.

Tate, Greg. *Everything But the Burden: What White People Are Taking from Black Culture.* New York: Broadway Books, 2003.

Vaidhyanathan, Siva. *Copyrights and Copywrongs: The Rise of Intellectual Property and How It Threatens Creativity.* New York: New York University Press, 2001.

White, E. Frances. *Dark Continent of Our Bodies: Black Feminism and the Politics of Respectability.* Philadelphia: Temple University Press, 2001.

Wilkinson, Richard. *The Impact of Inequality: How to Make Sick Societies Healthier.* New York: The New Press, 2005.

Wilson, William Julius. *When Work Disappears: The World of the New Urban Poor.* New York: Vintage Books, 1996.

Index